BEGINNER'S GUIDE TO PHOTOGRAPHY

BEGINNER'S GUIDE TO PHOTOGRAPHY

Ralph Hattersley

DOLPHIN BOOKS
DOUBLEDAY & COMPANY, INC., Garden City, New York

DOLPHIN EDITION: *1975*

This book was originally published
in paperback by Doubleday & Company, Inc., 1974

ISBN: 0-385-02083-X
Library of Congress Catalog Card Number 72–84964
Copyright © 1974 by Ralph Hattersley
Copyright © 1970 by Ziff-Davis Publishing Company
All Rights Reserved
Printed in the United States of America

9 8 7 6 5 4

To CLEVE,
CRAIG,
and LISSA

CONTENTS

Part One • How to Make Pictures

- **THE CAMERA** — 1
 - Introduction — 1
 - Choosing a Camera — 1
 - Camera Care — 6
 - Exposure Meters — 6

- **LENSES AND SHUTTERS** — 8
 - Focal Length — 8
 - Lens Speed — 10
 - Iris Diaphragm: Variable-size Door — 11
 - Shutter: Variable-speed Door — 12

- **EXPOSURE: "DOORS" WORK AS A TEAM** — 13
 - Subject Movement — 13
 - Body Movement — 14
 - Depth of Field — 14
 - Depth of Field and the SLR — 18
 - Depth of Field and the Rangefinder — 18
 - Door Versus Door — 18
 - Automated Cameras — 19

- **FILM** — 20
 - Roll Film — 20
 - Black-and-White — 20
 - Film Speed — 21
 - Speed and Grain — 22
 - Correct Exposure — 22
 - Charts and Flash Guides — 23
 - Separate Exposure Meters — 23
 - Built-in Meters — 25
 - Meters in General — 26

- **FILM DEVELOPMENT** — 27
 - Absolute Darkness — 27
 - Portable Darkness — 27
 - Things You Need — 28
 - Getting the Developer Ready — 29
 - Time and Temperature — 29
 - Agitation — 30
 - Agitation in the Hypo (Fixing Bath) — 30
 - Preventing Air Bubbles — 30
 - Film Handling — 31

The Anscomatic
and Paterson Tanks 31

Step-by-Step Developing 32

Care of Negatives 32

• *MAKING ENLARGEMENTS* **33**

Buying an Enlarger 33

Enlarger Lenses 34

Other Material You'll Need 35

• *PRINT MAKING* **36**

Your Working Place 36

Processing Prints: Basic Steps 37

The Additional Chemicals 37

The Two-Bath Hypo System 38

Hypo Eliminators and Print Washing 39

Print Drying 39

• *GETTING ORGANIZED FOR*
PRINTING **41**

The Wet Side 41

The Dry Side 43

Cleaning Your Enlarger 43

Cleaning Your Negative 44

Getting Your Image Ready to Print 44

The "Basic-Basic" Test Strip 45

Reading the "Basic-Basic" Strip 49

The Short-Exposure-Range Test 50

Multiple Test Strips 50

Developing Prints and Test Strips 50

Viewing Prints and Test Strips 55

Paper Grades and Printing Filters 56

Some Other Characteristics 58

Burning-In and Dodging 59

The Good Negative 59

Overexposure and Underexposure 61

Overdevelopment and
Underdevelopment 61

Overexposure with Underdevelopment 62

Film Speed Pushing 62

Making Contacts 67

• *PRINT FINISHING* **70**

Print Trimming 70

Print Spotting 70

Print Presentation 71

Part Two • The Aesthetics of Photography

• *JUDGING YOUR PICTURES* **75**

Good Pictures, Bad Pictures 75

Like and Dislike 75

Good and Bad, Effective
and Ineffective 76

What Photographs Do 77

The Functions of Photographs 78

Beautiful and Ugly 92

The Photographer Is Affected
by His Work 93

Print Quality 94

Part Three • Learning to See

The Tricks Will Help You 139

A Bonus Trick for Hard-Working
Students 139

• *LIGHT* 97

What Light Does to Things 97

Why We Have Trouble Seeing Light 97

White-on-White 98

White Background 99

A Necessary Detour 100

Camera Equipment 100

Lights 101

Direct, Bounce, and Edge Light 103

Light-Source Size 103

Shadows 104

Front, Side, and Back Lighting 108

Light-to-Subject Distance 110

Relative Obscurity 111

Contrast Control with Light
Reflectors and Absorbers 114

Evenness of Illumination 115

Separation 117

Tone Is Relative 119

Cast Shadows for Light Control 121

The Peephole-and-Squint Trick 122

The Picture-Frame Trick 123

Polaroid Check Pictures 123

The Moving-Light Trick 124

The On-and-Off Trick 124

Some Observable Qualities
of the Visual World 125

Visible Qualities, Objective
and Semisubjective 126

• *LIGHTING EXPERIMENTS* 141

Equipment and Materials 142

Preparing the Basic Setup 142

Exploring Contrast and Flatness 142

Exploring Separation and Blending 143

Checking Out the Background 144

Controlling the Subject-Background
Tonal Relationship 145

Lighting to Specifications:
Creating and Destroying Volume 145

Creating Volume 146

Destroying Volume 146

Manipulating Simplicity
and Complexity 146

Exploring Strength and Weakness 146

Exploring Space and
Two-Dimensionality 147

Exploring Dominance and
Subordination 147

Exploring Confusion 147

Exploring Beauty and Ugliness 148

Illumination from Within 148

Postscript to the Lighting
Experiments 148

Conclusion 149

How To Make Pictures

THE CAMERA

● Introduction

Photography is actually a very simple craft. However, if you are just a beginner it probably looks like a jungle to you. Many of the articles in the camera magazines probably make no sense to you at all. Thus you may find them both frightening and exasperating. The truth is that some professional photographers have the same problem, for like yourself they are less interested in scientific jargon than in making interesting pictures. The technological stuff really gets them into a tizzy.

The object of this book is to remedy the situation as much as possible. I will try to provide a starting place that is truly a starting place, instead of a point already 200 miles down the road toward professional photography.

I will not try to tell you all there is to know about photography, nor will I try to convince you that I'm a hotshot and a walking encyclopedia. I will very carefully restrict myself to *basic* ideas. Furthermore, I will very carefully leave out all kinds of information you don't really need to know about. These may be interesting, but there is no sense in cluttering up your head with them in the beginning. They would only confuse you at this point and possibly lead you to despair.

Of necessity, any road through the jungle of an unfamiliar subject must be constructed of words. In our case we must use photographic terms, or jargon. If you concentrate on learning what these terms mean, you will find it is easy to learn more about photography. The photographic magazines will finally seem intelligible to you, and so will the photo books.

To help you learn the basic terms, I'm having them printed in heavy type (**bold face type**) whenever I say anything about them that will help you understand what they mean. If you encounter such a term later on in the book and have forgotten what it means, skim back over the **bold face** words and find it again. Review the definition carefully, then return to your place in the text.

Besides being a road through the photographic jungle, this book has two main objectives: (1) to prepare you for learning more about photography and (2) to get you actually involved in making pictures. Instead of taking your film to the drugstore, you will be doing everything for yourself. Furthermore, your own pictures will be much better than those the drugstore could produce for you.

● Choosing a Camera

Though there are a great many kinds of cameras, I will not attempt to survey them all. If you are a beginner, this would only confuse and frustrate you. And it would be of little use in

helping you decide what kind of camera you should have. Long experience in photographic teaching has taught me that the vast majority of people now prefer to begin with 35-mm cameras. Assuming that your needs will be similar to those of the majority, I will limit my recommendations to cameras of this type. *However, the material in other sections of this book will accurately apply to all types of roll film, not just 35-mm.*

This book will not apply to the **Polaroid Land camera.** However, if you have one I'd recommend keeping it, for it is marvelous within its own realm. Use it for your pictures-in-a-minute and buy another camera—perhaps a very inexpensive one—for doing the kinds of things that will be discussed here.

If you already have a regular roll-film camera of some kind, you don't need another one right now. Even if it is a very simple and inexpensive one, you can do most of the things I will tell you about. Then, if you find yourself really interested in photography, you can begin to think about buying a more sophisticated camera. But don't jump to conclusions and act hastily. If you look at your needs realistically, you may find that the simple camera will permit you to do all the things you really want to do in photography. For example, if all you really want is small family and vacation snapshots, a camera for $25 or less may be very adequate indeed.

The standard 35-mm camera is first on my list of recommendations. One reason, as I have already mentioned, is that it is the camera most people wish to use anyway. Another is that the genius of the photographic industry has focused itself on it, making it the most useful, pleasurable, and convenient-to-use camera available.

Standard 35-mm cameras make small images (1 \times 1⅜ inches); but they are large enough for beginners to cope with very adequately. They use motion-picture-type film of the 35-mm size. It is 1⅜ inches wide and has sprocket holes (perforations) along each side. In the camera

these engage sprockets, which pull the film through.

Though the images are small, most people readily learn to make quality enlargement prints of 8 \times 10 or even 11 \times 14 inches.

I also recommend two other roll-film types, which make smaller images on 35-mm film. (The film is the same width, but the image is smaller.) They are the **126 cartridge-load camera** and the **half-frame 35-mm camera.** The first makes square images 1⅛ \times 1⅛ inches; the second makes oblong images ¾ \times 1 inch.

With both of these cameras I recommend that you limit yourself to prints no larger than 8 \times 10 inches. Most people find they are completely satisfied with prints of this size or smaller. Small prints are easy to fit into books, albums, and wallets. When you start making large ones you run into the problem of what to do with them. You also run into considerable expense, for photographic enlarging paper is costly.

Many very advanced photographers find that the 8 \times 10 size suits them better than any other. You should be aware of this lest you begin to think there is virtue in large size per se. Many very famous photographs are quite small.

The great advantage of the **126 cartridge-load camera** is its extremely simple operation, especially in loading the film. With the cartridge camera, there is nothing to stick into the camera but the film cartridge itself. This is no more difficult than putting a bookmark in a book. Also, this type of camera automates a good many other steps that nontechnical people would otherwise find frustrating.

The **126 cartridge-load camera** uses 35-mm film, though most photographers don't seem to know this. However, it only has sprocket holes along *one* side; these are spaced farther apart than those on standard 35-mm film. The idea of the cartridge is that you never have to touch the film nor hardly even think about it. You pop the cartridge into the camera, close it, and let the take-up lever do all the thinking for you.

In terms of the quality of resulting pictures, the range of 126 cameras is very wide. The least expensive models yield a quality that is fine for wallet size but not good at all for prints 5 × 7 and larger. The expensive models are almost in the professional class. Using them, a competent craftsman can easily get high-quality 11 × 14 prints. Furthermore, these very expensive 126s are even more heavily automated than the cheaper models and will do many more things. They are also much more durable and dependable.

For some people, the disadvantage of a 126 camera is that you get too few pictures per cartridge: only 12 for black-and-white films, either 12 or 20 for color. The 20-picture cartridge has a longer strip of film in it than the 12. Eventually, Eastman Kodak may load longer strips for black-and-white work.

For those who like to get a lot of pictures per roll, the **half-frame 35-mm camera** is the answer. The 35-mm film is loaded in standard cassettes in two lengths. One is a 20-exposure roll, the other is 36. Thus, in standard 35-mm cameras, you get either 20 or 36 images.

With the **half-frame cameras** you get either 40 or 72 pictures in a roll, for the images are only half the standard 35-mm size. However, since the images are smaller, they won't yield as good quality in large prints as the standard 35 will. A good craftsman can get quality prints up to 8 × 10 inches. Most people would be better off settling for 5 × 7s or smaller. If small prints are all you want, the half-frame may be your cup of tea. You can make half-frame color slides too; they are very nice indeed.

Another advantage of **half-frame cameras** is that they are very small and compact, whereas most standard-frame 35s are quite large and heavy. All the half-frame cameras will fit nicely into a man's jacket pocket or a woman's purse, while only a few of the full-frame cameras will. If you like to carry a camera with you at all times, without a shoulder strap, seriously consider the half-frame.

The Instamatic 44 is a cartridge camera selling for less than $10. Though easy to use, it doesn't have sophisticated features.

The Olympus Pen EE-2 is a half-frame 35-mm camera—small, durable, and of fine quality. It takes 72 pictures on a 36-exposure roll of film, 40 pictures on a 20-exposure roll.

The Nikkormat is a highly reliable SLR (single-lens reflex) type of camera. This type is very popular nowadays.

There is a kind of roll-film camera to avoid: the **subminiature.** It is smaller than a cigarette pack. It uses such small film (16-mm) and makes such tiny images that only a master craftsman can make passable enlarged pictures with it. Even he will have his problems. For a beginner it is worse than useless.

I've said that my primary recommendation is the standard 35-mm. It comes in two main types, called respectively **single-lens reflex** and **rangefinder.** One of the chief differences is that they employ very different means for viewing and getting the image in focus.

The **single-lens reflex camera** (called **SLR** for short) is by far the most popular type nowadays. The word "reflex" indicates that it embodies a mirror that reflects the image coming through the lens up into a viewing system that you look through when taking pictures. When you snap the shutter, the mirror flips out of the way so that the image will reach the film, then flips down again so you can still see the picture you're getting. It usually happens so fast you're not aware of the flip and return.

The image you see in the viewing system is

exactly the same as the image that reaches the film. If the viewed image is fuzzy (out-of-focus), the image on the film will also be. The placement of objects in the picture will also be the same for both images. People who buy **SLR** cameras find these factors extremely important. They are lacking in rangefinder cameras.

Rangefinder cameras take their name from the fact that they employ focusing systems similar to rangefinders on military cannon. A rangefinder simultaneously finds out how far away a pictorial subject is and adjusts the lens position to focus the subject on the film. It is very easy to use.

Rangefinder cameras have viewing windows that tell you what your subject looks like and how much of it you are including in your picture. In the center of the window is a little spot that you use for focusing. In some types of spots you have split images that come together when the subject is in focus. In others you have double images that become superimposed when the focus is sharp. In both types the focusing is very accurate.

The trouble with viewing windows on range-

The Canon QL 19 is a rangefinder-type camera. It is automated but has manual override, so that one can pick whatever aperture setting and shutter speed he wishes.

finder cameras is that they are actually windows. Thus, what you see through them always looks in sharp focus, whether it is near you or far away, even if the main subject of your picture is completely out of focus on the film plane. With the SLR you can tell whether something is out of focus because it clearly looks that way through the viewer. Not so with the rangefinder. *Everything always looks sharp,* whether it is or not. You can get very sharp pictures, to be sure, but only if you remember to use the rangefinder spot every time you take a picture.

Another problem with the **rangefinder camera** is that the image you see through the window (viewfinder) and the image that the lens passes through to the film aren't quite the same. On distant objects this doesn't matter at all, for you couldn't tell the difference between the images

if you tried. But on objects that are very close there can be a dramatic difference. Enough, indeed, to ruin many of your pictures.

The point is that your viewing window and your lens are looking at your subject from different positions in space. (The difference is called **parallax.)** At five feet or more it doesn't matter at all. Up close it can matter a great deal. Though there are systems for compensating for parallax (often built right into the camera), you still don't get exactly what you see through the viewfinder window. With SLRs, the viewed image and the recorded image are always identical, for they both come through the lens instead of through two different viewing systems.

These factors have made the rangefinder camera lose popularity. However, in cheaper cameras the rangefinder is a better bet than the SLR, for it is easier to make one that is sturdy. In a cheap SLR, one can't depend on the mirror mechanism (extremely delicate) holding up. In contrast, there are several rangefinder cameras in the $50 range that are quite dependable.

In terms of quality at low cost, a type of camera not yet mentioned here is recommended: the **twin-lens reflex.** Most models of this type use 120 film, which gives images 2¼ × 2¼ inches. They can easily be enlarged to 16 × 20 prints. The twin-lens has, obviously, two lenses —one above the other. The word "reflex" refers to reflection and the fact that there is a mirror behind the top, or viewing, lens.

This lens is used only for looking, so the mirror stays in place all the time. The bottom lens takes the picture. Not requiring a complex flip-and-return system, the camera can be made of good quality at low expense. Thus, if you want a good camera at less than $50, the twin-lens reflex is a good bet.

However, since it is fairly bulky and takes only 12 pictures on a roll, it is not very popular nowadays. You have, again, a **parallax** problem on looking at close-up subject matter (two lenses looking from different positions in space). And

you can't conveniently use it to make 35-mm color slides, which are very popular. But in terms of durability and dependability at low cost, it is a good buy.

Before closing, a bit more about price, and a word about the best source of cameras. In general, you pay for what you get. No matter how you look at it, a $75 camera is just not in the same class as a $250 one. Source is important, too. Dollar-for-dollar, an American-made camera is not as good as one made in either Japan or Germany. In this era, foreign manufacturers have the jump on us due to labor costs, money exchange rates, etc.

● **Camera Care**

A camera is a delicate precision instrument. Handled carefully, it will function well for years. Yet it can't take even as much rough treatment as a wristwatch.

Don't drop your camera and don't bump it into things. Don't force its levers, rings, knobs, and screws any more than you would intentionally overwind a watch. If you play strong man even once, you may ruin the camera or run up a high repair bill. Don't try to fix it yourself, or the bill will run still higher.

When not taking pictures, keep a cap on the lens. Clean it only with lens tissue, a soft sable brush, or a rubber syringe blower. Silicone polishing tissues for eyeglasses will damage its surface. So will fingerprints, which etch themselves right into the glass.

If you drop your camera in salt water, bid it a sad good-by. There is only a slim chance of saving it if you rinse it thoroughly with fresh water and take it immediately to a camera repairman.

Getting sand in it is almost as ruinous. It grinds down gears and screw threads so that they no longer mesh together snugly. Or it may lock up mechanisms so that they won't operate at all.

Don't put your camera in the glove compartment of your car or near a furnace or radiator. Don't store it in a damp place, especially in salt air.

If it has a built-in exposure meter, turn it off when it's not in use. Or if it has a cover, put it on.

If your film jams while you're advancing it, don't try to force the winding mechanism. You'll earn a fat repair bill. Just bid your pictures farewell, open the camera back, and take out the film. Load the camera again and give it another try. If it works, put in a fresh roll and start shooting again. If it doesn't, take your camera to a repairman.

Don't let your friends use it to learn photography. They are even worse than salt water.

The camera instruction manual is your bible, so keep it handy at all times. When you forget how to do something, look it up again. If you try to do it by experimentation you may seriously damage your camera.

● **Exposure Meters**

You ought to have a good exposure meter. A poor one isn't worth bothering with, for it will give you information that is not reliable. You can have a meter that is built into a camera or buy one that is separate. It is convenient to have both kinds if you can afford them.

With the more expensive and up-to-date cameras you can get high-quality built-in meters. Those on SLR cameras are extremely easy to use. On rangefinder cameras they are a lot of bother. With a good meter on either type camera, an extra meter is actually unnecessary, though handy to have at times.

Reliable meters of the separate type run from under $40 to more than $100. If your money is limited, you'd be better off to invest more in a camera with a good meter, for it will have other useful features as well. Many very good photographers have never used anything but built-in meters.

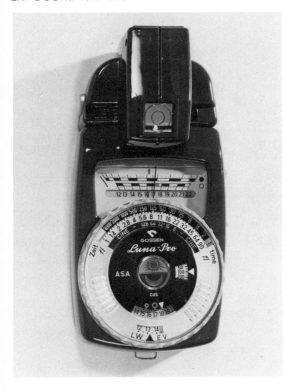

The Gossen Luna-Pro is a cadmium-sulfide-type meter that is extremely sensitive to light. It can even read moonlight, hence its name, *Luna*-Pro.

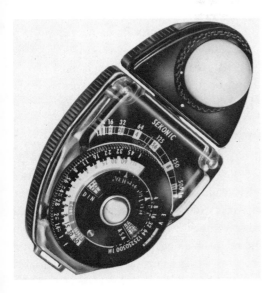

The Sekonic L-28C Studio Deluxe is a selenium-type exposure meter. It is very reliable and easy to use.

Meters are powered either by **cadmium sulfide (CdS)** or **selenium** cells. The former type requires a battery and works very well as long as the battery is fresh. Selenium meters (sometimes called **photoelectric** meters) require no batteries. If gently treated, they will continue to give you very accurate readings for more than twenty years and require no repairs at all.

The better **CdS meters,** such as the Gossen Luna-Pro and the Weston Ranger 9, are extremely sensitive to low levels of light, e.g., moonlight or candlelight. Cheaper ones have about the same sensitivity as selenium meters, sometimes a little less, and I don't recommend them. Either buy top-quality CdS or don't buy it at all.

In the $55 to $65 class are two excellent **selenium meters;** the Weston Master VI and the Sekonic L-28C Studio Deluxe. In some camera stores you can get reconditioned earlier models of both meters for $15. This is a fantastic buy, which I heartily recommend.

Except in dim light these selenium meters are accurate and dependable. Within their range they are better than even top-quality CdS meters. Nonetheless, the Luna-Pro has been my personal choice since it came on the market.

The advantage of the selenium meter is long-time dependability and no worry whether a battery is fresh enough to last through a photography field trip. With the top-quality CdS meter it's the ability to read light so dim that the selenium meter wouldn't read it at all.

Later I'll talk about certain problems in using meters properly, so that exposures are accurate. In terms of these problems, the best thing for the beginner is to have a high-quality SLR camera with a built-in meter. With it he can solve nearly all of them easily.

For a person who wants to experience photography at the lowest possible cost to himself, a meter, separate or built-in, isn't necessary at all. In a moment I will tell you how he can get along without one.

LENSES AND SHUTTERS

When we begin to talk about lenses and shutters the photographic jargon can easily become terribly confusing to beginners. I'll simplify as much as I can, but you need to know *some* of the jargon in order to carry forward your study of photography. You see, it was invented in the first place in order to make it possible for us to communicate with one another about photography.

● **Focal Length**

The technical definition of **focal length** would not make much sense to you at this point, nor do you actually need to know it. It is sufficient to know that focal length is one of the attributes of all lenses, that they may have different focal lengths, and that different focal lengths result in different pictures.

With 35-mm cameras, some common focal lengths of lenses are 21-mm, 28-mm, 35-mm, 50-mm, 90-mm, 105-mm, 135-mm, 200-mm, 250-mm, and 300-mm. As you see, we're going from small numbers to large ones. It is not surprising that the small numbers refer to **short focal lengths,** the medium numbers to **medium focal lengths,** and the large ones to **long focal lengths.** The 50-mm lens has been arbitrarily designated as the medium lens for 35-mm cameras. It is also called the **normal lens,** for most 35-mm cameras have a lens of this focal length or very close to it.

Lenses of 90-mm or longer are usually called **telephoto lenses.** Those descending in focal length from 50-mm are called **wide-angle lenses** for reasons I'll explain in a moment.

Lenses with focal lengths of 200-mm or more seem like telescopes, especially when you put them on an SLR camera and look through the viewfinder.

You can have someone stand quite a long distance from the camera and still have him fill up the whole picture. As you substitute progressively shorter focal length lenses he becomes smaller and smaller in the viewfinder. With a 21-mm lens he becomes very small indeed.

Shy photographers favor telephoto lenses, because they can sneak portraits of people without being near them. Such a lens could also be called a "narrow angle lens," though most people don't think of it this way. Like the pencil beam of a spotlight, it reaches out at a very narrow angle.

On the other hand, a 21-mm lens reaches out like a floodlight and includes a very wide angle of view—almost as much coverage as your eyes give you. The **fish-eye lens** goes another big step in coverage. Both the wide-angle and the fish-eye create a lot of image distortion, which many people find very interesting.

There are also **zoom lenses,** with variable focal length. As you look through the viewfinder and rapidly increase the focal length, you get the feeling that you are zooming out into space.

PICTURES MADE WITH LENSES OF DIFFERENT FOCAL LENGTHS.

As you can see, a 21-mm lens seems to encompass nearly everything, a 50-mm lens an average amount, while a 200-mm reaches way out and takes just a small piece of the whole scene. They do many other things, too, but you should learn what these are by actually using the lenses.

Since they are heavy, expensive, and not extremely sharp, they are of interest mainly to camera buffs and professionals.

● Lens Speed

Some lenses are called "faster" than others because they let more light into the camera in the same given length of time. It's like a big bathtub drain being faster than a small one. When you look at them, you see that fast lenses are greater in diameter than slow ones. Extremely fast lenses are almost as wide as soup plates.

Lens speeds are expressed in *f*-**numbers,** which are usually marked on the lens. *The smallest f-number on the lens is its maximum speed.* On 35-mm cameras the most common lens speeds are *f*/1.4, *f*/1.8, *f*/2, and *f*/2.8.

People find it confusing because an $f/1.4$ lens is **faster** than an $f/2.8$ one. The number refers to the size of the hole, you might say. To help you keep things straight, you might remember this rule: *The larger the number, the smaller the hole.* For example, $f/16$ is quite small and $f/45$ very small indeed.

● Iris Diaphragm: Variable-size Door

The **iris diaphragm** is a circular, variable-**size** door. It opens up as wide as the lens itself but never quite closes all the way. It got its name from the iris of the eye, which also opens and closes in what appears to be the same way.

It can be compared to a variable-size bathtub drain, which can let either a little or a lot of water through in a given time. The camera diaphragm controls the amount of light that reaches the film in a given time.

The various openings of the iris diaphragm are calibrated (carefully measured) and usually inscribed on the lens barrel. These markings are called f-**numbers.** A typical range of f-numbers is $f/1.4$—2—2.8—4—5.6—8—11—16. A few

35-mm cameras go on to $f/22$. Larger cameras may go to 32—45—64—90—125. It will help you understand if you look at your camera and find these markings I'm talking about.

On most cameras you can set the iris diaphragm openings manually. Try it. Remember the rule: *The larger the number the smaller the hole.* Look at your camera and the diaphragm markings will help you remember it. If you set the diaphragm at $f/2.8$, you see that you've got a relatively large opening. Set at $f/16$ it is quite small. You will find that it is useful to memorize the series of f-numbers given in the last paragraph. If memory fails, look at the lens barrel. They are all marked there.

Look again at the series of f-numbers. As you go in one direction through the series, you progressively double the size of the aperture at each marking **(stop).** In the other direction you halve the area at each **stop.**

When you double the area of the variable-size door (diaphragm or **aperture),** twice as much light can come through in a given time. If you halve it, half as much light comes through.

Let us choose three of the f-**numbers** that are

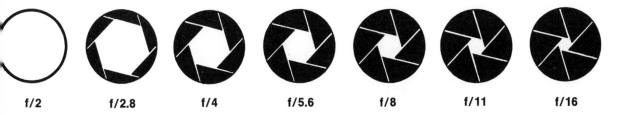

f/2 f/2.8 f/4 f/5.6 f/8 f/11 f/16

The camera diaphragm is actually a variable-size, circular door that doesn't quite close all the way. Notice that the largest openings have the smallest numbers, and vice versa. These openings are called f-numbers, f-stops, stops, or apertures.

marked in succession on the lens barrel—$f/2$, $f/2.8$, and $f/4$. We will start by setting the aperture at $f/2.8$. If we make it smaller by resetting it to $f/4$ (this is called **stopping down),** it shuts out half the light. But if we make it larger by turning to $f/2$ (called **opening up),** it lets twice as much light in.

● Shutter: Variable-speed Door

A camera has two doors. Variable-**size:** diaphragm (or **aperture).** Variable-**speed:** shutter. Though they don't look much like doors they function like them.

The iris diaphragm controls the volume of light to reach the film. The shutter controls the length of time during which it can enter. The periods of entry are of different lengths, called **shutter speeds.**

Cameras have series of shutter speeds. Going through the series in one direction we progressively double the time interval at each new shutter setting. In the opposite direction we halve the interval each time.

The more expensive cameras have a long **shutter speed series,** for example 1 sec—$\frac{1}{2}$ sec —$\frac{1}{4}$—$\frac{1}{8}$—$\frac{1}{15}$—$\frac{1}{30}$—$\frac{1}{60}$—$\frac{1}{125}$—$\frac{1}{250}$—$\frac{1}{500}$ —$\frac{1}{1000}$. You will notice that the doubling and halving are not always exact. For example, half of $\frac{1}{60}$ is not actually $\frac{1}{125}$. It is $\frac{1}{120}$. But $\frac{1}{125}$ and $\frac{1}{120}$ are so nearly the same size that for practical purposes we can think of them as identical.

Cheaper cameras will have fewer shutter speeds, starting perhaps at $\frac{1}{30}$ and going as far as $\frac{1}{125}$ or $\frac{1}{250}$ sec.

Many cameras have an additional setting called **bulb,** a rather peculiar name dating from the early history of photography. It means that on the bulb (or "B") setting you can push down the shutter button and hold the shutter open as long as you wish—an hour, for example. When you release the button the shutter closes again. You use "B" for taking pictures in extremely dim light.

In your reading in photography you will come across two additional terms you ought to understand: **focal-plane shutter** and **between-the-lens shutter.** Most cameras will have either the first or second kind. They look very unalike but serve exactly the same function.

A **focal-plane shutter** is a sliding door positioned in the back of the camera just in front of the film. The film position is called the focal plane, because the lens focuses the image on it. The shutter gets its name because it is very near this plane.

The **between-the-lens shutter** is either positioned inside the lens itself (between its glass elements) or is just behind it. It looks something like the side view of a fist opening and closing.

The better 35-mm cameras have focal-plane shutters. The focal-plane shutter is a part of the camera, not of the lens. It means that you can have a whole series of lenses for your camera and not have to have a separate shutter for each one. This saves a lot on weight and expense. The between-the-lens shutter is usually a part of the lens.

EXPOSURE: "DOORS" WORK AS A TEAM

When you are not taking pictures, the film in your camera is in utter darkness. You take a picture by exposing the film to light. When you press the shutter release, the shutter flicks open for a moment, **exposing** the film.

When the camera shutter opens, the image of the subject you are photographing strikes the film. *This image is entirely made of light.* Thus, when I say the image strikes the film it is exactly the same as saying that light strikes it—or "exposes" it.

The film needs **correct exposure,** however. Selecting either the shutter speed or the aperture arbitrarily just won't do at all. In a moment we'll investigate as far as necessary the problem of determining correct exposure. At this point I merely wish to give you a rough idea of how the two "doors"—diaphragm and shutter—function as a team.

Using the variable-**size** door (diaphragm or aperture) you can make either a bright or dim image strike the film. At a large opening (like $f/2$) the image (light) will be bright on the film. At a small opening (like $f/16$) the image (light) will be dim.

Using the variable-**speed** door (shutter) you can have the image remain on the film for a long, medium, or short time.

To expose the film correctly means to let a certain definite **quantity** of light fall on the film.

This quantity is expressed as light intensity multiplied by time. We can get the quantity we want by letting a lot of light into the camera for a relatively short time, or a little light for a relatively long time. Using either approach we can come up with total quantities that are identical.

In photography, we call these quantities "exposures." We say that we can get the "same" exposure with a lot of light in a little time or a little light in a lot of time.

If we've gotten the correct combination of light intensity (controlled by the aperture) and time (controlled by shutter speed), we call the result "correct" exposure. This means we've permitted a carefully determined quantity of light to react on the film. Sometimes it is best to get "the" exposure with a lot of light (large aperture) and a short time (fast shutter speed). Other times it is best to use less light (smaller aperture) and a longer time (slower shutter speed). Here's how you should make your choice.

● Subject Movement

If your subject is moving and you photograph it at a slow shutter speed your picture will look fuzzy, or blurred. The faster it moves the higher the shutter speed required to freeze its movements and get a sharp image.

On a sunny day you can use very small aper-

tures and very high shutter speeds at the same time. This is generally considered a very desirable situation.

On heavy overcast days, in deep shade, after sunset, or indoors, the situation is very different. The light available is relatively dim. In order to shoot at even a moderately fast shutter speed you may have to have a very fast lens with the aperture open all the way. For example, under a heavily overcast sky you might have to shoot at $\frac{1}{125}$ sec and $f/2$, even with a fast film. Many modern films are very sensitive to light and are called **fast films.** This means that for the correct exposure you don't need an enormous quantity of light to strike the film.

Indoors, the situation with respect to freezing movement is even worse, unless one has an electronic flash unit. In many rooms the best one could do for shutter speed with an $f/2$ lens might be $\frac{1}{30}$ sec—with a very fast film like Tri-X. Using a slower film you might not be able to take a picture at all.

The main point I wish to make here is that large apertures such as $f/1.4$, $f/2$, and $f/2.8$ give you opportunities to use higher shutter speeds than you could with smaller apertures. Furthermore, you may desperately desire the higher speeds in order to freeze movement.

• Body Movement

There is another factor that gives you blurred images: the movement of your own body. If you jiggle, your camera does too. You have to do the same things to counteract body movement as you do to freeze subject movement. Use fast film, fast lenses, high shutter speeds, and as bright a light as you can get.

By practicing, some people can develop such steadiness that they can hand-hold cameras and get sharp pictures at $\frac{1}{15}$ or even $\frac{1}{8}$ sec. Beginners, however, are lucky if they can get away with speeds as low as $\frac{1}{125}$. For such a person it is hopeless to try to get sharp pictures by hand-holding a camera in dim light.

There are two solutions to the problem, however: flashcubes (or electronic flash units) or tripods. Flashcubes will let you shoot at rather high shutter speeds. Electronic flash will give you the equivalent of very high shutter speeds.

With your camera on a tripod you don't need high shutter speeds. No matter how slow your shutter speed you'll get sharp pictures—as long as your *subject* isn't moving. You can even use the bulb ("B") setting and make sharp pictures with hour-long exposures.

There is a problem in seeing that the tripod itself doesn't move, however. When you press the shutter release you may jiggle both the camera and the tripod. You can prevent this by using a cable release (a wire-like tube with a spring-loaded plunger) for activating the shutter. If you bend the cable release into a half-loop it will absorb your body movement so that it doesn't reach the camera and tripod.

If you don't have a tripod it helps to rest your camera on a table, chair, or stack of books. In this case you should buy a cable release. It is quite inexpensive, and using very rickety props for your camera, you can still get sharp pictures.

The more expensive 35-mm cameras have self-timers. They also can be used to get sharp pictures when the camera is on a tripod or propped up on something. The idea is that you set the self-timer, press the shutter release, then stand away from your camera. By the time the shutter fires, all the movement in the camera and its support will have quieted down.

• Depth of Field

When you take a picture with several objects in it, the one you focus the camera on will be sharpest. Objects closer to the camera are less sharp and those *very* close to it may be totally blurred. Objects farther from the camera than your subject also get progressively less sharp.

Some of the objects in front and back of the object focused on may be *acceptably* sharp, how-

ever. This means they look sharp to the eye, though under a magnifier they would seem less so. Thus, within the picture-taking area in front of the camera there is a *zone* of acceptable sharpness. The length of this zone from front to back is called **depth of field.** Some people remember what it is if they think of it as **depth of sharpness** instead. But depth of field is the term in common use, and you ought to memorize its name and meaning.

Depth of field can be *increased* by **stopping down** (making the aperture smaller). It is *decreased* when you **open up** (make the aperture larger). The term "stopping down" comes from the fact that *f*-**numbers** are also called *f*-**stops.** Thus, to go down one stop means to make the

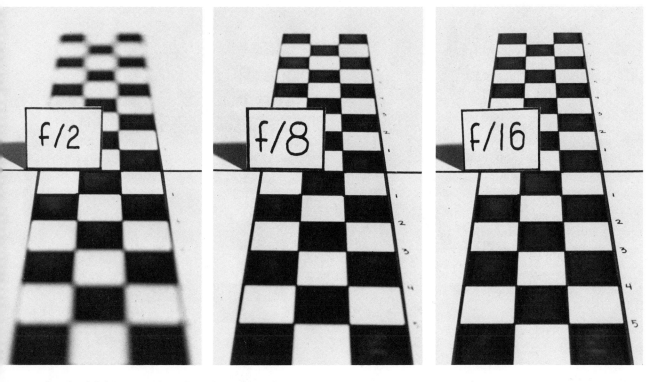

Depth of field test made with a 50-mm lens. The squares on the checkered grid are 1 × 1 inches. The f-number cards (f/2, f/8, and f/16) were about 2 feet from the camera. The measure of depth of field is the total depth of sharpness both in front and behind the card on which the lens was focused. It is obvious that when you are close to a subject there is very little at f/2, a tangible increase at f/8, and quite a bit at f/16. With distant subjects there is much more depth of field at all of these f-numbers.

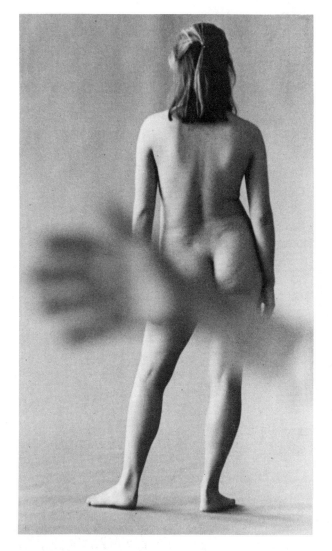

Pictures made with a 200-mm lens, one when it was
focused on the model, the other when focused on the
hand. The hand and the model are about 30 feet
apart, though the lens seems to compress the distance.
There was not enough depth of field to make both
subjects sharp. Having fuzzy areas in a picture is
called "using selective focus." That is, you select some
things to be sharp and others to be fuzzy (or out of
focus). There are a lot of interesting possibilities in
this technique, for it changes the appearance of
reality in strange and exciting ways.

aperture (diaphragm) one *f*-number smaller, for example, to change from *f*/8 to *f*/11. To open up a stop we would go from *f*/8 to *f*/5.6. This "stop" jargon is used all the time in photography, so you ought to concentrate on remembering it.

Depth of field can be *increased* in yet another way: by focusing on something farther away from the camera. In contrast, it is *decreased* by focusing on something closer. When your subject is *very* close to your camera—for example, when you are using close-up attachments on the lens —there is hardly any depth of field at all. Many cameras have **depth-of-field scales** marked on the lens barrel. They look pretty tricky but aren't really. There are two sets of numbers opposite each other. It helps if you remember what they stand for. One stands for feet (or, sometimes, meters, which are a little more than *three* feet). The other stands for *f*-numbers, or *f*-stops.

The foot (or meter) scale tells you how far away from you things are. You can use it to learn to estimate distances, a useful skill in photography. All you have to do is focus on an object, then look at the scale and read how far away it is. You can also read the depth of field without having to adjust the scale.

Say that the object is 8 feet away. The number 8 will be right across from the scale's center mark. On either side of the center mark is a duplicate series of *f*-numbers. The similar numbers on either side closest to the center mark will be the *f*-number representing the speed of the lens (the largest *f*-stop, for example, *f*/2).

As I've suggested, there will be two *f*/2s. On the scale, one will be right across from the distance (in feet or meters) that represents the *near* side of the depth of field. The other *f*/2 will be across from the number for the far distance. If you shoot your picture with the aperture set at *f*/2 this is precisely your depth of field—which includes the near and far distances within which objects are acceptably sharp and the sharpest point of all, which is approximately in the middle.

If you stop down to *f*/8 you use the two *f*/8 markings on the scale. You will find the near distance nearer, the far distance farther, and the total depth of field greater. The depth of field itself is not indicated, but you can figure it out by subtracting the near distance from the far. Subtract and you get the depth in numbers, representing either feet or meters (sometimes both, on two separate scales).

Many people are very frightened of the depth-of-field scale, because it has numbers on it. Packages of meat at the grocery store have numbers on them too, but that doesn't make them ominous. Read and reread what I've just written. Then you will find that the scale is less terrifying. Study also the picture of the lens with the depth-of-field scale—and the caption with it.

A 28-mm lens, showing the depth-of-field scale (bottom) and the *f*-number settings (top). You can see that the aperture is set at about *f*/11 and the lens focused at 4 feet. This gives us a depth of field (depth of sharpness) from about 2¾ to 8 feet. All objects falling within this range will be acceptably sharp.

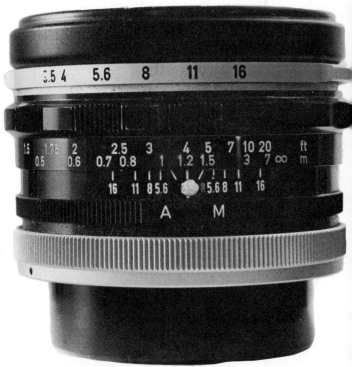

• Depth of Field and the SLR

One of the main reasons for the great popularity of the SLR (single-lens reflex) is that you can actually *see* the depth of field before you take your picture. The object you focus on looks sharp. Things in front and behind look progressively less sharp. You can't see this at all with rangefinder cameras.

You focus an SLR with the lens wide open (at the largest aperture). With this lens setting, the image is as bright as it can get, so that you can see well to focus accurately.

Unless you are working in dim light, however, you usually make your picture with the lens stopped down. This changes the depth of field, of course. With less expensive SLRs you stop the lens down to the desired *f*-number manually before shooting. Then you can see the image is perceptibly darker in the viewfinder. You can also see that the depth of field has been increased. Seeing this depth is very useful, for it tells you a good deal concerning how your picture is going to look. It won't look that dark, however.

On most SLRs the stopping down is automated. You preselect the *f*-stop you want to use and set a pointer at that marking. This doesn't actually change the aperture size. This happens when you shoot your picture and the camera stops itself down. It stops down before it permits the shutter to open.

The mirror is also lifted out of the way after the shutter release is pressed. If it weren't, no light would reach the film. After the exposure, both the mirror and the aperture return to the pre-exposure position. With the mirror back in place you can still see your subject. With the aperture fully open again it has maximum visibility. With most shutter speeds this happens so rapidly that you're hardly even aware of it. Thus, there is no perceptible break in the continuity of your seeing. This break is very disturbing in cameras that aren't automated.

With many SLRs there are ways of "previewing" your depth of field. That is, you can push a button or twist a ring and stop the lens down for a look, then open up again for maximum visibility through the viewfinder. As I've said, the final stopping down is automatic.

There are great advantages of this depth of field preview capability. One of them is that you'll get a much better idea of what your picture will look like if you are photographing things close to your camera. Or when part of your subject is nearby and the rest quite a distance away.

In these circumstances the image is often radically altered by stopping down. That is, what you see with the aperture wide open in the focusing position is not at all like the picture you'll get when stopped down. By previewing, you see what the difference will be.

• Depth of Field and the Rangefinder

You will recall that sighting through a range-finder camera is looking through an actual window, not seeing an image passed through the camera lens into an optical system. Therefore, *everything* looks sharp *all* the time. The problem is that lenses don't see that way. You may see something as sharp and the lens may record it as out of focus on the film.

For a good many kinds of pictures this doesn't matter at all, for example, shooting subjects that are more than five feet away, in daylight. Assuming you've remembered to focus, most of the time you'll get pretty much what you see in the viewfinder. This is even more probable if you favor wide-angle lenses, which give you a great depth of field. Lenses give the very same depth of field on rangefinder cameras as they do on SLRs.

• Door Versus Door

You will recall that the diaphragm (aperture) and the shutter function as doors. They both let light into the camera. One controls its intensity, the other its duration. The sections on subject and body movement talked about sacrificing small

apertures in favor of large, to get as high as possible shutter speed in dim light. As you can now see, this also entails sacrificing depth of field.

Many a time photography is an either/or proposition. In moderately bright light, you can either stop movement or get great depth of field. You can't do both. In sunlight you can, of course. If you demand both indoors, you have to use either high-output tungsten or electronic-flash light sources, especially if you are using color films, which are relatively slow.

• Automated Cameras

Many of the things that have been discussed in the section on lenses and shutters are taken care of by automated cameras. To a large degree they do your thinking and remembering for you. You just point them at your subject and they choose their own shutter speeds and aperture settings. Whether you have one or not, it is still a good idea to know the problems they have to solve. Another excuse for including the lens and shutters section is that there are numerous advantages to having cameras that are not automated, or in which automation systems can be manually overridden.

If you wish to do the thinking for yourself, the information I've given is critically important. Many readers have no choice, of course, for they already have thinking cameras that can't be manually overridden or, in contrast, ordinary cameras that hardly think for themselves at all.

FILM

Photographic film consists mainly of a thin, clear, flexible plastic sheeting with gelatin coated on one side of it. Though the gelatin is the same basic stuff as Jell-O, it has been thoroughly dried, so that it is quite tough and hard.

Finely mixed in the gelatin are light-sensitive silver compounds. The gelatin functions as a glue that makes them stick to the plastic base. The mixture of gelatin with a silver compound is called an **emulsion,** which is a term you should remember.

The coated side of the film is called the **emulsion side,** or merely **the emulsion.** The uncoated side is called the **backing side,** or **backing.**

● Roll Film

For use in the cameras we've discussed, film is cut into long strips, then rolled on spools. With 35-mm films the spooled film is kept in light-tight cassettes, with one end left protruding so that the film can be attached to the mechanism that feeds it through the camera.

The 126 cartridges are completely self-contained and have two spools built into them. One is for the unexposed film. The other, called the "take-up spool," is for film with images exposed on it. The cartridge completely eliminates the confusion of threading film across sprockets and into gear systems.

Larger-size roll films such as 120 have only the spools themselves with film rolled on them. How-

ever, to keep the film from getting exposed to light, it is backed with a light-impervious strip of paper, called the **backing paper.**

The film in the 126 cartridge is also backed with paper, but the photographer never touches it until he breaks open the cartridge to remove the film for development.

In all three spooling systems the film is loaded **emulsion-side in.** Thus, if you hold a bare roll of film in your hand your fingers are touching the **backing,** *not* the **emulsion.** In a moment you'll see why it's important to know this.

● Black-and-White

If you've looked ahead you've seen that the book gets into film development and enlargement printing and that it deals with black-and-white images, not color. Do-it-yourself color developing and printing are a bit too complex for beginners. However, when you've got a good background in black-and-white work, it will be relatively easy for you to go into color.

Beginners are always advised to choose one film and stick to it. Jumping from one kind of film to another will only confuse you.

If your camera has shutter speeds as high as $\frac{1}{500}$ sec, use Kodak Tri-X (ASA 400) exclusively. If the speeds don't go that high, use either Verichrome Pan or Plus-X, which are rated at ASA 125. But choose only one of them and stick with it. The only problem with Tri-X is that it is

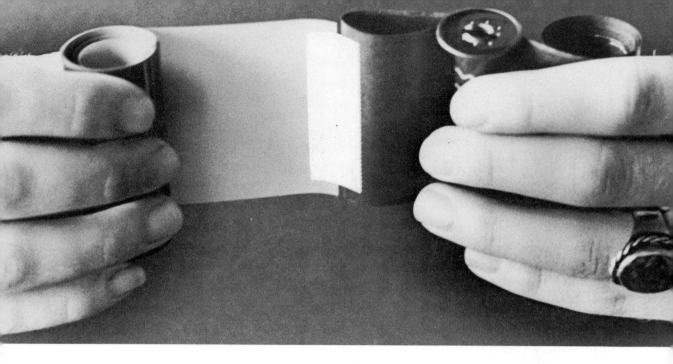

The proper way to separate roll film from its paper backing. The film is in front, the backing paper behind it. One must not touch the surface of the film; and it should be held only by the eges. This is all done in total darkness.

too fast for some cameras. Otherwise it is the world's best all-around black-and-white film.

• Film Speed

The speed of a film is its relative sensitivity to light. Thus, a fast film is very sensitive to it, a slow one less so. The sensitivity is given in numbers as the **ASA speed,** which is an international standard. Fast films have speeds around ASA 400 or higher. Medium speeds are around ASA 125. And slow films are around ASA 50 or lower.

ASA speeds are related arithmetically. Thus ASA 400 is twice as fast as ASA 200, four times as fast as ASA 100, and eight times as fast as ASA 50.

Beginners find it hard to understand just what these differences really mean. Their inclination is to think that an ASA 1600 film is *immensely* faster than one rated at ASA 400, for 1600 is a large number and 400 relatively small. Actually, the speed difference isn't much. The ASA 1600 film is only *four times* as fast as the ASA 400 film.

Let us see what difference it would make photographing in dim light, where high-speed films are much sought after. Let us say that you are already using your maximum lens aperture (say $f/2$) and a shutter speed of $\frac{1}{8}$ sec with an ASA 400 film. Since you wish to use a higher shutter speed, you think of using a faster film. An ASA 800 film will allow $\frac{1}{16}$ sec and an ASA 1600 one will only allow you to boost this up to $\frac{1}{30}$ sec. Not so much difference, is it?

You should keep this information in mind to discourage you from going gung ho for superhigh film speeds, for reasons we'll now discuss, or for pushing film speeds in development, which will be mentioned again later. Beginners should avoid both these traps like the plague.

• Speed and Grain

A developed film image is called a negative, because the tones of the subject come out reversed (negative). If an object is *light* it comes out *dark* on the film. *Dark* objects result in *light* (**thin** or **clear**) areas. Photographers prefer the terms "thin" or "clear." They like the term **heavy** for dark areas.

One of the characteristics of negatives is granularity, which shows up in enlargement prints as a kind of sandy look. It makes smooth objects look as if they were made of granite or sandstone.

Grain is related to film speed. With a very fast film you often get **coarse-grain,** medium speed: **medium-grain,** slow speed: **fine-grain.** This way of relating speed to grain is an ancient formula in photography. However, photographic scientists have been working for years to make fast fine-grain films.

DAYLIGHT PICTURES

Set your exposure meter or automatic camera at ASA 125. If your negatives are consistently too light, increase exposure by using a lower film speed number; if too dark, reduce exposure by using a higher number.

If you don't have an exposure meter or automatic camera, use the exposures given in the following table.

DAYLIGHT EXPOSURE TABLE FOR *PLUS-X* PAN FILM			
For *average* subjects, use f-number below appropriate lighting condition.			
Shutter Speed 1/200 or 1/250 Second	Shutter Speed 1/100 or 1/125 Second		
Bright or Hazy Sun (Distinct Shadows)	Cloudy Bright (No Shadows)	Heavy Overcast	Open Shade †
f/11*	f/8	f/5.6	f/5.6

*f/16 at 1/200 or 1/250 second for brilliant scenes, such as those containing much sand or snow—OR
f/8 at 1/100 or 1/125 second for backlighted close-up subjects.
†Subject shaded from the sun but lighted by a large area of sky.

For handy reference, slip this table into your camera case.

Though it is fast, Tri-X is a fine-grain film. Those who want even finer grain should try Panatomic-X (ASA 32). However, it is not recommended for beginners, as there are certain tricks to using it properly. Furthermore, people shouldn't get hung up on grain as such. There are immensely more important things for one to concern oneself with in photography.

• Correct Exposure

Taking a picture involves exposing your film to the proper quantity (intensity × time) of light. As mentioned earlier, the light that strikes the film is in the form of an image, or light pattern. It is useful to remember that this image *is* light and is *nothing but* light.

If you are photographing John Brown, the only thing relating to him that ever gets into your camera is the light that he reflects. The lens collects the light that is reflected by various parts of his body and forms it into an image on the film plane.

There are several factors that you take into consideration in determining the correct exposure:

1. *Light intensity:* How much light is falling on your subject?

2. *Subject reflectance:* Is your subject reflecting a large percentage of the light (white rabbit), a small percentage (black cat), or an average percentage (like things you photograph most of the time)?

Charts of this kind come with film or with flashbulbs. They are very carefully designed by the manufacturer and highly useful for making exposure determinations. Using them, one can get along very well most of the time without owning an exposure meter. This helps explain why so many people take successful pictures without even knowing the most fundamental facts about photography. A chart of this type has to be carefully read, however, and this takes a little effort.

3. *Angle of reflectance:* Is your subject front-lighted, sidelighted, or backlighted?

4. *Film speed:* How sensitive to light is your film? Therefore, what quantity of light is required to expose it properly?

There are several devices for helping you measure these factors and relate their effects: exposure meters, daylight exposure charts, floodlight exposure charts, and flash guides or computers. The easiest to use and quite dependable are the charts and flash guides.

● Charts and Flash Guides

Charts explaining how to use the film come in every film package. Flash guides are printed on the carton that flash bulbs or cubes come in, or on the flash gun itself. Charts and guides are very dependable—if you do *exactly* what they say you should. They have certain limitations you should know about, however.

One is that they assume you are going to photograph something that reflects an average amount of light. For 97 per cent of the time you will, but not always. If you follow charts and guides and photograph something that is very light (snow, a polar bear), you will overexpose your picture. In photographing something very dark (a black or dark gray thing) you will underexpose. Though you should be aware of this, it isn't something to worry about unduly, for practically always you'll be photographing subjects of average reflectance.

The daylight exposure chart that comes with your film is extremely reliable in certain sections. The readings it gives for "bright sun" and "hazy sun" are entirely reliable. "Cloudy bright" and "open shade" are reliable most of the time. The "heavy overcast" exposure is not reliable at all. In this case an exposure meter is a must.

The floodlight exposure charts you find in photography books are usually very safe to use. So are the flash computers built into most modern flash units. The charts for flashcubes are even more accurate. Using such data, one can get along

very well without an exposure meter, which is a fairly recent invention. Not so long ago there were no meters, and photographers got along very well indeed by relying on charts, guides, and their own experience.

● Separate Exposure Meters

All the meters mentioned earlier can be used in two distinctly different ways: one, to point at the light source—two, to point at the subject. You must understand that these approaches are *entirely* different.

A light-source reading is called an **incident reading** and requires an incident meter or having an **incident attachment** slid over, or attached to, the light-sensitive cell of a reflectance meter. It is usually an opalescent sphere.

For beginners, **incident readings** are usually the most accurate—if the light is striking the subject straight-on or at an angle no greater than 45 degrees. Taking the reading is dead easy. You just stand *in front of your subject* and point the incident sphere halfway between the light source and where you intend to stand to take your picture. Simple to do and very accurate.

However, the calibration of incident meters and meters with incident attachments assumes that your subject is reflecting an average amount of light. For very light subjects you've got to **close down** an *f*-stop or more to compensate. For very dark subjects, open up. In either case, it's best to shoot at *several* different *f*-stops to make sure that *one* of them will be the correct exposure. This is called **exposure bracketing.** It is so effective that it is very popular with advanced amateurs and professionals. It works best for static subjects such as buildings, landscapes, still lifes, and so on. Since these things aren't going anywhere, you can take as many bracketing shots as you like and know that your picture won't slip away from you. With moving subjects, exposure bracketing usually isn't practical.

The other kind of reading, where you point your meter at your subject, is called a **reflectance**

reading. You are actually measuring (reading) the light that your subject reflects. For this kind of reading be sure that the **incident attachment** has been slid aside or removed. You cannot accurately make reflectance reading with an incident attachment or make good incident readings with a meter at the reflectance setting. This is a common mistake you should avoid. Except for built-ins, most meters can be used for both incident and reflectance readings.

Even if you are a beginner, most of your reflectance readings will be fully reliable. They will not be, however, if your subject is in front of either a very light or very dark background and you are standing far enough away to read *both* the subject and background. The problem is easily solved if you move up close enough to read *only the subject.* With that exposure data you can then back up again and take your picture.

TAKING A CLOSE-UP READING WITH A CAMERA HAVING A BUILT-IN METER.

When photographing a subject against a background either much lighter or darker than itself, always make a close-up reading. Otherwise, the exposure will be way off.

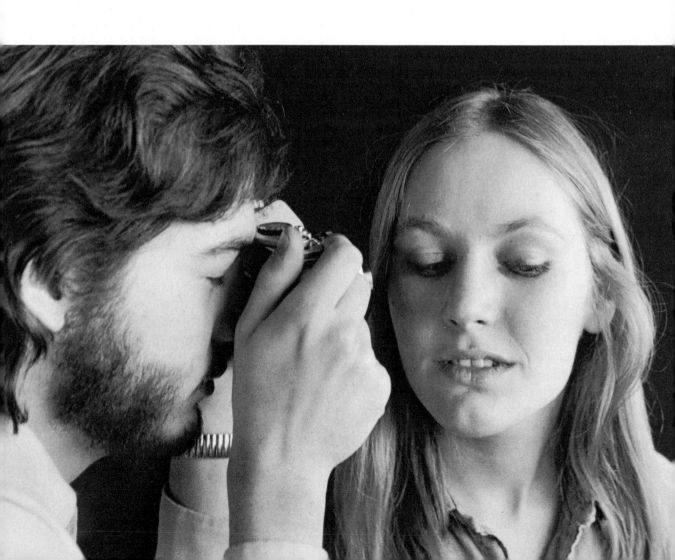

After making your reading, back away until your subject is properly framed in the viewfinder. You can be certain that the exposure will be just right. If the young man in the illustration had taken his reading from the shooting position, he would have badly overexposed the girl. Had he been using a white background, he would have underexposed her.

● Built-in Meters

Most built-ins, especially in SLR cameras, are reflectance meters of the cadmium-sulfide (CdS) type. The readings they give are reliable, except when your subject is in front of a very light or very dark background. You solve this problem just as you would with a separate meter. You move up close so that you're reading only your subject. (You can see the exact coverage in your camera viewfinder.) Then you stand back again to take your picture. This trick is probably the main secret of using built-ins properly. And not using it is the main source of failure.

There is potentially a mechanical source of error with built-ins: a worn-out battery. It gives readings that are too low and leads to overexposure. Be sure your battery is fresh before starting on a vacation or camera field trip.

• Meters in General

Reflectance meters, either separate or built-in, take care of the angle-of-reflectance factor without your having to think about it. All you have to remember (very important) is to take your reading from the same angle you intend to take your picture from. It just won't do to read the back or side of a subject, then shoot it from the front.

Incident meters do not compensate for the angle-of-reflectance factor, which is why using the incident attachment is suggested only if your subject is lighted straight-on or at an angle no greater than 45 degrees. Forgetting this rule will rapidly lead to inaccurate exposures.

All meters compensate for the film-speed factor, provided that you set the speed on the meter dial. Failure to do this completely destroys the validity of your readings. Though most separate meters can be used for both incident and reflectance readings (with different settings or attachments), people tend to use a given type mainly for just one method. For example, the Weston Master for reflectance, the Sekonic for incidence.

FILM DEVELOPMENT

When you snap a picture, light (in the form of an image) strikes the film. It has a chemical effect on the silver compounds in the **emulsion.** It is so subtle, however, that you can't see any change.

You use a solution called a **developer** to intensify the chemical effect and make it visible. This visible image on film is called a **negative.** After development, the emulsion is still light-sensitive and would turn black if it were exposed to light. You use another solution called a **fixer** (or **fixing bath)** to desensitize it. After the correct amount of time in the fixer the negative image is stable and you can safely look at it in the light.

● **Absolute Darkness**

Except when it is being exposed to images in your camera your film must always be in absolute darkness. Just before and during development there must be absolute darkness too. If not, the film will be **fogged** (darkened over all its area). **Fog** destroys the possibility of getting good pictures.

The beginner's problem is in finding a place that is absolutely dark. A special darkroom for photography is the ideal place, but he doesn't usually have one. However, a clothes closet works equally well, provided that the rest of the house is also dark. If not, enough light leaks in around or under the door to fog the film. This can be prevented by nailing weather stripping around the closet door and using a rolled-up rug to block light coming under it.

One doesn't need the darkness for very long, for once the film is in the developing tank it is safe from light. Inside the tank, absolute darkness prevails. Chemical solutions are poured in and out through the light-tight pouring trap.

Thus, the only need for total darkness is during the time it takes you to remove your film from its spool (and cassette or cartridge), load it into a developing reel, pop the reel into the tank, and put the top on. With practice, this takes about five minutes. After loading, you can turn on the light.

● **Portable Darkness**

If it is inconvenient to establish absolute darkness in your home, you can buy portable darkness at a camera store and use it wherever you wish. It's called a **film-changing bag.** It is a square, black, light-tight bag that can be opened with a zipper. It has arm holes with elastics, so that when your hands and arms are in the closed bag no light can get in.

Unzip it and put in your film cassette, developing reel, developing tank, and tank top. For Kodak cassettes you also need a bottle opener; and a pair of scissors may be useful.

Zip the bag closed and thrust your arms through the elasticized openings. Then load your film into

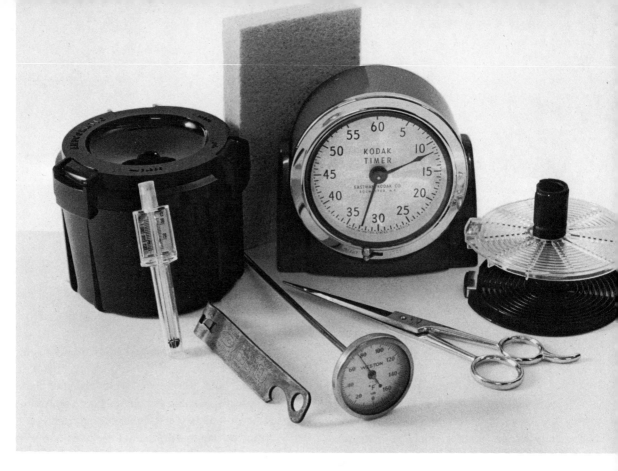

EQUIPMENT NEEDED FOR DEVELOPING 35-MM ROLL FILM.

developing reel and tank by touch—all in safe, absolute darkness.

The one problem with the bag is that it's warm like a heavy coat, so it's best to work in a cold room or near a fan or air conditioner. It is not good to get sweat on undeveloped film, for it may leave permanent marks.

● Things You Need

Exposed film
Developing tank and reel
Photographic thermometer
Timer (or clock or watch)
Funnel (glass or plastic)
Measuring cup (glass or plastic)
Viscose sponge
String
Clothespins
Towel (paper or cloth)
Scissors
Glassine negative sleeves
D-76 developer solution
Fixing solution **(hypo)**
Water
Storage containers for D-76 and fixing solution (plastic, glass, or stainless steel)
Bottle opener (for Kodak 35-mm cartridges)

Developing tank with reel: The only ones recommended for both beginners and advanced photographers are the Anscomatic (one reel tank) and the Paterson Multiunits (up to eight reels). Both systems employ "self-loading," or "walk-in,"

reels, which are very easy to load. If you are a beginner, loading some other types of plastic reels will drive you right up the wall. So will loading stainless steel reels.

If you insist on stainless steel reels and tanks, the Nikor is recommended. The four-reel tank is the handiest, but you can get those that will hold eight or more reels or as few as one. Because Nikor tank lids tend to jam when you're developing, you should replace them with Kindermann tank lids, which never jam. If you are mechanically adventurous you can make your own tanks and lids out of plastic sewer or drain-pipe material. You can save a good deal of money this way. However, I wouldn't use them with any developer except D-76. Some developers are badly affected by many types of plastics. I certainly wouldn't use drainpipe tanks for color processing.

Thermometer: Avoid the heavy glass ones, for they take too long to register a change of solution temperature. As a result you may develop film at the wrong temperature. Buy a stainless steel one, such as the FR (inexpensive) or the Weston (both better and more expensive).

Developer: Though there are numerous good film developers, D-76 is recommended as both good and inexpensive. Buy the dry chemical in the gallon size and store the mixed solution in 4 one-quart jars that are tightly capped. Using one jar at a time, the others will remain filled to the top, thus having little or no air in them. Air shortens the life of a developer. The gallon size saves you money and insures your having as much as you'll need when you want it.

Fixer: Use either an acid hardening fixing bath or a "rapid" (or "quick") fixer. Any brand will do and it doesn't matter whether you buy it in the form of dry chemicals or as a solution. Buy the one-gallon size.

Containers: Developer should be stored in glass jars or bottles, preferably brown, or in plastic bottles made especially for photographic developers. Bottles made from other types of plastics may destroy or lessen developer life. Used household-bleach containers are really asking for trouble. The brown glass jars you can get from the druggist are especially good for chemical storage.

For use during development, containers (dishes, saucepans, trays, bowls, etc.) for a developer should be glass, plastic, or stainless steel. Most other metals will cause developer fog. This includes aluminum, aluminum foil, cast iron, ordinary steel, and enameled steel that has been chipped.

Fixers are less of a storage problem, and you can use plastic bleach or detergent bottles if you wish.

For mixing your developer from the dry chemical, use a plastic bucket from the dime store.

● Getting the Developer Ready

No matter what kind of developer you use, you should mix the **stock solution** from the dry chemical the *day before* you want to develop film. If you use it right away, you'll get a considerable increase in **grain** in your film and may get the effect of having developed it twice as long as you should have.

Just before you are ready to use your D-76, dilute the **stock solution** half-and-half with water. If it is too hot, use cold water. If too warm, use cold. It is very important that the temperature of your **working** (diluted) **solution** falls within the temperature range given with the accompanying chart.

Mix enough **working solution** to fill your developing tank all the way to the top, even if your film reel fills up the tank only part way. Plastic juice containers are handy for holding both developer and **hypo** (the jargon for **fixing bath)** prior to pouring them into the developing tank.

● Time and Temperature

Developing film can be compared to cooking. Each food is cooked at a certain temperature for

a certain amount of time. The wrong combination of time and temperature can be disastrous. This is also true of film, and the time and temperature limits are even more exacting. Temperatures must be carefully measured with a thermometer, developing times followed exactly.

D-76 can be used at any temperature between 65° and 75° F. However, for each level of temperature there is a special developing time.

The size of the tank you use also makes a difference in the time you should take. The time and temperature chart applies to tanks like the Anscomatic, Paterson, and Nikor, not to the large ones that hold several gallons.

I recommend using D-76 1:1 (one part developer, one part water). However, I have included the developing times for using it at full strength. Diluted, the developer is used just once, then discarded. Straight, it can be used again and again. Since some of its energy is used up each time, the D-76 must be replenished after each use with a solution called D-76R. Different-size rolls of film require different amounts of replenisher per roll. Because this involves keeping track of more details, I don't recommend it for beginners.

FILM SIZE	D-76R
126 (12-exposure)	¼ oz.
135 (20-exposure)	½ oz.
135 (36-exposure)	¾ oz.
828	¼ oz.
127	½ oz.
120	¾ oz.

• Agitation

The developing chart mentions agitation at 30-second intervals throughout development. This is to prevent mottle, uneven image tones, and air bubbles (which leave little round clear spots). *Too much* agitation leads to equally disastrous results, so follow the agitation schedule exactly.

Anscomatic tank: You agitate by twisting the agitator rod vigorously back and forth. Immediately after you pour the developer in, twist the rod for a continuous 30 seconds. Then after every additional half minute of developing time, agitate for 5 seconds.

Paterson and Nikor tanks: You agitate by turning them upside down and back. Do this constantly for the first 30 seconds. Then tip them three times (takes about 5 seconds) after each additional half minute of developing time.

• Agitation in the Hypo (Fixing Bath)

No matter what type of tank you use, you have to agitate vigorously (for 30 seconds) right after you pour in the hypo. If you don't, you may get air bubbles which prevent the hypo from reaching the emulsion. They cause little round dark spots.

• Preventing Air Bubbles

I've said that air bubbles which prevent the developer from reaching the film may cause round clear (or gray) spots. They are lighter than the surrounding image (more transparent) and record as darker spots on the print. Bubbles in the hypo make darker spots and print lighter than the rest of the image.

One of the preventatives is to fill the tank all the way to the top, even though less solution might cover the film adequately.

Another is to pour water into the tank for one minute before you start developing. Agitate vigorously during this time (to remove the air bubbles so that all the film surface is thoroughly wetted). Then pour out all the water. Immediately pour in the developer and follow the agitation schedule given.

If you use this prerinse system (highly recommended), it later takes about 30 seconds for the developer to replace the water that has soaked into the emulsion. However, if you take 30 seconds in the water rinse *after* development you don't have to alter the development time. Even

though the film is then in water, there is still active developer in the emulsion. Until the hypo is poured in, development continues. Thus the 30 seconds required for the developer to replace the water is compensated for later in the rinse after development.

The rinse time after development is otherwise counted as a part of the developing time. If it is 9 minutes, say, you develop for 8½ minutes and rinse for ½ minute.

● Film Handling

Undeveloped film should never be touched on the emulsion side, for emulsions are sensitive to your body chemistry. One touch will leave a permanent fingerprint.

If your hands are *clean* and *dry,* however, you can safely handle the *backing* side. You can tell which side is which by remembering that films are loaded on their spools *emulsion side in.* Thus, if you are holding film in your fingers while it is still on the spool you are touching the *backing,* which is safe to do.

Usually, the film curls *toward its emulsion.* This also helps you remember which side is which. The side inside the curl is the emulsion. The exception is film that has been used in cameras in which the "take-up spools" roll it up with a reverse curl. Film that has stayed in such a camera for a long time after being exposed sometimes has the reverse curl permanently impressed in it. To prevent this, remove the roll immediately after it has been exposed.

● The Anscomatic and Paterson Tanks

The instructions that come with the Anscomatic tank and reel are very well written and illustrated, so there is no sense in repeating them here. Read them carefully and you'll have no trouble at all. Keep the instructions and the tank together, in case you forget some points and need to learn them again.

Once you've used the Anscomatic you'll al-ready know how to use the Paterson, without having to be told. They both work splendidly and are very good for rank beginners and very advanced photographers. Because they are plastic, however, they must be treated carefully. If you drop either tank on the floor you might as well bid it a permanent good-by. Don't think you can escape this problem by turning to stainless steel equipment. If you drop a steel reel it throws the flanges out of alignment so that it will never load properly again.

Both Anscomatic and Paterson reels can be adjusted to accept a variety of roll-film sizes. They accept 35-mm (both 20- and 36-exposure lengths), 126, 828, 127, 120, and 620.

They accept 5-foot lengths of film. Since 126 and 828 films are much shorter, you can tape two of them together and load them on the same reel.

Developing times (in minutes) in D-76

Roll films, including 126 cartridges and 35-mm	Dilution	Anscomatic, Paterson, and similar tanks; agitation at 30-sec intervals throughout development				
		65F	68F	70F	72F	75F
Verichrome Pan	Full strength	8 min.	7 min.	6½ min.	6 min.	5 min.
	1:1	11	9	8	7	6
Plus-X Pan	1:1	10	8	7	6	5
Tri-X Pan	Full strength	10	8	7	6	5
	1:1	13	11	10	9	8
Panatomic-X	Full strength	8	7	6½	6	5
	1:1	11	9	8	7	6

● Step-by-Step Developing

It is a very good idea to sacrifice a new, unexposed roll of film and use it for practice. Seen in the daylight, you can learn how it is put in the cassette (135), cartridge (126), or on a spool with backing paper (120, 127, etc.). This will give you the experience and confidence to work in total darkness.

1. In total darkness, load film reel and put it in the tank. Put cover on.

2. Turn on the light.

3. Prepare developer. (Dilute it to the working solution and check its temperature. If necessary, make it hotter or colder.)

4. Using the development chart, find the proper developing time and set the timer.

5. Put a jar or bottle of hypo (fixing bath) in a convenient place.

6. One-minute prerinse in water, with constant agitation. Then pour out water.

7. Pour in the developer and start the timer.

8. Develop film for the preselected correct time, following carefully the agitation schedule.

9. Pour out developer. (*Discard it.*) Pour in water, agitate for a few seconds. Pour it out again. These steps should take a total of 30 to 45 seconds and are counted as part of the developing time.

10. Immediately pour in the hypo and agitate vigorously for the first 30 seconds. After 10 more minutes, pour the hypo *back into its storage bottle*. If you're using a rapid fix, cut the time to 5 minutes. Now take the top off the developing tank if you wish, for the film is no longer light-sensitive.

11. Wash the film (still on the reel and in the tank) with running water for 20 minutes.

12. Sponge the water off the film with a clean viscose sponge and hang it up to dry.

The temperatures of all the solutions should be pretty close, or there will be an increase in grain. If they are within 5 or 6 degrees of each other, this is all right.

The final wash should not be more than 20 minutes, for the emulsion gets progressively softer and susceptible to damage. Excess washing also increases grain. Hot water will ruin your negatives altogether, for the emulsion slides off.

Before wiping your film, soak the sponge thoroughly. Just before wiping, wring out the sponge and brush its surface vigorously with your hand to make sure there is no grit on it. Grit will scratch your film. So will long fingernails and just about anything else that touches an emulsion made very soft in processing solutions.

Wipe the film thoroughly enough to remove all but the very small droplets of water. Large drops cause permanent drying marks, which make your prints look very messy. There is absolutely no way to remove them.

Make a drying line for your film by threading clothespins onto a piece of string. Put up the line in the least dusty room in your home, for dust on film is a very bad thing. The bathroom is usually the best bet.

To prevent the wet film from curling up, weight it with an additional clothespin at the bottom.

Note: The easiest way to remove the film from either an Anscomatic or Paterson reel is to pull off the reel's adjustable flange.

● Care of Negatives

Though they don't look it, negatives that have been dried are still extremely susceptible to damage. They look and feel tough and indestructible. However, they easily pick up minute scratches, fingerprints, and dust, all of which show up badly on prints.

Always handle negatives by their edges. As soon as they are dry, cut them into strips and put them into glassine envelopes for their protection. Do not roll the film up to store it, for this almost invariably causes scratches. Five frame lengths are convenient for 35-mm, six frame lengths for 126 and three for 120. It makes them easier for handling and for making contacts (page 67).

MAKING ENLARGEMENTS

You make enlargements with a machine called an **enlarger.** (Makes sense, doesn't it?) An enlarger is a rather simple machine that is very much like a slide projector. In fact, *some* slide projectors make excellent enlargers. Conversely, *most* enlargers make effective, though quite cumbersome, slide projectors.

The average enlarger embodies a light source, a light-condensing system, a negative carrier (holder), a lens, a system for focusing the lens, and a system for raising or lowering the enlarger head, to get either large or small images.

Though enlargers look complicated, they are immensely more simple than cameras; so don't be afraid of them. The great complexity of cameras is all hidden on the inside. Enlargers only *look* complex because you can see most of the parts.

To make an enlargement, you put a negative in the negative carrier and put the carrier in the enlarger. Then you turn on the enlarger light, so that an image is projected on the enlarger baseboard. Focus the image, then turn out the light again.

Next, put a piece of photographic enlarging paper in the exact place where the image was, taping the corners down so that it doesn't curl or move.

Thereafter, you treat the paper as if it were a piece of exposed film: Develop, fix, wash, and dry it. However, you don't have to work in absolute darkness, because photographic paper has been deliberately made insensitive to certain colors of light. You can therefore work under special yellowish lights **(safelights)** without fogging the paper. With these inexpensive **safelights** you can see what you're doing rather well during the entire enlarging process. Therefore, you need not be concerned with the thought of panicking in the dark. Most people find the yellowish light very comfortable and encouraging.

There is a bit more to it than this, but not much. Making enlargements is *dead easy!* Any six-year-old can be taught how in a matter of minutes.

● Buying an Enlarger

Though I would seldom consider buying a second-hand camera, it would be my first thought with an enlarger. Used cameras are trouble, all of it hidden from view. Stay away from them. Most of the things that can go wrong with an enlarger are both easily seen and easily repaired. Furthermore, a rather disreputable-looking enlarger often turns out to be a gem, even if it's twenty or thirty years old.

Used enlargers are constantly available from $15 to $20, machines that cost from $50 to $75 new. Such enlargers are usually adequate, though not topnotch.

My advice would be to invest from $75 to $125 in a used machine and get something really good. Enlargers that are scratched, worn, slightly rusted,

with electrical wiring frayed—but mechanically in good shape—are your best bargains, for the prices run low on account of the blemishes. However, they don't matter a whit, and the wiring is easily replaced. They must be sturdy and mechanically sound, however.

Telling whether a machine is mechanically sound is like sizing up a toy for a boisterous boy. If it looks even slightly fragile you know he'll have it apart in a short time. An enlarger of similar fragility will soon start to malfunction, even if you treat it gently. Buy one that looks boyproof—with good care it will last for years. Stay away from the cheap plastic machines that have been selling for the past few years. They're even less durable than plastic toys.

If you like, you can select enlarger quality by matching it to your camera quality. If you have a $30 camera, buy a $30 enlarger. Both have lenses that will give you fair-quality pictures up to 4 × 5 inches in size, not larger.

With a better camera, think of a better enlarger. Otherwise, you will lose most of the quality your camera brings you. To get the very best quality out of a *topnotch* camera, you need to back it up with a *topnotch* enlarger, and vice versa. In general, price is a pretty good indicator of quality, except in used equipment.

Do not, however, get yourself hung up on quality. If all you want is small snapshots for your family album you can get along very nicely with a cheap enlarger.

• Enlarger Lenses

Enlarger lenses vary considerably in the sharpness of the image they will project. Cheap, low-quality lenses are not much better than bottle glass, and thus are called "pop-bottle lenses" in photographic jargon. No matter how good your camera, they will make only fuzzy, unsharp prints. They're fine for album or wallet size, however.

Brand new, the high-quality lenses will cost about $85. Look for a used one, even if it's very

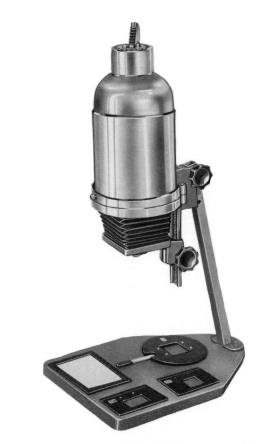

The Fotolarger Junior 1, about $25. Good enough for a start.

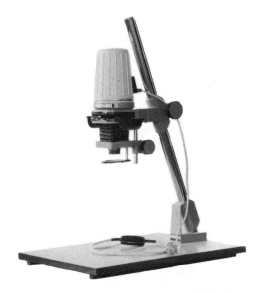

The Axomat II, about $120 with a standard lens, a top buy at medium cost.

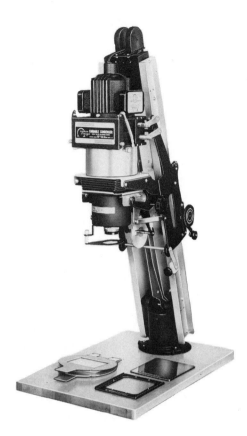

The Automega D3V (less lens, about $400). A first-rate professional machine.

old. As long as the lens glass is clear and un-scratched you are safe, even if all the black lac-quer has been worn off the lens barrel.

Like camera lenses, enlarging lenses have *f*-numbers, or *f*-stops. Quality lenses will yield sharp pictures at nearly full aperture. Lenses of low or moderate cost may be very unsharp at such a wide aperture, but sharp when stopped down quite a bit. However, one is not always so lucky, so you should make arrangements to test a lens before making your purchase final.

● Other Material You'll Need

The following list is not as long as it seems, for many of the items are repetitions from the list of things needed for developing negatives. They are repeated in order to make it clear to you what you'll need when you start to print.

Double-weight, variable-contrast enlarging paper
A set of variable-contrast printing filters
Print developer, gallon size
Two print tongs, rubber-tipped bamboo
Hypo (acid-hardening fixing bath), gallon size
Hypo testing solution, small bottle
Hypo eliminator, quart or gallon size
Plastic pail for mixing chemicals
Beer-can opener
Turkish towel, for keeping fingers dry
Stirring rod, or stick, or large plastic serving spoon
Plastic or glass funnel, preferably with a filter (or a coffee filter)
Plastic or glass jugs or jars for storing chemicals (glass of *special* plastic for the developer)
Glass or plastic measuring cup or graduate (a graduated, 2-quart, plastic orange-juice con-tainer is very good)
Viscose sponge(s)
White plastic print-developing trays, three or five
Safelights, one or two, with Kodak OC or Du-Pont S55-X filters
Photographic blotters, or blotter roll or book
Printing easel
Dodging and burning-in tools (homemade)
Electric interval timer or inexpensive metronome (optional)
Lens-cleaning tissues
Glassine negative envelopes
Silicone negative-cleaning cloth
Ordinary ½-inch paintbrush, new
9 × 12-inch piece of heavy, unscratched plate glass
Tray siphon, for print washing (optional)

Frankly, collecting these things is a bit of a hassle. However, when you've gotten them to-gether, learned what they are for, and found a place to store them, everything becomes quite simple.

PRINT MAKING

● Your Working Place

It is desirable to work in a room that provides absolute darkness—until you turn on the safelights, which illuminate it very well with the correct type of light. However, absolute darkness is not as critical for printing as for negative developing. If you can *barely* see your way around the room (before the safelights have been turned on and after your eyes are adjusted to the dark), you'll have little or no trouble with prints getting fogged.

If you work after sunset, almost any room in a house or apartment will provide the degree of darkness you require.

Unless they have special darkrooms, most people prefer to work in either the kitchen or bathroom. The fact that they have running water is useful, though not at all necessary. An unused utility room, walk-in closet, or spare bedroom works just as well, though you have to carry water to them in a plastic bucket.

Kitchens are especially useful because they have tables or counter tops for developing trays, enlargers, and so on. However, almost any reasonably sturdy working surface will do—a card table, the top of an ironing board, a piece of plywood laid across the bathtub, a bureau top, etc. Your enlarger is the only piece of equipment that requires a really steady surface, for if it vibrates your prints won't be sharp. If you're going to put trays or developing tanks on a surface,

protect it from photographic chemicals by covering it with newspapers and plastic sheeting from the grocery store. Old plastic tablecloths and shower curtains are especially handy, and you can use them again and again.

It's a very good idea to divide your workroom into a *wet* and a *dry* side. The dry side for the enlarger, photographic paper, interval timer, and other things connected with exposing the print. The wet side for chemicals and water, trays and tanks. If you're severely cramped for space, the division can be *above* and *below*. Use the counter or table top for working dry, shelves (or boxes or stools) underneath for chemicals. The *above* and *below* system is not very convenient, but a lot of people use it.

The important thing is not to drip chemicals or water into the dry area, for they are ruinous to photographic paper, negatives, and metal equipment such as enlargers and timers. If not immediately mopped up, chemicals are also ruinous to paint, varnish, and linoleum. In three or four hours, a puddle of print developer will turn any one of them into a thick gravy. If the developer is wiped up immediately you'll find there's no damage, so don't get uptight about it.

Developer can stain cloth badly and hypo can bleach it, so work in old clothes or wear a plastic apron.

If you have enough room for a wet and dry

side you'll probably want two safelights: one hanging three feet above the developer tray, the other over the enlarger area. In a smaller space you can get by with one light. A nail or two and some string will suffice for rigging up your safelight(s). But don't dangle light cords into chemicals, unless you like getting electrical shocks.

Don't use larger than recommended bulbs (usually 15-watt) in your safelight(s). And don't have them any closer than three feet from photographic paper. You can see better if you do, but you'll also get fogged prints. The safety of a safelight is only relative, not absolute.

• Processing Prints: Basic Steps

Since developing a print is only part of the ritual, the procedure as a whole is referred to in the jargon as **processing.** Only two chemicals are needed absolutely, though it is much better to have some additional ones.

I'll start my explanation with the minimum: print developer and hypo. Into the developer you put a piece of enlarging paper that has been exposed to an image (light) by the enlarger.

In a few moments another kind of image (positive instead of negative) arises on the paper. It's a magic you'll never forget or cease to find wonderful. Dim at first, it gradually grows darker and clearer. When it is dark enough, you put the paper (now called a **print)** into the hypo, which brings the darkening to a halt.

In five to ten minutes the print is forever safe from light, so you turn on the **white light** (as opposed to the yellowish safelight). That's all there is to it. If you want to keep the print, you later wash it clean of hypo and dry it.

• The Additional Chemicals

Though you can make excellent and lasting prints with just developer and hypo, it is very uneconomical. The main reason is that the developer is chemically antagonistic to the hypo. In a very short time, its alkalinity neutralizes the acidity of the hypo, on which its function depends. When this happens you have to discard the hypo and mix a fresh solution. If you haven't noticed it's been neutralized, you'll start getting yellow-stained prints, which you will also want to discard. They are quite ugly.

To protect the potency of the hypo, we use a **stop bath** right after the print comes out of the developer. Its entire function is to stop development and acidify the print so that the alkalinity of the developer, which is soaked into the emulsion and paper fibers, won't ruin the hypo. Acetic acid is used in this bath, though common vinegar will work too.

But the stop bath can also be ruined by alkalies carried over from the developer, though not right away. When it happens you may not know it; and the still-alkaline prints will rapidly ruin the hypo. Your prints will then stain, though you won't see the yellow stain under the yellow safelights. In white light they'll look terrible.

To get around this problem, you should use an **indicating stop bath** which lets you know when to discard it and mix a fresh bath. When it is no longer useful it turns purple, which is readily seen even in the yellow light if you use it in a white plastic tray. I recommend white plastic for *all* your trays.

Each of your prints should stay at least 10 or more seconds in the stop bath. If you just rush them through, the bath doesn't have a chance to do its job and you'll knock out the hypo.

Both the stop bath and the hypo are *very* antagonistic to the developer, so don't drip them into the developer tray. If you have either stop bath or hypo on your fingers, wash them thoroughly before you stick them into the developer again. The rule in photography is: *Don't drip anything into anything else.* Failure to observe it will only lead to tears.

Even when prefaced by an effective stop bath, the hypo eventually conks out and causes stained prints. As I've suggested, you won't detect the

stains until it is too late. And once you've gotten them, there is no way of getting rid of them.

There are two ways around the problem: Use a hypo testing solution or count your prints so that only a prescribed number are processed through a given hypo bath.

Kodak says that one gallon of hypo will fix one hundred 8 × 10 prints. Since hypo is cheap and risks of contamination high, you should cut the number to 50. When 50 prints have been through the bath, discard it.

For hypo testing, use either Edwal Hypo-Chek or a Kodak Testing Outfit. With either, all you have to do is put a bit of hypo from the tray into a small glass. To it add several drops of the test solution. If a precipitate forms, discard the hypo bath. If it doesn't, the hypo is still O.K.— for a while. Rather than making constant checks it is more convenient to be profligate with hypo. Dump it out if you have even a *suspicion* there is something wrong with it.

There is a crude but useful rule-of-thumb check for stop bath and hypo. In the developer, a print is slippery, like an eel. In a stop bath or hypo that is acidic enough, it immediately loses the slippery feel and turns sort of rubbery. And so does the skin on your fingers. Therefore, if either your fingers or a print feels slimy-slippery in the stop bath or hypo, you know for sure something is wrong with the solutions.

• **The Two-Bath Hypo System**

Though you can get along with just one hypo bath you'll save yourself a lot of trouble if you use two. You will find it useful to understand why this is true.

First, we should look into what hypo does. In photographic emulsions (on films and papers) there are silver compounds that are both light sensitive and insoluble in water. After an image has been developed, there is still a good bit of the unexposed silver compound left. It must be de-sensitized, or it will turn the entire image black. Hypo does this job very effectively.

However, the hypo itself must be removed. And so must the new compounds formed of hypo and silver. Left in an emulsion, they will soon stain or bleach it. Fortunately, both the hypo and the hypo-silver compounds are soluble in water—sort of. Thus, in a long enough time they can be washed out of emulsions.

There is another fly in the ointment: The longer a hypo bath is used the less soluble are the hypo-silver compounds it creates in emulsions and paper backing (prints). Though the bath may still be effective in fixing the image, the silver compounds are getting less and less removable in water.

The remedy for this is very simple: Put the print in a used hypo bath for fixing the image and into a fresh bath afterward to create hypo-silver compounds with maximum water solubility.

Kodak says you can safely process two hundred 8 × 10 prints through a two-bath system. Since this applies mainly to experienced craftsmen, prudence says it is better to cut the number to one hundred. Remember that hypo is cheap and that it is good to be profligate with it.

You start out your system with two gallon-size trays (12 × 15 inches) of freshly mixed hypo. Call the one nearest the stop bath the **first hypo,** the other the **second hypo.** When you've processed a total of 50 prints through both trays, dump out the first hypo and move the second hypo into its place, renaming *it* the first hypo. Pour fresh hypo into the empty tray, for a new second hypo.

Have separate storage bottles for each hypo bath, one labeled "first hypo," the other "second hypo." On the "first hypo" bottle, tape a note card for keeping track of how many prints have been run through it. All in all, this is an easier system than running constant chemical tests on the hypo. And if such tests aren't run frequently they won't do much good.

Do not suppose that a two-bath system eliminates the need for using a properly active stop bath and for putting prints in it for the correct amount of time. With a too-short immersion time

or a conked-out stop bath you can knock out a two-bath hypo system in less than an hour of printing.

Nonetheless, the two-bath system is by far the best for darkroom goof-ups or klutzes. It tends to have certain built-in safeguards to help people who never seem to get *anything* right in photography. If a group of klutzes is sharing a darkroom, it is an *absolute must*.

In using the two-bath system, immerse prints for 5 minutes in each bath—no more, no less—then put them into a tray of water. Too long in hypo causes print bleaching, especially if the hypo is fresh, as it nearly always is in the second hypo.

There are two types of hypo: standard and rapid. Use only the former, as rapid (or quick) fixers are quite fast in their bleaching action and tend to conk out unexpectedly. Rapid fixers are fine for film.

If a print is too dark to start with, it can often be lightened to just the right degree by leaving it quite a while in a fresh hypo bath.

● Hypo Eliminators and Print Washing

Even with the two-bath system the hypo-silver compounds in prints are just *barely* water soluble. It still takes an hour to wash double-weight prints adequately in running water. To cut down radically on the time required, run your prints through special solutions that make the compounds more water soluble. Recommended are Permawash, BFI Solution, and Kodak Hypo Clearing Agent. To be safe, double the washing times the manufacturers recommend.

Working in the home, the best way to wash prints is in a large tray at the bottom of the bathtub. With it use a Kodak Tray Siphon, which takes the hypo out of the bottom of the tray. Heavier than water, hypo will sink to the bottom and stay there, unless it is siphoned out.

Another method that is good, but inconvenient, is to use the whole tub for washing. Put the prints in the bottom and fill up the tub. Move them around for 5 minutes, then take them out and drain the tub. Repeat the whole cycle three more times—for prints that have been treated with a hypo eliminator. With untreated prints, do it several more times, making sure that the total immersion time is at least an hour.

The temperature of wash water makes quite a difference. Too cold, the washing is badly done. Too hot, the hypo is impregnated in the paper fibers and the emulsion gets soft and liable to damage. The optimum temperature is 70° to 75° F. If prints are left too long in warm water the emulsions will slide off. However, they can be left overnight in cold water without perceptible damage.

If prints aren't moved around during washing, the hypo won't be washed away. It collects between prints and stays there, so that only their edges get properly washed. This doesn't help much when it comes to avoiding stains.

● Print Drying

The most economical way to dry prints properly is to wipe off both sides with an immaculately clean sponge, then lay them face up on towels from the laundry hamper. The reason for insisting on a clean sponge but not clean towels is that the probable contaminants in your sponge will ruin your prints, while good old human dirt will not.

As your prints dry they will start to curl. Pick them up while they're still damp enough to feel cool and stack them, face-up, on top of one another. Then put them under a heavy weight until they're fully dried. If you forget and let them dry all the way in the open air, they may get curled up like cast-iron spaghetti. In this case, soak them again in water and repeat the whole drying process. Other ways for uncurling prints usually damage them. If the humidity is just right, there won't be any curling at all, even if you don't put your prints under a weight.

If you do exactly as instructed and they curl anyway, it is because the air is too dry—or the emulsion of your prints is. In this case, soak

them thoroughly in a **print-flattening** solution before sponging them off to dry. If they still curl, increase the strength of the flattening solution and curse the devil for making photography such a maverick process sometimes.

For a more convenient and aesthetic drying method, put your prints between *photographic* blotters after sponging them off. These come in sizable sheets, rolls, or drying books. I personally much prefer them in sheets. I like to have about two dozen on hand. Taken care of, they last several years.

Never use *ordinary* blotters, for they contain hidden chemicals highly destructive to print longevity. So do *most* papers, for that matter—so it won't do to dry carefully washed prints in old telephone books, or to lay them to dry on newspapers. If you don't care how long your prints will last, dry them any way you like.

Here we are, already talking about drying prints before you've been told how to make one. That's the trouble with photography. There's no proper starting place, so that things get written down in the wrong order. However, by following the section headings you'll be able to sort things out in any order that suits your taste.

GETTING ORGANIZED FOR PRINTING

The hardest part of printing is collecting your materials and equipment and getting set up for your very first session in the darkroom. After that, there is nothing hard about it, and any six-year-old can do it.

● The Wet Side

Let us say you have a room large enough for both a wet and dry side. How should you organize it?

On the wet side, start out by covering your work surfaces with newspaper or plastic sheeting. Then mix your print developer stock solution in a plastic bucket. Unlike the negative developer, you don't have to do this the day before, as there is no problem with grain in photographic papers. It will be too hot for printing, but you can cool it down when you dilute it. A plastic bag filled with ice cubes will bring the temperature down rapidly.

On the plastic-covered work surfaces, line up your trays with as much orderliness as the room layout will permit. There is a traditional (and useful) lineup for the trays: developer, stop bath, first hypo, second hypo, water holding-bath. In a pinch you can get along with just three trays: developer, stop bath, hypo.

It doesn't matter what standard brand of print developer you use, though Dektol is most popular. Be sure *not* to use a *film* developer, however. You must use a *print* developer, so check the labels carefully. Dilute your stock solution 1:2—one part developer, two parts water. (The first number *always* stands for the proportion of chemical, the second for the proportion of water.) Modify the temperature of the water so that the diluted solution comes out in the temperature range from 65° to 75° F.

Prepare the next tray by using 2 ounces of indicating stop bath per gallon of water (or ½ ounce per quart). CAUTION: *Always* put the water in the tray *first!* The stop is a fairly strong acid. If you put it in the tray first and pour water on it, it may explode onto your face.

Both the first and second hypos are poured straight from their bottle without dilution.

For the water holding-bath you need only water—almost to the top of the tray. It's easier to work if *all* your trays have their contents up to a half inch of the top. In shallower baths it is hard to manipulate the prints. This is not wasteful, because you can pour partly used solutions back into storage bottles and use them again. If the developer turns brown, however, it should be discarded. As you can see, photographers need a lot of bottles or jars. Be sure each one has a label on it, so that you don't get things mixed up.

Put one of your print tongs near the developer tray, the other near the stop bath. Nearby, have a bucket or juice container of water, for washing your hands. If you can, keep your hands dry by manipulating your prints with the tongs. *Always,* if you get solutions on your hands, wash and dry

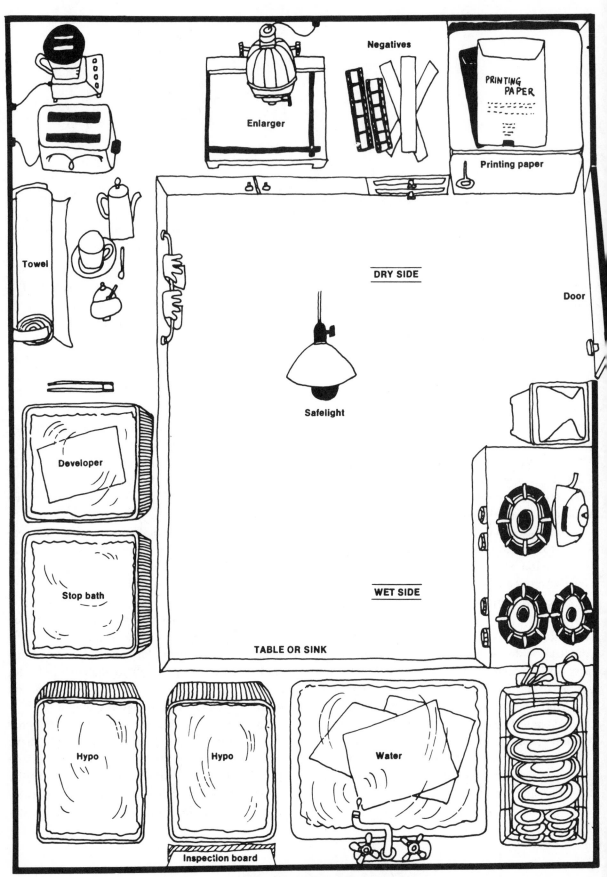

SET-UP FOR PRINT-MAKING

them thoroughly before going to the dry side of your darkroom. Failure to do this can wreak havoc with your equipment and materials, for chemical contamination is very destructive. So is water itself, if not wiped off.

I haven't mentioned tray sizes. Working with fairly large trays is much the easiest way, though smaller ones are adequate. Ideally, the two hypos and the water holding-bath should be in 12 × 15-inch trays, unless you intend to make prints larger than that.

For small prints, the developer and stop-bath trays can be 8 × 10 inches. If you only want wallet-size prints, you might as well standardize on 8 × 10 trays on all the baths except for the last one, which should be larger. After processing, you will use it for print washing, so you need quite a bit of room in it.

One of the important ideas behind having a wet and dry side to your workroom is to make sure that no chemicals or water are dribbled across the room. This applies to the floor as well as to work surfaces. The sign of a craftsman is a dry and unspotted floor. Though it's easier to splash around freely, you'll save yourself agony if you teach yourself the craftsman antidrip discipline. This is a good deal more important than it sounds. If you can't manage this with one turkish towel, get two of them.

● The Dry Side

The most important thing about the dry side is that it should be *spotlessly clean* and *bone dry.* This applies also to everything in it, including enlarger, safelight, negatives, timer, printing paper—and the electric toaster and the spice rack, if you can't move them out of the way. *In photography cleanliness is next to godliness. If you want success train yourself to work clean.*

To prepare the dry side of your room, wipe off *everything* with a damp sponge, then dry it carefully. If you would be reluctant to eat a meal from a work surface, then it just isn't clean enough for photography. Do I make myself clear?

When everything is clean and dry, distribute your equipment and materials in an orderly way so that you can find things in the relatively dim glow of your safelight.

It is this dimness, incidentally, that encourages sloppiness. Don't let yourself be deceived just because you can't *see* yourself splashing. Discipline yourself so that you never take a step without your towel being in easy reach. Better yet, carry it draped from your waist. Do not get anything wet except the *inside* of your processing trays. Assume that all wetness elsewhere is chemical and that it is your bitter enemy.

Do not use protective covers on your dry-side work surfaces, for this only encourages sloppiness.

Wet or dry, photographic chemicals are fine conductors of electricity. If you smear them on an enlarger or an electric interval timer, look forward to some very unpleasant electrical shocks. If your floor is wet you can kill yourself. It's more likely, however, that you'll merely get knocked cross-eyed.

● Cleaning Your Enlarger

You surely realize by now that dirt is a malevolent enemy of photographers. With the enlarger itself the problem is chiefly dust. Since enlargers are made so that they can easily be taken apart for cleaning, the dust problem is easily overcome.

With a damp sponge, carefully wipe off all inside and outside plastic or metal surfaces. Remove all the glass elements except the lens and clean them with warm water, soap, and a soft towel. Polish them as if they were your Aunt Emma's fanciest glassware.

Clean the inner and outer surfaces of your lens by breathing on them, then wiping them with **lens-cleaning tissues.** Do not use the kind of cleaning tissues used for eyeglasses, for they may cause chemical damage.

If you have variable-contrast filters, clean them as you would the lens. They scratch very easily, so take great care.

Clean the negative carrier with a damp sponge. Wash off the enlarger baseboard until it is sparkling clean. If you have a printing easel, wash it carefully too. Be sure to get everything bone dry after you've washed it, or things will start to rust. Rust is even worse than dust in photography.

When not in use, wrap the enlarger head in plastic sheeting to keep out the dust.

• Cleaning Your Negative

Though this material is written for the beginner, it is exactly the same information I would use for training a master craftsman. One indication of the craftsman is that he is an expert at cleaning negatives.

In the section on film development I emphasized the great importance of drying your negatives in a dust-free place and putting them into glassine envelopes immediately afterward. Even if you've done this, however, you still have to clean each individual negative just before you print it.

The greatest problem is dust, which clings to the back (the shiny side) of negatives. Unfortunately, negatives easily pick up a charge of static electricity. This turns them into actual magnets for dust. Instead of waiting for dust to fall on them, they attract it from everywhere in their vicinity.

Using an antistatic rinse before hanging wet negatives up to dry helps a lot. Another approach is to get rid of the dust and static later, just before printing a negative. For this you use an **antistatic cleaning cloth.** The German one made by Ciba is recommended.

To clean a negative, you fold the cloth and gently pull the *entire strip* of image frames through the fold. You can do this several times, if necessary. If you clean only the frame you intend to print, the static charge is not removed. Thus, before you can get the negative into the enlarger it will have attracted more dust. Sometimes, especially in a cold, dry printing room,

you have to repeat the cleaning process three or four times. Frankly, this problem can drive you to distraction, no matter how expert you are.

After a cleaned negative has been put in the negative carrier, a couple pieces of dust or lint may fall on it. These can be picked off with an ordinary ½-inch paintbrush. This brush should be very slightly greasy. You can get it this way by rubbing it from time to time on the oily place at the base of your nose. Oddly, nose grease is one of the most popular negative cleaners among professional printers. Just before using the brush, draw its bristles firmly between your fingers to remove any dust that may have gathered. Do this several times. And keep it wrapped in paper so that it picks up as little dust as possible.

You should keep your antistatic cloth wrapped up too. Otherwise, it will add more dust than it removes from negatives. Furthermore, some of it will be gritty like sand and cause scratches. Scratches on the back side (shiny side) show up as white "scratches" on your prints. Those on the emulsion side (dull side) print as dark "scratches." The prints aren't scratched, you see, but they certainly look like it.

Greasy marks can usually be removed from the back of negatives with plain surgical cotton, or cotton dampened with rubbing alcohol. The same is true with light gray streaks deposited by the water the negatives were washed in.

I can't overemphasize the importance of careful negative cleaning. If you follow my advice you will soon be pleasing yourself immensely with your prints. If not, you'll be weeping loudly in your beer.

Make a few careless prints and see what I mean. They'll look fine under the safelight but terrible in white light. The myriad of distasteful white spots and marks and squiggles you'll see will come from the miscellaneous crud on your negatives.

• Getting Your Image Ready to Print

As you've probably suspected, your first printing

session will be a very long one—you have so many new things to learn. After a few more sessions you'll find that you can get set up and have your first finished print within 20 minutes. So don't despair!

Clean your negative, position it in the negative carrier, and put the carrier into the enlarger. The next thing to learn is the range of image sizes you can get. First, run the enlarger head all the way up to the top of its supporting pole. Turn on the enlarger light and open the lens to its widest (brightest) aperture. Now focus the image on the enlarger baseboard.

The image you now have is the largest you can get without projecting onto the floor. (If your enlarger pole will pivot you can do this.)

Next, do the same thing with the enlarger head moved all the way *down* on its pole or stanchion. This is the smallest image you can get in a straightforward way. However, you *may* be able to get a much smaller image and get it focused. You do this by putting boxes or a stack of books on the baseboard and trying to focus the image on top of them. Whether you can depends entirely on the construction of your enlarger's focusing system.

Now make some visual tests for image brightness. Open up, then stop down the lens to see how brightness changes. Of course, you can see best at full aperture, which is why you should open up before trying to focus.

If your lens has **click-stops** you'll hear a light click every time you reach a new *f*-**number** (*f*-**stop).** As you are **stopping down,** each new click means that the light intensity has been cut exactly in half. Conversely, each click while **opening up** means that it has been precisely doubled. If you don't have click-stops, look at the markings on the lens barrel with a penlight flashlight.

Knowing what aperture settings mean in terms of halving or doubling light intensity is a very important part of printing. So you'd better get the information down pat. Though some people

print for months without learning it, they don't really understand what they are doing.

Now experiment in getting the image the exact size you want. For this purpose, use a piece of ordinary paper cut to the same size as the printing paper you wish to use. Or you can use the back of a piece of printing paper, but you can't later use it for making a picture. Put it on the enlarger baseboard and focus the image on it. Now run the enlarger head up or down to adjust the image size. You may have to adjust its position and the focus several times to get the exact size you want. Move the focusing paper around too. Or if you have a printing easel (a kind of glassless picture frame for holding the paper), move that around to frame the image.

Though this kind of information seems very obvious to people with any experience, many people take a long time to learn it.

Do not try to make a print yet, for your very first print should be what is called a "test strip." Furthermore, it should be properly made.

● The "Basic-Basic" Test Strip

Since you'll now learn about several types of test strips, we'll call the most fundamental kind "basic-basic." You'll find yourself using all the types throughout your entire experience with photography. Therefore, it's a good idea to learn to make them properly.

Your most important use for a test strip is to learn how long you should leave the enlarger light turned on when you are making a print. With too much time, your print will be too dark. With too little, it will be too light; or there will be no image at all. There are many other things you can learn from test strips. We'll get to them in a moment.

There are several factors that work together to determine the correct exposure time. They are:

1. how *fast* a printing paper you are using,
2. whether your enlargement is small (bright image) or large (much dimmer image),

3. whether your negative is **thin** (lets a lot of light through) or **dense** (lets little light through),

4. whether you are using a large lens aperture (lots of light) or a small one (little light),

5. what printing filter (if any) you are using, and

6. the relative brightness of the light bulb your enlarger uses. (Enlarger bulbs range from very bright to very dim.)

To these factors we can add the relative efficiency of the enlarger-light housing and light-condensing system, the actinic quality of the light source, lens efficiency, and the voltage of the electrical input.

Don't get uptight now. I've frightened you on purpose so that you will respect the test-strip experiment you are about to perform. You will be relieved to hear that a properly made test strip co-ordinates all these factors so that they won't addle your head. Moreover, it gives you all the information you need in an easily interpreted form—*but only if you make it correctly*. Fortunately, this is dead easy.

For several reasons I'm going to dwell at length on exposure test strips. First, because learning to make them properly can free you from any critical need of a printing teacher. Directly or indirectly, the strips will clearly explain most of the effects you'll encounter in your prints. In fact, they'll be self-evident.

Second, test strips will help you understand *all* of photography, not just printing itself. It happens that photographic papers react to light and chemicals in much the same way as films do. Thus, most of what you learn about papers will also apply to film.

Furthermore, enlargers and cameras are so much alike that some types can be used interchangeably. In the old days, enlargers were even called "enlarging cameras." Through using your enlarger you will learn about your camera.

Next, your understanding of the function of *f*-stops on your enlarger lens can be directly applied to understanding *f*-stops on your camera lens. They do the same job, for the exposure problem is basically identical with both machines. With film you use brighter light and faster emulsions, so the exposure times are faster—fractions of a second. However, it is the *principle* of exposure that you need to understand.

The final reason for dwelling on test strips is to show you how to turn yourself into a fine craftsman. Test-strip discipline is the foundation for this.

Let us now make the first "basic-basic" test strip. For this first one you should use a full sheet of printing paper. Later, you can use narrow strips of it most of the time.

Clean your negative and put it in the enlarger. Adjust the position of the enlarger head to get the image size you want, properly focused with the aperture wide open. Then stop the lens down either two or three stops (to make the image sharper). Turn off the enlarger light. Now position your paper for exposure. Either use an easel or tape to hold it in place, for you are going to make a *series* of exposures on it.

You will need a piece of cardboard somewhat larger than the printing paper, since you will use it to cover up parts of the image while making *individual* exposures. The cardboard will effectively block out all light, whereas ordinary paper won't.

You'll also need a way of timing the exposures accurately, for without accurate timing an exposure test strip is valueless. For this purpose, an electrical interval timer or metronome is ideal. However, you can also count seconds under your breath with pretty fair accuracy.

You are going to make seven *individual* exposures, the first two for the *same* amount of time, but the rest for *different* times. For the first one, you expose the *whole sheet* of paper. Thereafter you progressively *cover up* more and more of it with the cardboard. Some people will tell you to do it the other way around (progressively *uncover*) but they don't realize this is a much harder way. Please ignore their advice.

No matter what exposure time you start out with, the exposures in a series should have the same *relationship* to one another. The *first* and *second* exposures are *always identical. Remember this!* Thereafter, you *double* the exposure each time.

Usually people start out with 2 seconds. Thus the *individual* exposures in the series would be: **2 sec, 2 sec,** 4 sec, 8 sec, 16 sec, 32 sec, 64 sec.

But you could also start with, say, 8 sec. In this case the series would be: **8 sec, 8 sec,** 16 sec, 32 sec, 64 sec, 128 sec, 256 sec. One reason for starting out with a longer time would be the use of a very slow enlarging paper, which requires longer exposure times than usual. Another would be in printing an overexposed and dense negative, which lets little light through. Remember, you can start with any time you want, as long as you keep the *relationships* the same.

So far we've been talking about *individual* exposures. However, after you develop your exposure test strip you have to begin thinking of *total* exposures, which is quite a different thing. Adding the series of *individual* exposures, starting

with 2 seconds, the *total* exposures would be: 2 sec, 4 sec, 8 sec, 16 sec, 32 sec, 64 sec, 128 sec. Notice that when the *individual* exposures are *totaled* the first two numbers are *not* the same. Each number in the series (each time total) is exactly double the one preceding it. Notice that the *total* for the last exposure step is 128 seconds, though the longest *individual* exposure it received was 64 sec.

I'm hammering on the difference between *individual* and *total* exposures because most people, even budding mathematicians, easily get mixed up on it. You *must* get it straight in your mind in order to make and interpret test strips. If you don't, you'll make the wrong kinds of test strips and garble the information they offer you.

When you are *exposing* an exposure strip you should concern yourself only with what the individual exposures should be. However, when you *look* at a test after it's been processed you should only think of the exposure *totals*. In the name of George Eastman I ask you to get this straight in your mind. If you do you'll find that a printing teacher is not really necessary for you any longer.

INDIVIDUAL EXPOSURES

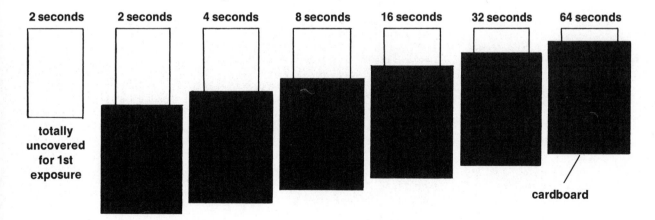

2 seconds 2 seconds 4 seconds 8 seconds 16 seconds 32 seconds 64 seconds

totally
uncovered
for 1st
exposure

cardboard

EXPOSING A BASIC-BASIC TEST STRIP

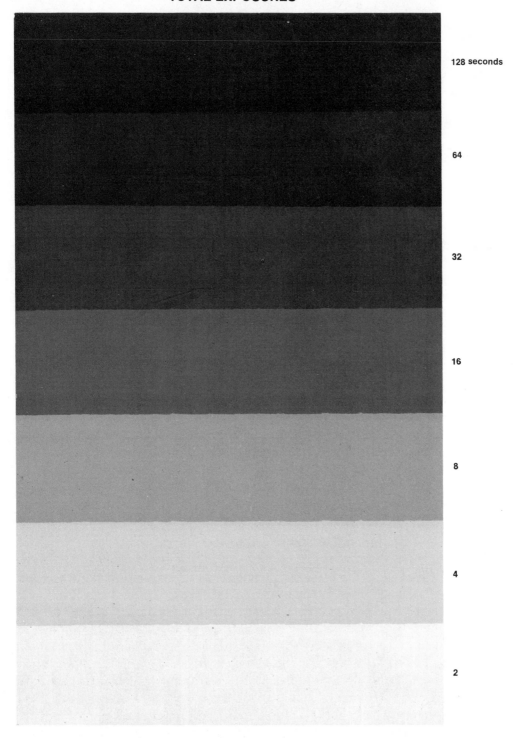

128 seconds

64

32

16

8

4

2

This is what a "basic-basic" test strip would look like
if you made it without putting a negative in the
enlarger. The light alone creates the tones. The longer
it falls on one area, the darker the resulting tone. If
you want to make photograms (by placing objects
directly on the printing paper), make this kind of test
strip to tell you the exposures for whatever tones you
may desire.

• Reading the "Basic-Basic" Strip

After you accurately expose a test strip, you must process it properly. (See later section.) After processing, you can "read the information out of it."

The first piece of information you'll want is the correct total exposure time for your print. The test strip gives you a series of total time from which to make your choice. As you see in the illustrations, the image has been broken up into sections, each with a different tone.

In a bright white light look at all the tone sections and choose the one that looks best to your eye. The total time it received during exposure is the exposure time you should use in making your print.

You figure out what this time is by "counting by doubles" from the lightest toned section: 2 sec, 4, 8, 16, 32, etc. If the tone you like is in the fourth section from the bottom, the proper **basic exposure** for your print would be 16 sec.

Sometimes, the sections with 2, 4, or 8 seconds total will have no image at all, no tone. This merely means that these total exposures weren't enough, considering the light intensity and paper speed, to affect the paper. In counting by doubles, you can *imagine* where the first few toned sections would be if there were any. Or you can count back by halves from the 128-second section, which is the darkest total exposure.

You may find that one section is a bit too light and the one next to it too dark. In that case, use a time in between. For example, if 8 is too light and 16 too dark, try 12 seconds for your final print. Or if the 8-sec section is very close to being right, use 10 seconds for your print.

Your test strip also gives you visual information concerning the contrast of the printing paper or filter you should use. (See later section.) Say that the 8-sec section looks just right tonewise, but lacks contrast. It's quite easy to see. It means you should shift to a higher-contrast printing paper or filter. This is equivalent to twisting the contrast knob on a TV set.

The test strip also gives you information that can be used for **burning-in** and **dodging.** (See later section.) The sections lighter than the one you like tell you the effect of dodging for various amounts of time. Those that are darker tell you about the effects of burning-in for specific amounts of time. If you like, you can make special test strips only for the purpose of determining either dodging or burning-in times. If you already know your **basic exposure** for the print as a whole, this is a reasonable thing to do.

You solve the next problem by using your knowledge of what *f*-stop settings on your enlarger lens do. Let us say that on your test strip the 2-second section is the one that looks just right. Unfortunately, 2 seconds is too short a time if you want to do some dodging. Furthermore, an interval timer isn't very accurate at any time less than 4 or 5 seconds. If you're counting the time, you can easily be 20 or 30 per cent off in a 2-second span. For reasons like these, you'd like to use a longer time but still get the same tone for your print. This is very easily done by merely reducing the light intensity (by stopping down the enlarger lens).

To go from a 2-sec exposure to 4, stop down once. For 8 seconds, twice. For 16 seconds, thrice. For 32 seconds, four times. Remember that for each stop down you cut the light intensity in half. Therefore, to get the same exposure (light intensity × time), you have to double the exposure time each time you stop down.

For a variety of reasons, the range of convenient exposure times for beginners is between 10 and 20 seconds. Professionals work in much shorter times because they have both skill and specialized interval timers. One masterful pro's basic exposure is usually ½ second, which is extremely short. One should also avoid exposures which are too long. When they run longer than 20 seconds you bore yourself with waiting, and your enlarger overheats. Too much heat will burn out the electrical insulation, turning it to a scorched brown powder. At around 20 seconds your negative may pop out of focus (like a color

slide) due to heat, which gives you a fuzzy print. Heat also cuts down on the life of your enlarger bulb.

It is very simple to cut the time. If the best tone on your test strip is the 32-sec one, open up *one* stop, which shortens the time to 16 seconds. If the best one is 64 seconds, open up *two* stops for 16 seconds. In opening up, however, you sacrifice image sharpness. The degree of sharpness loss depends on the quality of your lens. Poor lenses are very bad at large apertures, good ones quite passable.

The "basic-basic" test strip won't meet all your needs. It works best when you need a wide range of exposure times to help you zero in on an unfamiliar enlarger or a photosensitive material (film or paper) of unknown speed. When you've made the initial test, you can use the test strips with a more limited exposure range, thus pinpointing your basic exposures with greater accuracy.

Once you know how an exposure test strip works you might as well save money on enlarging paper by using 1-inch slices of it instead of whole sheets. If you use slices you should be sure to position them so they cross the important parts of the image.

• The Short-Exposure-Range Test

After a while you get to know approximately what an exposure should be just by looking at the brightness of the image on the paper you use for focusing. Then there is no point in running tests through a wide range of times. You use a short-range strip.

For the first exposure, choose the time you think is the lowest likely one, say 8 seconds. Then use shorter *identical* exposures for the rest of the series. As before, you make the first exposure (8 seconds) without the cardboard, then use it to progressively cover up the printing paper for the others. You could try this series of *individual* exposures: 8 sec, 2, 2, 2, 2, 2, 2. To get the *total* exposures, just start with 8 for the lightest step

and add 2 seconds for each additional step. With increments of 2 seconds, the range of *total* exposures would be from 8 to 20 seconds. If you wish, you can extend the range by using increments of 3 or 4 seconds.

• Multiple Test Strips

There is one problem with the types of test strips mentioned so far: The toned sections in them cross different parts of the image. Sometimes there is only one area that you really need information on.

In this case, make a series of single exposures, each one on its own 2 × 2-inch piece of paper. For each exposure, put a piece of paper in the same place on the printing easel. To remember each exposure time, write it on the back of the chip of paper with a pencil (not a ball-point pen). Then it doesn't matter how much they get mixed up later. Process all the chips at the same time.

Though you can use smaller chips, it doesn't work too well. Our judgment of image tone goes awry if the areas we're looking at are too small.

You can also use chips to get information on exposures for areas you wish to burn-in or dodge. In the hypo tray, you can put the chips on top of the basic print and actually see the tone difference. Move them around until they line up with the image on the print.

• Developing Prints and Test Strips

Prints and test strips should be processed in exactly the same way. The tendency is to rush test strips through so that you can get a look at them as soon as possible. However, this negates the value of most of the information they contain. Therefore, you should always give tests their full processing time and proper treatment all along the way. Though they don't look important enough for all this consideration, they are actually the secret of learning to print well.

The print-developer stock solution is usually diluted 1:2 just before you intend to use it.

In printing, developer temperature and developing times are not nearly as critical as they are in film processing. However, there are optimum *ranges* of time and temperature within which you should try to stay.

For temperatures, it's best to stay within the 65° to 75° F. range.

The developing time ranges vary according to the temperature of the developer. A warm developer brings up the image faster than a cold one. If the developer is around 65° F., stay within the time range of 1¼ to 2½ minutes. If it is around 75° F., develop within the 45-second to 1¾ range. For getting high-quality prints, it is important to stay within these recommended time and temperature ranges.

In an emergency, you can develop temperatures above 75° and below 65° F. Prints can even be made at temperatures over 90° F. and below 55° F. At high temperatures the time should be cut back, or you may run into a fogging problem. If you go much below 65° F., the developing action slows down considerably, until it nearly stops altogether. This may necessitate times of 5 to 10 minutes, which are very inconvenient.

If you develop less than the recommended times, your prints are liable to be muddy or mottled. If you develop for too long, you may get fog, stains, or both.

If you've overexposed your print, it will develop fully in too short a time—say 20 or 30 seconds. Though you may like the picture all right, it's a long way from being good. *Always* throw this kind of print in the wastebasket *immediately.* Then make another one with a shorter exposure. *If the print finishes development within the recommended developing time range, you can be sure that the exposure was correct.* In fact, this is the standard way for gauging correct exposure. Of course, the print tones should look right too, neither too light nor too dark.

If your print has to go too long in the developer, it was underexposed. Since going over the developing time often degrades the image subtly with stain or fog, discard the print *immediately* and make another with a longer exposure. This, again, is a *must!* Immediately discarding bad prints is a very important part of the craftsman discipline. If you don't, you'll turn yourself into a sloppy printer by undermining your judgment. You talk yourself into accepting less than the best, then begin to believe your prints are actually excellent. This is a very hard trap to get out of.

There are important things to know about the actual processing procedure. Throughout the entire developing time, the print should be kept underneath the developer surface and constantly agitated. Do this by gently nudging it to and fro with either your finger tips or print tongs. Do not hold on to the edge of the print, for the heat of your fingers will cause developer fog.

After development, put the print or test strip in the stop bath for at least 10 seconds, with agitation for the first 3 or 4. If you like, you can leave it there for 3 or 4 minutes without harming it. But this can lead to sloppy habits, so I don't recommend it. Nudge the print as before.

When you put the print in the first hypo, agitate again for the first 3 or 4 seconds. Be sure that it is pushed under the surface. Leave it there for exactly 5 minutes, then put it in the second hypo.

Leave it in the second hypo for exactly 5 minutes, then transfer it to the water hold-bath. You can leave it there until you're ready to stop printing and wash all your prints. If it goes longer than 5 minutes in the second hypo it's liable to bleach. This is much less likely in the first hypo. Most of its bleaching power has been exhausted (if it has been previously used as a second hypo).

Too short a time in the hypo leads to obnoxious yellow stains.

After 2 to 5 minutes in the first hypo a print is no longer light-sensitive. One can safely turn on the white light and examine it. If the emulsion still has its natural yellowish color, turn the light out again and wait until the yellow disappears. You'll get permanent stains if you don't.

128
sec

64

32

16

8

4

2

PRINT WITH 8 SECONDS EXPOSURE

A GOOD BASIC-BASIC TEST STRIP

BASIC-BASIC TEST STRIPS

When you make a test strip for your very first time you should use a large enough piece of paper to include the whole picture. Later you can use narrow strips, which will save you a lot of expense on paper. At first, you'll probably get a test strip that is either too dark or too light. If it is too dark it means that too much light is getting through the lens aperture. Stop the aperture down one, two or three more stops (*f*-numbers) and try again. If it is too light, open up the aperture.

Sometimes you'll get too light a strip when the aperture is already as wide open as it will go. This means that your negative is too heavy (too dark because of overexposure or overdevelopment). But it can also mean that the light bulb in your enlarger isn't very bright or that your printing paper is very slow (relatively insensi-

128
sec

64

32

16

8

4

2

TOO LIGHT:

APERTURE STOPPED DOWN TOO FAR

TOO DARK:

APERTURE OPENED UP TOO MUCH

tive to light). Whatever the reason, the thing to do is start your exposure series with a longer time. For example, instead of making the first two individual exposures 2 seconds and 2 seconds, start out with 8 and 8. The entire individual exposure series would then be 8 - 8 - 16 - 32 - 64 - 128 - 256. You will find these long exposure times very tedious. The way to avoid them is to expose your film properly.

Always develop your test strips for the same length of time you intend to develop your final prints, even if you can tell within the first 20 seconds they are in the developer that they are either too light or too dark. Those that are too dark give you information on burning-in (how much extra time gives you how dark a tone) those too light, on dodging times.

MULTIPLE TEST STRIPS (OR CHIPS)

5 seconds

10 seconds

15 seconds

20 seconds

25 seconds

30 seconds

35 seconds

40 seconds

There are times when you want exposure information on a specific part of a picture and are less interested in the picture as a whole. Then is the time to make multiple test strips, or chips. They should be about 2x2 inches or slightly larger. If they're too small it throws your judgment off. You don't have to cut your chips as neatly as those on this page, nor do you have to position them with such precision. Time the exposures accurately, however, and develop all the chips at once for your normal print developing time. Write the exposure time on the back of each chip (with pencil).

It is not hard to determine the correct exposure from a test strip (or series of chips), because it gives you a number of choices. Seeing a group of exposures all at the same time makes selection easy. If you limit your choices too much, you don't give your intuitive aesthetic sense enough information to work on. You will find yourself making inferior prints without being aware of it. So give yourself a break and make plenty of tests.

In the text I talk about test strips mainly as a means of determining correct exposure. However, they can also tell you if you are printing your picture with the right contrast of printing paper or printing filter. In judging contrast, it is very important to be looking at a chip or section of a basic-basic test strip that has the correct exposure. Areas that are too light or too dark give an untrue picture of the contrast problem, thereby throwing your judgment way off.

Examining a test strip will tell you if your negative and your enlarger's optical system are clean enough. Sharply defined white spots or squiggles on the test represent dust, lint, or hair on the back (shiny) side of the negative. Poorly defined, fuzzy spots or blobs come from dust or lint on one of the glass surfaces in the optical system. Careful cleaning is the way to get rid of both kinds. Under a dim light you may not see any of these things on your test strip, but under ordinary or bright light they may look very bad indeed.

Before judging a test strip, wipe off the surface water or hypo. The bright glitter of liquid gives you a false impression of how tones will look when they're dry. It especially falsifies the appearance of dark areas, which look unusually black and brilliant when they are wet. Dry, they may look quite dull.

Printing papers tend to darken slightly after they're dried. Therefore, if you are choosing between an exposure that is slightly too dark and one just a bit too light, choose the lighter one. It will be just a smidgen darker after it's dry.

Sometimes you'll find that the exposure that looks best on a test strip won't be the best one for the final print. The thing to do is to make several final prints with slightly different exposures. Again, this is a matter of giving yourself choices so that your aesthetic sense

has something to work with. In your first few months of printing you should frequently make extra prints. After that you will seldom need to. You may think it is a waste of paper, yet in the long run it will save you money.

• Viewing Prints and Test Strips

Remember that while developing prints you're working under a yellowish safelight. You can learn to judge prints fairly well under this light after you've had a little experience. However, it is not bright enough to enable you to make *fine* judgments of print quality. Therefore, a print-judging light is of utmost importance. It is recommended that you use a rather bright one. A 150-watt bulb at a distance of 3 or 4 feet is about right. Or you can stand near a window that lets in a lot of daylight.

If you use too dim a light you can't properly judge the dark areas in your prints. In such a light they may look all right, while in better light they may be flat and muddy. Areas that you want black may look that way but later prove to be merely dark grays. In dim light you can't be sure that your prints are unstained. It is good for one thing, however: judging contrast, dodging, and over-all pictorial composition. You should use dim light, but a bright light too.

If your judging light is too bright you will tend to make prints that are darker than they should be, for they look just right under such a light. However, under average-illumination conditions they will appear dark and dull.

It's a good thing to judge prints at a distance as well as close up. At 6 or 8 feet you can tell a lot about print contrast, picture carrying power, composition, dodging, and burning-in.

Your special judging light should also be used for test strips. To judge tests only under a safelight or in poor illumination may entirely negate their value to you.

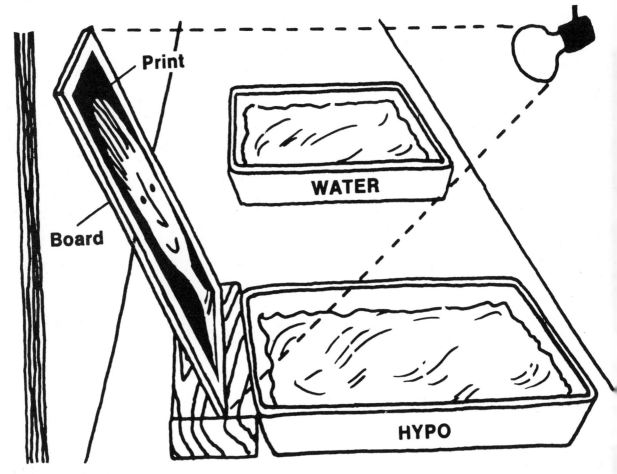

It is convenient to have a print inspection board on your second hypo tray. Use a 150-watt inspection light.

• Paper Grades and Printing Filters

Ordinary papers come in a range of contrast grades, sold in separate packages. You can buy one contrast of paper, or several. Special "variable-contrast" papers have a built-in contrast range in a single emulsion. Thus, from one package of paper you can get a whole range of contrasts. You control the contrast by using special printing filters.

The idea of contrast in a print is the same as for TV. Some images are too *flat*, others too *contrasty*. In some the contrast is just right.

If a print is too *flat*, you change to a higher-contrast paper or printing filter. If it is too *contrasty*, you shift to a *lower*-contrast paper or filter. It's as simple as that.

Degrees of contrast in papers or filters are indicated by numbers, low numbers standing for low contrast, higher numbers for high.

The contrast numbers in readily available "graded papers" run from 1 through 6. Thus, 1 is very flat, 6 very contrasty. Normally, you use high- or low-contrast papers to compensate for low or high contrast in negatives. For example,

THE EFFECT OF USING DIFFERENT FILTER
NUMBERS OR PAPER CONTRAST GRADES.

Contrast grade No. 0. It is usually used for very contrasty negatives to make prints that look "normal." Prints from normal negatives will look quite flat. Those from flat negatives will look flatter than flat.

Contrast grade No. 4. Use this for flat negatives of normal density or negatives that are flat because they are too thin (underexposed and/or underdeveloped). You'll seldom need a more contrasty filter or paper than this one.

Contrast grade No. 2. There are two grades that are considered "normal"—No. 2 and No. 3. Thus a negative with "normal" contrast will print just right on either one or the other. This is how you tell if a negative has the right contrast.

Contrast grade No. 6. This is the highest contrast available, and it comes only with Agfa Brovira No. 6, a graded paper. There are no filters this contrasty. Use No. 6 for dramatic effects or for normal prints from very flat negatives.

you might print a very flat negative on a 5 or 6 paper. You would print a contrasty negative on a 1 paper.

Paper grades 2 and 3 are considered to be of normal contrast. Negatives that print best on either of them are called normal contrast too.

For many reasons, your negatives are likely to vary considerably in contrast from frame to frame, though they may have been exposed and developed correctly. Thus, if you're using graded paper it is good to have a number of packages in different contrasts. If you can afford it, it's nice to have 1 through 6. However, you can usually get along very well if you have only 2, 3, and 4. If you can only afford one package, buy the 3.

You tend to save quite a bit of money if you use variable-contrast papers, for you only have to buy one package at a time. By buying in quantity you can save quite a bit. You save in another way. When you're printing with graded paper and don't have the right contrast grade for a set of negatives, you often go ahead and print them anyway. Later, you see your prints aren't as good as you persuaded yourself they were and decide you must print them over again—with the right contrast. This is very wasteful, of course, but people do it because they get anxious to see what their pictures look like. If you have variable-contrast paper you don't make this mistake.

However, in using papers with built-in contrast you must make an initial outlay for printing filters, which are fairly expensive. But if you do quite a bit of printing they pay for themselves in a short time.

Using the filters is very simple. With the set, you get a little filter holder that attaches to the enlarger lens. Before making a print you just slip a filter into the holder, selecting the filter number according to whether you're printing a low-, normal-, or high-contrast negative. That's all there is to it.

In variable-contrast papers the range of contrasts is not quite as great as in graded papers. It is only 1 through 4, as compared with 1 through 6. However, the 1-through-4 range will take care of nearly all your printing needs. If necessary, you can supplement your variable-contrast paper with small packages of 5 or 6 graded paper.

Graded papers have just a bit more brilliance, or "snap." They also permit you to make good prints from negatives which are a little too thin. With variable-contrast papers you need good negatives to make good prints.

Don't try using printing filters with graded papers. They just won't work.

• Some Other Characteristics

Printing paper comes in two thicknesses, called single-weight and double-weight. The single-weight costs a little less, but is not recommended. It is very easily creased or cracked, and it can give you some very irritating problems with curling. Double-weight will save you a lot of agony.

Paper comes in many "surfaces," or textures—glossy, semiglossy, matte, semimatte, pebbled, silk, canvas, and so on. Suit your own taste in this, but I would recommend starting with either glossy or semiglossy. Using the drying systems mentioned earlier, both will come out with a soft, pleasant sheen.

The color of paper varies somewhat, from brownish or ivory to neutral black-and-white. Start with the neutral colors, for they give a good rendering for a wide range of pictorial subjects. Warm-colored papers are used mainly in formal, commercial portraiture.

Some of the variable-contrast papers come in two speeds: high speed and regular. Unless you have a fairly expensive enlarger with a bright light source, use the high speed. However, you must be sure that you block out all white light from the room you print in. You must also, with any speed of variable contrast paper, use only OC or S55-X safelight filters. Other types of yellowish filters will cause fog.

You should also be aware that some papers are made especially for contact printing and others

for enlarging. The contact papers are very, very slow, so don't try using them for making enlargements. Your exposures would be unbearably long.

• Burning-In and Dodging

Sometimes a print will look just right except for one area that is too light. We correct this by **burning-in.** The idea is to let the image (light) shine on this part of the paper for a little *extra* time, while at the same time blocking it off from the rest of the paper.

You do this by cutting a hole the size of a dime or quarter in a piece of cardboard. After the **basic exposure** has been made, hold the cardboard under the enlarger lens and turn on the light again. Hold the cardboard so that the light shines through the hole onto the part of the image you wish to darken. Move the hole around, back and forth and sideways, so that the burned-in area will blend smoothly with the rest of the image. This is analogous to touching up something with a can of spray paint. You can see what you're doing pretty well, because the whole image shines on the cardboard. For really precision burning-in, use quite a large cardboard and hold it an inch or two above the printing paper. The image on the cardboard will be so sharp you can see the details very well.

At first, you'll have to experiment to learn how much extra time to use for burning-in. With experience, however, your guesses will become very good and you won't have to experiment much.

Sometimes a print will come out just right, except for an area that is *too dark*. In this case, we don't use *extra* time. Instead, we just block off light from the too-dark area for part of the basic exposure time. You can do this by sticking your fist in the way of the light for a little while. However, it is more convenient and accurate to use a **dodging tool.** This process of blocking off light is called **dodging.**

For a dodging tool you need a piece of straight wire about 10 inches long. To one end tape a round piece of cardboard about the size of a silver dollar, to the other a piece about the size of a dime. You use this dodger to cast shadows on image areas that would otherwise get too dark. Move it around so that the lightened area will blend with the rest of the image. For a large area, use the large end of the dodger. For a small one, use the small. The size of the shadow cast can be varied by moving the dodger closer or farther away from the lens.

Again, you'll have to experiment to see how much time you should dodge. It is usually somewhat less than half of the basic exposure time. Too much dodging will make an area look washed out. Thin negatives, or thin areas of normal negatives, will take relatively little dodging before washing out, which gives them a flat, muddy, gray appearance.

One generally times dodging and burning-in by counting under the breath, though it is sometimes convenient to use the interval timer for burning-in. In the beginning, people find it confusing to move a dodging tool (or burning-in tool) and count at the same time, so they usually do it too long. With a little practice the problem disappears.

• The Good Negative

A good negative is one that you can use to make good-quality prints without too much of a hassle. In contrast, a bad one will yield only prints that range from poor to horrible. Or it might be only moderately bad, so that by fighting with it, an expert could eventually come up with a fairly good print.

The time to investigate the difference between good and bad negatives is after you've had a little experience in printing. Until then it would be hard for you to visualize the relationships between negatives and prints.

Also, you have to know how to make a rather good print before you can accurately use your

DODGING AND BURNING-IN

The burning-in tool (left) is an 11 x 14-inch cardboard with a hole in it (can vary from dime-size to 3 inches across). The dodger (center) is wire with two cardboard disks taped to it, one dime-size, the other about 2 inches. Dodging (lower left) means holding light back for part of the exposure time. Burning-in is adding more light locally than the basic exposure time. Both tools should be moved around during use to blend tones.

The burning-in tool (left) is an 11 X 14-inch cardboard with a hole in it (can vary from dime-size to 3 inches across). The dodger (center) is wire with two cardboard disks taped to it, one dime-size, the other about 2 inches. Dodging (lower left) means holding light back for part of the exposure time. Burning-in (lower right) means locally adding to the basic exposure time. Dodging and burning-in tools should be moved around during use to blend their effects with the image.

print quality as a gauge for negative quality. Fortunately, printing can be easily and quickly learned, so that you can soon get into the problem of evaluating negatives.

Printing experience is also important in helping you understand what you should *do* if your negatives aren't good. Making prints helps one comprehend the problems of exposure and contrast, both in the negative and print. It also helps one learn about optimum negative density (relative darkness).

• Overexposure and Underexposure

Correctly exposed negatives are generally easy to work with. Overexposed and underexposed ones can cause all kinds of problems.

The cause of overexposure is too large a quantity of light striking the film (in the form of an image). It may be from too slow a shutter speed, too large an aperture, or both.

As film gets more and more exposure, it builds up **density.** That is, the silver deposit after development gets progressively darker. In photographic jargon, an overexposed negative is called **heavy** or **dense.**

With an excess of negative density we run into several problems. There is a loss of image sharpness. Graininess is considerably increased. Areas that record as highlights in prints lose their "snap" (contrast). Highlight details smear together, or blur. They also expand into surrounding areas.

The excess density cuts out a lot of light in the enlarger, making it necessary to use extraordinarily long exposure times. Even in professional enlargers, exposures sometimes run up to 2 or 3 minutes or more. In smaller machines they can be as long as 10 or 15 minutes. Even moderate overexposure of a negative can make printing times with amateur enlargers painfully long.

The causes for underexposure are exactly opposite those for overexposure.

The underexposed negative brings us an entirely different set of problems. There is no loss of sharpness or increase in graininess, nor is there a blurring of highlight details. There are some rather great disadvantages, however.

Underexposure seriously reduces the contrast in a negative, sometimes to a point where even a No. 6 printing paper won't compensate for the flatness. Prints made with such negatives have muddy-looking dark areas that lose all their feeling of space and form. In the jargon, such areas are referred to as "flat," "muddy," or "washed-out." They lose all image detail, turning to a light-gray nothingness.

The underexposed negative itself is called "thin." If it's greatly underexposed it even looks thin, like clear plastic film, because there is so little silver (black) in the emulsion.

No matter how carefully you clean a negative before printing it, minute particles of dust still cling to it. With normal negatives, these extra-tiny dust motes won't show in the print. However, with extremely thin negatives they all show up in prints as ugly little flecks of white. And no matter how many times you clean your negatives you can't get rid of them.

The most obvious characteristic of prints made from thin negatives is that they are disagreeably grayish and washed-out looking. The shadow areas are flat and lacking in image detail. Such prints have no "sparkle" or "snap."

In closing this section, I wish to remind you that correct exposure controls **negative density.** Too much exposure: too much density. Too little exposure: too little density.

• Overdevelopment and Underdevelopment

Film development mainly controls **negative contrast,** though it also affects density. The more you develop a film, the greater the resulting contrast in the negative. Conversely, the less you develop it the less contrast.

Besides building up negative contrast, overdevelopment increases grain substantially. Details in dense areas bleed together or merge, with a resulting loss in image sharpness.

An excess of contrast may make it impossible to compensate by going to a low-number (flat) printing filter. In general, filters and paper grades are designed to compensate for *too little* contrast and won't go very far in correcting *too much*. Since the normal filter or paper is 2, the only flattening number is 1. All the others are to increase insufficient contrast.

With *underdevelopment,* there is no grain increase. In fact, the grain will be slightly finer than usual—provided that the underdeveloped negative is not also overexposed.

The main problem with underdeveloped negatives is a flatness, often beyond correction with even a No. 6 paper. With extreme underdevelopment the tones may be mottled. Again, there is the problem of minute dust motes showing up in prints. In extreme underdevelopment there is little chance for the developer to build up the image density, so you get very thin negatives.

Factors that promote *overdevelopment* are: too active a developer (one freshly mixed, or the wrong kind, like Dektol, which is a *print* developer); too long a developing time; too much agitation; and too high a developing temperature.

Factors commonly leading to *underdevelopment* are: an exhausted or oxidized developer; a developer that has been contaminated with fixing bath or stop bath; a developer accidentally diluted too much; too short a developing time; and too low a developer temperature.

• Overexposure with Underdevelopment

There are times when your pictorial subject is so contrasty in itself that a normally exposed and developed negative will come out so contrasty that it won't even fit the lowest number of filter or paper. Photographing in the bright summer sunlight of the Middle East represents such a situation. Lighting contrast is very high. With normal exposure and development, the shadows would be very black in one's prints and would have little or no image detail. To make them printable one would have to reduce the contrast between the sunlighted and shaded areas of the images. This is done chemically, through underdevelopment. That is, one cuts the developing time.

However, underdevelopment also leads to a loss of negative density, for density requires time in the developer to build up. To compensate for such an anticipated density loss, one merely overexposes his film to start with. A good way to do this would be to overexpose by two stops, which would safely permit contrast reduction by cutting the film developing time in half.

To overexpose by two stops means to open the aperture two more *f*-stops than your meter reading tells you to—or to slow the shutter speed down by two positions on the shutter-speed dial on your camera.

If you are going to overexpose quite a few pictures, there is a way to do it without having to make special calculations for each one. Just divide the film's ASA speed by four and set the adjusted speed on your meter. For example, you would change Tri-X film's 400 speed to 100 and set the 100 on the meter dial. Then by using the meter just as you ordinarily would, you get readings that automatically give you two stops underexposure. Describing underexposure and overexposure in terms of stops is commonplace photographic jargon.

You wouldn't have to travel to the Middle East in order to use this system. Unless there are no shadows to speak of, you can profitably use it any place when the sun is shining brightly. It is especially useful if you are taking close-up pictures of people in the sunlight. It softens the facial shadows, which are otherwise much too harsh.

• Film Speed Pushing

Film speed pushing is a fairly old technique in photography, but it is not recommended for anyone but an expert. Though it is very easy to do, it can lead to a lot of difficult printing problems.

Pushing is simply underexposure and over-

EXPOSURE/DEVELOPMENT TEST:
TRI-X DEVELOPED IN STRAIGHT D-76 AT 68 F

1/16 normal exposure	1/4 normal exposure	normal exposure	4x normal exposure	16x normal exposure
ASA 6,400 4 stops under 1/500 at f/8	**ASA 1/600** 2 stops under 1/125 at f/8	**ASA 400** normal exposure 1/30 at f/8	**ASA 100** 2 stops over 1/8 at f/8	**ASA 25** 4 stops over 1/2 at f/8

4 min.—½ normal development

 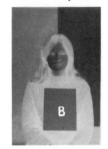

8 min.—normal development

 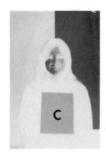 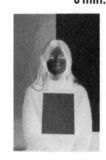 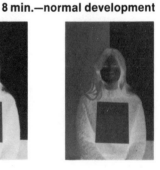

16 min.—2x normal development

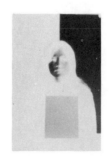 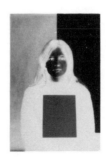 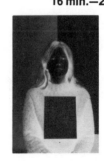 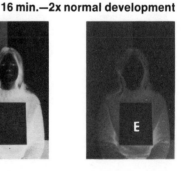

Tests like this one can only be done with cameras that have manual settings for shutter speed and aperture setting. Unless automatic cameras have manual overrides they can't be used. Making exposure sequences like these is sometimes called "exposure bracketing." Some people bracket by increasing or decreasing exposure in jumps of one stop. However, I think you can see what has happened better if you make two-stop ones. In running tests it is important to do everything as accurately as you can. Time and temperature should be right on the button. The developer for each test should come from the same storage bottle. For each roll use a fresh solution, diluted accurately. Just how your negatives will look after you do this test depends a lot on the subject matter you are photographing. If you really want to learn what happens in photography it would be a very good idea to repeat this test on various kinds of subjects. However, if you only do it once you'll learn a lot.

ENLARGEMENTS FROM TEST NEGATIVES, MADE WITH A NO. 2 (NORMAL) PRINTING FILTER

The printing exposures on these five pictures varied considerably, from an ultrashort for print A to an ultra-long one for print E. Each of the five exposures was the one that would make the face look best. All prints were developed for exactly 1½ minutes in Dektol diluted 1:2 at 68 F. The reason for standardizing on time and temperature is that variations would affect the contrast of the prints somewhat, thus confusing our judgment of how the contrast of a given negative will record in a print made with a filter of specific contrast. As nearly as possible, one should test for just one thing at a time. Testing for more things often confuses the issue so much that you can't tell what really happened.

The print of negative A shows that heavy underexposure and underdevelopment are ruinous to negatives. (On a following page you will see how far Brovira No. 6 paper can go in compensating for a negative so terribly thin and flat.) Print B shows that heavy overexposure isn't too bad if you combine it with underdevelopment. Notice that the range of contrast, from light to dark, has been considerably reduced. For a subject that is too contrasty to start with, this is a good way to treat it: overexposure and underdevelopment. (See text.) Print D indicates that underexposing your negative by four stops isn't so awfully bad if you increase the developing time considerably. However, you do lose all the detail in the shadows, which is disastrous in many kinds of pictures. Print E indicates that massive overexposure combined with massive overdevelopment sometimes leads to negatives that are still printable. But you run into print-exposure times of 5 minutes or longer. Also there is graininess and loss of sharpness, which show up badly in enlargements of 5 × 7 inches or larger. To see what really happens in tests like these, you have to do them for yourself. Because of certain shortcomings of the reproduction process, pictures and negatives printed in books don't look very much like the originals. You will find it informative and exciting to do the experiments.

A

D

B

C

E

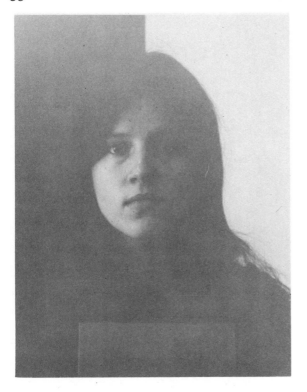

This is negative A printed on Brovira No. 6 to see if
extreme thinness and flatness can be compensated for
with a printing paper of very high contrast. There is
some improvement, but not enough to make a really
fine picture. We must conclude that No. 6 won't save
every underexposed and underdeveloped negative.

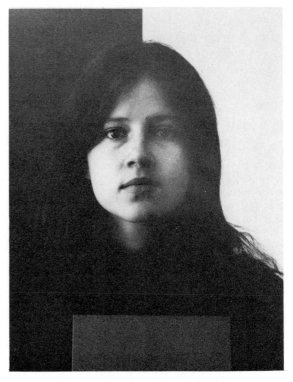

Negative D (badly underexposed but heavily
overdeveloped) looks a lot better on Brovira No. 6.
This shows you what happens when you shoot Tri-X
at a speed of 6400 and develop it twice the normal
time. The image looks fairly good in terms of its
contrast and tonal range, but there is little detail in the
midtones and shadows.

development. It is called "speed pushing" because
it involves using an "adjusted ASA speed." It's
not really ASA at all, but it is a speed rating that
works.

In the section on deliberate overexposure and
underdevelopment we made our adjustment by
dividing the ASA speed. In this section we will
multiply it, or "push it up" to a higher number.
You can also set the higher number on your
meter so that you don't have to perform mental
calculations.

The most common reason for pushing film
speed is to enable you to shoot at higher than
ordinary shutter speeds under dim light condi-
tions. For example, a sports photographer does it
in order to shoot indoor basketball games without
using electronic flash.

Certain films are fairly often "pushed." For
example, Tri-X (ASA 400) is often pushed to
800, fairly often to 1600, and now and then to
3200. The results of using 800 are usually fairly
good, 1600 fair to poor, and 3200 almost invari-
ably bad, so there is no point in pushing unless
you absolutely have to.

In the speed range 400—800—1600—3200,
each number is the double of the one preceding it

and represents a one-stop increase in film speed. Thus, shifting from 400 to 3200 represents a three-stop increase, or gain.

We would call this a "gain" because it means we are shooting at a faster shutter speed (three shutter-speed settings faster than normal). However, the so-called gain is usually illusory, for the resulting negative is usually no good.

Of course, when you push a film you have to compensate for the underexposure by deliberately overdeveloping. Since it is not recommended, the adjusted developing time figures have not been provided. However, you can get a pretty good idea of how much time should be increased by looking at the chart showing the effects of exposure and development on negatives.

People who *have* to push films invariably work out the extended developing times for themselves by experimentation.

The main reason for even mentioning film speed pushing is that you are certainly going to run across people who will praise it to the skies. Therefore, you at least ought to know what it is. If you can possibly avoid it, do so. You will run into printing problems that would drive even a master printer crazy.

● Making Contacts

Most photographers who use roll films find it very convenient to have all the images on a given roll printed on one sheet of paper, usually 8 × 10 inches. The jargon name for such a multiple print is a **contact.**

As the name suggests, it is made by putting all the negatives from one roll of film directly on (in contact with) the printing paper. However, the contact made this way is not very tight, so it is improved by pressing the negatives against the paper with a plate of glass (refer to the list of materials and equipment for printing).

Earlier, it was advised that you cut your negatives into strips as soon as they are dry after processing. You can figure out how many frames you should have in a given strip by determining how it will fit on an 8 × 10 sheet of paper. This is the usual procedure.

For your contact, you need a convenient light source with which to make the exposure. For this, your enlarger is well suited.

To make your contact, use the very same paper as for making enlargements. Make your very first contact print in the form of a test strip. Once you get your exposure information you can use the same exposure for all future contacts— without making additional test strips.

Start by running the enlarger head all the way to the top of its standard. Stop the lens down one or two stops. Arrange the negatives on the printing paper emulsion side down and cover them with the glass plate.

Now make a "basic-basic" test strip in exactly the same manner as you would in making an enlargement. Develop it as carefully as you would a fine print. This is important, for you want quality contacts to look at, not mushy-looking garbage.

After processing, look at the contact test strip under your viewing light to see which of the toned sections has the correct exposure. On a small card, write down the time, aperture setting, enlarger head position, and whether these particular negatives are normal, thin, or dense. In the future, you will use the same data and settings for all negatives of similar density. When you contact heavier or thinner rolls, record the exposures required. This little data card can save you a lot of bother, so be sure to have one.

If on a given contact you miscalculate on the exposure, make it over. A craftsman will never settle on anything less than a high-quality contact, since one of poor quality won't give him accurate information with respect to the quality and nature of his pictures. In addition, it will undermine his morale.

Always process contacts properly. Many people don't, and they build very bad printing habits as a consequence. If you give even an inch to slov-

enly habits they will soon dominate your entire range of photographic techniques.

If your contacts aren't wire sharp, it means that your plate of glass wasn't heavy enough to hold negatives and paper in good contact. In that case, hold down opposite sides of the glass with your hands during the exposure. If you hold it down you can successfully use fairly light glass rather than plate. Since plate glass is quite expensive, you may want to do this anyway.

It is best to look at finished contacts with a strong reading glass or a special illuminated magnifier made for that purpose.

Most people "mark up" their contacts with china-marking ("grease") pencils, usually red. They do this to indicate to themselves which frames they've selected for printing and how they want to crop (frame) them. It also helps them keep track of which glassine sleeves contain the negatives they're looking for. An advantage to using china-markers instead of, say, ball-point pens is that you can easily remove the marks with a soft cloth and a dash of rubbing alcohol or lighter fluid.

Many people file their contacts and negatives together. If you do much photographing, you'll soon see that an adequate filing system is important in helping you keep track of what you've done.

In my long years of photographing I've accumulated literally bushels of contacts. Relatively few of the images have been enlarged. In terms of pleasant remembering, I find that I get nearly as much joy from looking at my contacts as I do at enlarged prints. Since this may also be true with you in the future, make your contacts carefully.

A 35-mm contact sheet, printed full size. Photographers like to make notes to themselves, usually in red china-marking pencil. They very carefully select, analyze, and mark up the frames they want to print. Then they pick out the strips of film that have the selected frames. The whole procedure helps them decide how well they've solved their pictorial problems, what corrections are needed, and how they should make their prints.

PRINT FINISHING

After enlargements are processed, washed, and dried, they often need additional work, which the jargon calls **print finishing.**

● **Print Trimming**

Often, a print can be greatly improved by trimming off its borders or by changing its proportions altogether. One can trim prints with scissors, of course, but they don't do the neatest job.

For a really craftsmanlike trimming job, try using a sharp wallboard knife with a straightedge. The trick here is to make several strokes of the knife along each cut. If you try to do it in one stroke, the knife will push the ruler out of position, making a crooked trim line. It is also important to use a very sharp, new blade. If you know how to sharpen things one blade will last for years. If not, have a package of new blades on hand; they're cheap.

To help keep the ruler from sliding, glue little squares of sponge rubber on the back.

When trimming you should have some kind of expendable surface underneath your print. It doesn't help human relations if you use the top of your mother's best table as a cutting surface. Ordinary non-corrugated cardboard works very well. Even better is the back surface of a piece of untempered Masonite.

If you can afford it, a regular paper trimmer is very nice. However, you should invest in a really good one, for the cheaper ones give ragged trims which are out of square. They also fall apart in a year or two. Use your trimmer only for prints, not mounting boards. Boards have an abrasive in their sizing that dulls trimmer blades, making them nearly useless for print trimming. Cut mount boards with a wallboard knife and straightedge.

There is a type of trimming board that cuts with a wheel instead of a blade. It is efficient and safer than the blade type. Furthermore, its construction makes it impossible to misuse it by cutting mount boards. Though it's a lot of fun to use the blade type is recommended.

● **Print Spotting**

Even if you do a very good job of cleaning negatives before printing them you still get occasional dust spots on prints. Avoiding them entirely is nearly impossible. They can be eliminated with little trouble. The process is called **spotting,** which is short for "getting rid of white spots and lines."

For this we use a special **spotting brush** and liquid **spotting dye.** The brush has a small sable (not camel's hair) tip that comes to a very sharp point and is made especially for photographers. The dye, also special, is like an ordinary black ink, except that it is more neutral in color and doesn't have the same sheen.

The idea of spotting is to push tiny quantities of dye into the white spots, so that they blend with surrounding image areas and disappear. It's

a bit more difficult than it sounds, for there is a problem in getting the right tone and in putting dye only into the spots and not into the areas surrounding them. This can be quite a hassle. Moreover, printing paper emulsions don't soak up dye very neatly.

The secret of getting the dye into the right places is to work under a very bright light (even a photoflood), so that you can see where the needle-sharp brush tip is touching the image surface. People with poor eyesight find that a reading glass helps, and it's a pretty good idea for those with perfect vision. For my own farsightedness, I had my optometrist make me special magnifying eyeglasses, which focus 5 inches in front of my eyes. He objected to this unorthodoxy but made them anyway. Not only do they help in spotting but they eliminate my need for a magnifier when I'm giving my 35-mm contacts a critical check for image sharpness. A jeweler's eyepiece should work equally well. One thing is certain: If you magnify the spots it is much easier to stick dye into them.

The secret of controlling the tone is to dilute the spotting dye in varying degrees with water and to control carefully the amount of dye loaded in the brush. For this, use an ordinary saucer, a small glass of water, and a paper napkin.

Before starting to spot, use the brush to ladle half a dozen brushloads of dye onto one section of the saucer. Onto another section ladle a dozen or more brushloads of clean water. By dipping your brush into the two puddles, you can easily get any dye percentage you wish.

Use the napkin for quantity control. Drawing the loaded brush lightly across it removes the dye excess, which would otherwise come off on your print in unsightly gobs. Once they are there for even a second they won't come off. The dye sinks into the emulsion and stays there.

The secret of getting the emulsion to accept the dye evenly is to dampen slightly the area in which you wish to work. The dampness should be in the emulsion, however, not on the surface

as tiny globules of water. So wipe the globules off the emulsion, lest they diffuse the dye in a most unaesthetic way.

You can use dye for many things other than just filling in white spots and squiggles. You can darken fairly large tone areas, add dark shapes and lines, paint out objects you don't like, sharpen fuzzy edges, etc. You can do a surprising number of things in retouching faces. If you wish to work this extensively with the dye, you should try something else: Use a non-hardening fixing bath for your prints. It makes the emulsion accept the dye much more smoothly.

On the market there are liquid fixers that come in two bottles, one of which contains the hardener. All you have to do is leave out the second bottle when you make the dilution. This won't harm your prints at all, so don't worry about it. A cheaper way is to get hypo crystals and make your fixing bath with them. The problem is in finding stores which sell them.

Some print spotters have a big problem with nervous hands that make brush control impossible. There are several good solutions to the problem. A glass of beer or a highball helps. So does a tranquilizer. Slowing down your breathing for a few minutes is the cheapest way. The funniest (but very effective) is to put a paper bag over your head for five minutes, which functions the same as slowing your breathing down.

Stay away from coffee for the time being, or tense emotional situations. Slow down your thinking if you know how, or lead your mind to dwell on pleasant and placid situations.

● Print Presentation

After you've made a few prints you'll probably have a problem in deciding how you want to present them to the world (and yourself). If you just leave them lying around they curl up in an unsightly way and soon get scratched or torn.

For very small prints, I suggest a regular photographic album. Hold them in place with glue-

CLEVER SELECTION WILL SOMETIMES TURN ONE
PICTURE INTO SEVERAL.

All of these pictures were shot from the same position,
using 21-mm, 50-mm, and 200-mm lenses. The one made
with the 21-mm lens shows the whole scene. The other
pictures show details selected from it.

You can do somewhat the same thing by cutting
prints into rectangular pieces. The idea is to see how
many interesting pictures you can get, and it's not
unusual to get three or four from one larger one.

A better approach is to do the cropping with the
enlarger, so that small details can be blown up to a
more substantial size. This is not only good practice for
learning composition but useful experience in seeing
how quality varies from one degree of enlargement to
another.

At high degrees of enlargement the image tends to
"fall apart," i.e., lose sharpness, highlight brilliance,
contrast, crispness, etc. It is therefore best to do the
cropping in the camera, getting different magnifications
by using lenses of various focal lengths.

backed photo corners or with Kodak Rapid Mounting Cement on their backs. Stay away from ordinary cements and transparent sticky tapes, for they eventually bleach or stain the parts of the photograph they touch. They contain photo-destructive sulfur compounds. Ordinary cements and glues, including rubber cement, can't be used on the *backs* of prints, either, for they eventually bleed up through them and raise havoc with the emulsions.

Prints up to 8 × 10 in size look very nice in three-ring notebooks. You can put them back-to-back in the plastic sleeves (8½ × 11 inches) that fit the notebooks. Lots of people like to use the small zipper portfolio cases that take the same size sleeves.

For many years I've kept all my 8 × 10s in the boxes the printing paper came in and have been entirely satisfied with the idea. If people want to look at prints I just hand them a box or two.

If you like, you can put prints in the cheap (but nice-looking) frames they sell at Woolworth's. I've seen even professional print exhibits displayed in them. The narrow black frames are the best ones for photographs. The more ornate ones tend to overwhelm the images.

Using drymount tissue is the best way for sticking prints permanently onto cardboard or photographic mount board. A sheet of this tissue looks somewhat like a piece of semitranslucent paper but is actually made of pure glue. It gets soft when it's hot and hardens again on cooling.

To use it, you put it on a cardboard or mount board and put a print of the same size on top of it. Then you use both heat and pressure to melt the glue and assure tight and smooth contact between the print and the mount. With prints that are smaller than 8 × 10, you can do this rather easily with an ordinary electric pressing iron set for wool. So as not to risk abrading the emulsion, it is best to put a sheet of typing paper over it while you're ironing. It is also best to start with one edge of the print and iron your way across

rather leisurely. And don't get the iron too hot, or you'll bleach the print.

For large prints one needs a mounting press, which combines rather sizable pressure plates with a heating element. However, they are quite expensive and take up quite a bit of space. There is always someone you know who has one and will let you come to his place and use it. Or you can join a camera club, for they nearly always have one. And they have lots of other things too, including people competent to teach you from the point at which this book leaves off. Many a professional photographer has gotten his photographic education through a camera club.

The messy print was made with a very dirty negative. The other one was made at the same time, but spotted later. To spot a print means to fill in the white spots and squiggles with black dye, using a sable brush with a very fine point. Most people don't like to spot, so it's a good idea to clean your negatives very carefully just before printing them.

The Aesthetics of Photography

JUDGING YOUR PICTURES

● Good Pictures, Bad Pictures

After you've developed and printed a few rolls of film, you'll begin worrying over whether your pictures are any good. It never fails to happen. This problem is so difficult that many photographers worry about it for years. I hope that by giving you some ideas about pictures I can shorten your worrying time.

One of the biggest troubles with photographs is that people don't really know what to make of them (true of both photographers and non-photographers). They are fun to look at without thought or comment—everyone knows this—but when we try to analyze them the suffering begins.

Photography is like a trap, for it gets people deeply involved in it. This intense involvement inescapably forces us to think about pictures. When we find ourselves examining photographs, we discover with dismay that we don't know how. It is confusing and frustrating that we can't think about photographs the way we do about other things.

Perhaps the basic reason people fail in thinking about photographs is that they've never really tried to make sense of the reality they depict. We go through our daily lives seeing hundreds and thousands of things we hardly think about at all. In fact, if we were forced to think about them we couldn't survive, for there wouldn't be time for anything else. Photographs thrust these half-ignored things into our attention, demanding that we consider them. Though non-photographers can easily ignore the pictures we cannot.

Once we've been trapped by the medium we are automatically compelled to consider the contents of all the pictures we see, especially our own. Never having thought about them before, we find ourselves in a quandary concerning what and how to think.

Ordinary thinking won't work with photographs. It is not really thinking, anyway, but a type of remembering. Other people's ideas—from school, books, newspapers, TV, etc.—flit through our minds and we call it thought. From such sources there is a vast reservoir of second-hand ideation we can call to mind any time we like. It's different with photographs, for there is no handy reservoir. It is useless to search the memory. The things that have been said about photographs aren't very accessible. You really have to dig hard to find them. Thus, a person who has to cope with a picture has to think for himself, which can sometimes be difficult.

Despite the tribulations, one of the great attractions of photography is that it can promote original thought. However, most people need a little help in the form of concepts concerning what the medium is and what it does. We can start by showing how photographers talk about pictures.

● Like and Dislike

When experienced photographers discuss pictures the words like and dislike are often heard. Indeed, some photographers rarely employ any

other terms. Used carefully, like and dislike are a great help in photographic thinking. Used sloppily, they confuse it. To preserve these two very useful terms and avoid confusion we should remember certain things every time we use them or hear them used:

1. They are words which describe *emotions,* not objective facts outside of people;

2. the people who use them are mainly unaware of how they really feel, even to the point of getting their likes and dislikes confused;

3. people know even less concerning *why* they have these feelings;

4. a person's feelings for a picture may have little or nothing to do with the picture itself;

5. they may have nothing to do with whether the photographer achieved his purpose;

6. they may relate to the photographer but not to his picture; and

7. these feelings may not agree with what anyone else feels about the picture. Despite appearances, I don't think there is any exaggeration here.

Though it's a chore to remember all these things when we think with the terms like and dislike, they are nonetheless useful in helping us examine our pictures. In truth, they take us so close to the center of our involvement we couldn't get along without them if we tried. After all, the whole point is to make pictures we like and respect and we can't help judging whether we've been successful. Thus, like and dislike are terms that are here to stay, though they must be treated with suspicion.

Few people will be satisfied in deciding whether they like a picture. Most will go on to ask themselves why. This is a fruitful question that can be pursued to great depth. Carried far enough, it leads us into a very useful form of self-analysis, for photography is one of the finest self-analytical tools we have. Nowadays, many people are using it this way. They carefully ascertain whether they like or dislike pictures, then persistently dig for the reasons. The reward, of course, is self-discovery. There is little more one could ask for. The majority, however, avoid using photography to help them dig into themselves. They wish to avoid the pain it brings, not understanding that pain is necessary for growth.

What if a person refuses to pry into his psyche to learn why he likes or dislikes his pictures? Can he learn to criticize them expertly? No, for such a skill is earned only through years of the most intense self-examination. But is it necessary to be an expert critic? No, it isn't. One merely has to be moving in the right direction. With time and experience he will reap many rewards from photography. The great majority of photographers are rather poor critics, though very capable in judging photographic technique. Despite this shortcoming they've gotten much from photography.

Technique brings us back to the question of like and dislike, for good technique is simply the type that all competent photographers have learned to like. If they like the technique in a picture, it's good. If not, it's bad. It is as simple as that. Through the years, this idea of good technique has been turned into an absolute which has been formulized. Thus, people can use the ideas embodied in the formula as an external standard for judging their work. They don't even have to make up their minds whether they like it but can rely on the judgment of others as it has been preserved in the formula.

I suspect that the majority of photographers do this, but they are still left with the questions whether they like something and why. Only full answers will leave one entirely satisfied; and each of us must answer for himself. Ultimately, each of us must also decide for himself what makes a good picture. No outsider can tell us in a way we can understand.

● Good and Bad, Effective and Ineffective

Good and bad are terms commonly used in discussing photographs. Most photographers couldn't

get along without them. However, one should avoid them rigorously in thought and speech unless he carefully qualifies them with each use. We shouldn't say, "This is a good picture," but "It is good *because* . . ." We must always make sure to have a substantial list following the "because," for no picture should be considered good (or bad) for just one reason. Unless thoroughly qualified, good and bad are words without meaning or with too many meanings. Useless for clear thinking. Even if we do qualify them it is better to do without them, for they have a long history of blanking out thought and distorting reason. Anyone who uses them a lot ought to be very suspicious of himself.

When most people look at pictures and say good or bad they actually mean they do or do not like them. This often has nothing to do with the worth (relative goodness) of the photographs. It is a personal emotional reaction disguised with words to sound like objective evaluation. It is also the most common use for good and bad. For people who do this, the wise thing is to discard the terms in favor of like and dislike, which makes it obvious that comments are personal and emotional. Though it may make them feel too exposed in the presence of others, it leads to more accurate thinking.

It is also useful to substitute effective or ineffective for good and bad, though they don't always mean the same thing. The new words lead us to another way of looking at photographs: in terms of their relative effectiveness in doing things to (or for) people. All photographs are made to be looked at. And photographers generally hope for fairly specific reactions in their viewers, whether the pictures be scientific, documentary, photojournalistic, or pictorial. This is even true of the photographer who keeps his pictures entirely to himself; he wants to react to them himself in a certain way.

Using effective and ineffective also leads to the question of purpose. It is not enough to say something is effective; we must also say for what pur-

pose. Many of the photographers I've known seem to thrive on thinking about pictures in terms of purpose and relative effectiveness in achieving it. Therefore, I suggest it might work equally well for you. Certainly, it is better than incautiously using the terms good and bad.

It is good to keep in mind that an effective picture may not be one people should like. For example, a poster urging you to protest destruction of the ecology: The more it stirs your ire and revulsion the more effective it is. Consider this when you're distressed at disliking one of your pictures. Perhaps it wouldn't make sense to like it. Remember, you can explore the negative side of life as well as the positive. You should explore, also, both sides in order to develop fully your creative potential.

We should also be aware that effective pictures may be bad ones. They may achieve their purposes very well, but these purposes may be bad. The Adolf Hitler regime was expert in using photography in support of virulent Nazism. Merchants often use it effectively in selling inferior merchandise. For politicians, it is sometimes a means for lying about a candidate's qualifications.

Perhaps the important thing for the beginner is to understand that the worth of his pictures depends both on their effectiveness and the relative goodness of their purposes. On the other hand, he can safely sidestep such questions until he is well advanced in photography. His first problem is to learn how the medium works.

• What Photographs Do

When we get tired of using effective, ineffective, and purpose (which are formal terms and are a bit stuffy), we can adopt the word *do*. It's a short word that gets right to the point: What do photographs *do?* As you'll see in a moment, they do lots of things. It will help you measure your progress if you learn what some of them are.

This awareness is useful, because the diversity of photography creates problems for begin-

ners. Without even thinking about it, they wander all over the photographic map, shooting pictures of all types. Not recognizing the types or knowing what they are traditionally supposed to do, they fall into confusion. However, if you are aware of them it is less likely to happen to you.

Another common problem is that the beginner often sets out to make one kind of picture and accidentally creates another instead. He then compounds his difficulty by failing to see what he has done. All he knows is that he didn't get the effect he wanted. He doesn't understand that his picture may be quite good from another point of view.

The student often attempts to make a specific type of picture without giving any thought to what it is supposed to do. Some beginners, for example, like to make fashion photographs, but seldom realize that the function of such photographs is to sell garments, jewelry, perfume, etc. They usually end up with bastard crosses between glamour and fashion pictures, then wonder why they don't like them very much.

The solution to problems such as these is to think about the various types of pictures and what they can and cannot do. Though it takes a while to get everything clear in mind, it is not something to worry about. Time and effort will take care of everything.

● The Functions of Photographs

We will now see what photographs do. Though there are dozens of types and subtypes, we will limit the discussion to thirteen. This is quite enough for people just getting started in photography.

Stimulate memory: Photography is used more to stimulate memory than for any other reason. The family snapshot is the primary example of this. We snap our loved ones in order to remember our experiences with them. However, as memory stimulators, photographs can be much more sophisticated than snapshots. Some are even masterpieces.

Pictures made to help memory shouldn't be judged too completely right away, for only time will tell how well they've worked. Sometimes you'll find that a picture you dislike now will be a favorite in ten years because of the memories it evokes.

Pictures made to aid recall don't necessarily have to be pretty. In fact, pictorialism may be extraneous and even work against their main purpose. Too, we may have good reasons for wishing to remember some very unaesthetic things, such as a memorable night in a shoddy motel, the mess a hurricane made in the back yard, and Uncle George's broken leg. These things aren't pretty, but they are a part of life and interesting to recall when the pain has been forgotten.

Provoke an aesthetic response: Many photographers concentrate entirely on making pretty or beautiful pictures. If successful, they evoke aesthetic feelings or appreciation. These photographers often think of themselves as pictorialists and specialize in pretty girls, handsome landscapes, and similar subjects. The best of them have a powerful command of the medium, especially print quality, which is considered a thing of beauty in itself.

Because pictorialism has a long history in photography, a long list of rules and principles has grown up around it. They work rather well in making handsome pictures, though they tend to limit the imagination somewhat. The best place to learn about them is in camera clubs, which have for many years specialized in pictorialism.

Beauty is a complex subject and one doesn't learn to understand it in a day. Beginners trying to make beautiful pictures may be disappointed by results which are not pretty at all. Or if they do capture beauty now and then, it is hard to recognize. They may not have learned to see, or not developed through experience an appreciation of the aesthetics of their medium. One must understand that seeing well as a photographer is a difficult art. It takes a while to learn,

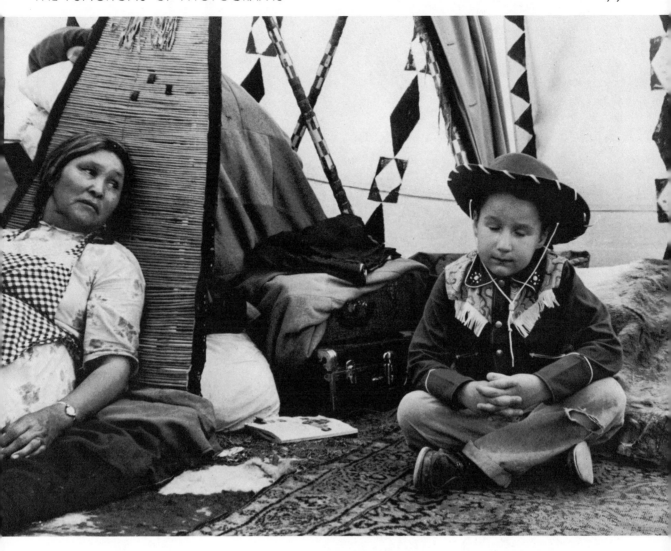

The author's son, Craig, photographed inside an
Indian tepee with an Indian woman. It was during the
very last medicine dance of the once-great Blackfoot
Indian tribe in northern Montana. Craig was so
excited he kept his eyes closed. This is a personal
photograph, a stimulus for tender memories.

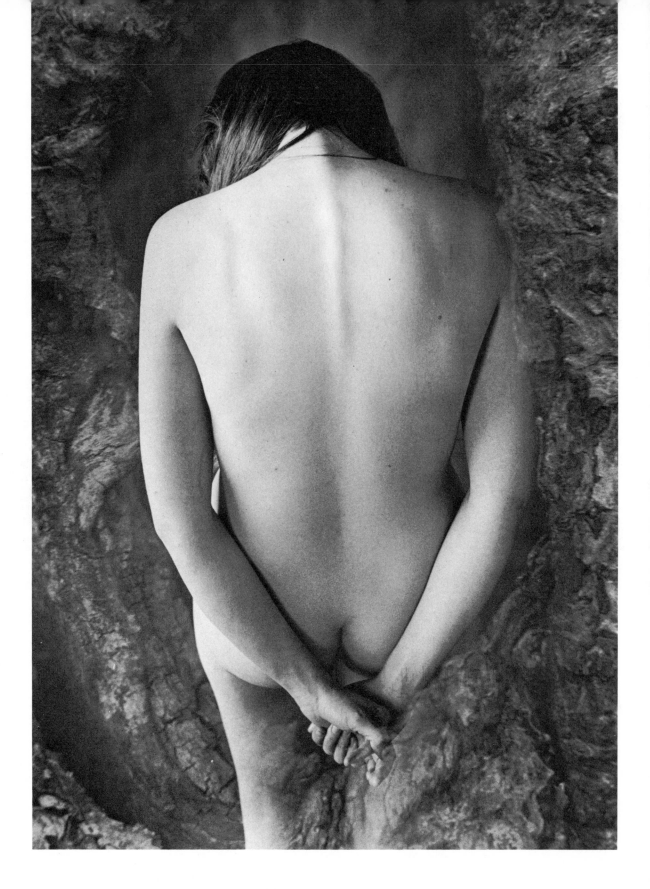

A montage of a young woman's back and a knothole in a tree. The primary purpose here is to stimulate an aesthetic response in the viewer. That is, one is supposed to be moved by the beauty of the tender young back in its rustic frame. The girl's pose should also lead the viewer to wonder how she feels and what she's thinking about.

and failures must be expected in the beginning. Instead of condemning inadequate work, the student should respect it for where it is leading him. When he arrives, he will be able to create beauty almost at will.

Arouse emotion: One of the most popular objectives in photography is to make pictures that really flip people out. The choice of subject is all-important here, though technique should be handled well too. The favorite subjects are people showing strong emotions, such as anger, lust, jealousy, fear, resentment, and pride. The idea is that one can record such things in photographs and use them to provoke emotional responses in viewers.

The all-time favorite is love, or affection. The genuine thing is a bit hard to find, but it does survive here and there. It is most often seen in parent-child relationships. If photographed well, it evokes strong responses in the viewer.

When a beginner starts to photograph in this area he is usually beset with ethical questions. How far should he intrude into the emotional lives of others? Is it right to use people's emotions to create photographs for one's personal use? Is it O.K. to photograph them without their knowledge and, without asking their permission, show the pictures to others? Questions like these plague the photographer until he answers them for himself. If he tries to push them aside and go against his ethics, he'll spoil photography for himself.

Another problem is the photographer's shyness. It is difficult to approach people who are expressing strong emotions, for they may react adversely to being photographed. The answer is to go places where people don't mind being photographed, such as protest marches, festivals, athletic events, folk rock concerts, parks, etc. There, people's natural exhibitionism comes out and they don't care if they are photographed while expressing themselves. For synthetic emotion, theater groups have much to offer. With a little skill, a photographer can make it look like the real thing. Sometimes there is a lot of real emotion in such groups.

The beginner should understand that really good emotional pictures are fairly rare; one cannot expect to get one on every roll of film. Even the world's best professionals can't do it.

Prove that one has done something: A popular use of pictures is to prove one has climbed Mount Everest alone, walked on the water across Lake Michigan, baked a wedding cake thirty feet tall, or convinced his mother-in-law she should leave on the second day of her visit. The vacationer's camera helps him prove unequivocally where he went and what he did. The home handyman takes before and after pictures of the den to prove he made a mare's nest into a beautiful place.

Photographic proof often turns into a form of bragging. It's harmless, people like to do it, and there are some things worth bragging about. Why shouldn't a proud father show pictures of his baby, silently bragging that he helped produce a healthy child? Does it matter if a young man shows pictures of his pretty girl friend to help build himself up in the eyes of others?

The proof picture only has to make its point.

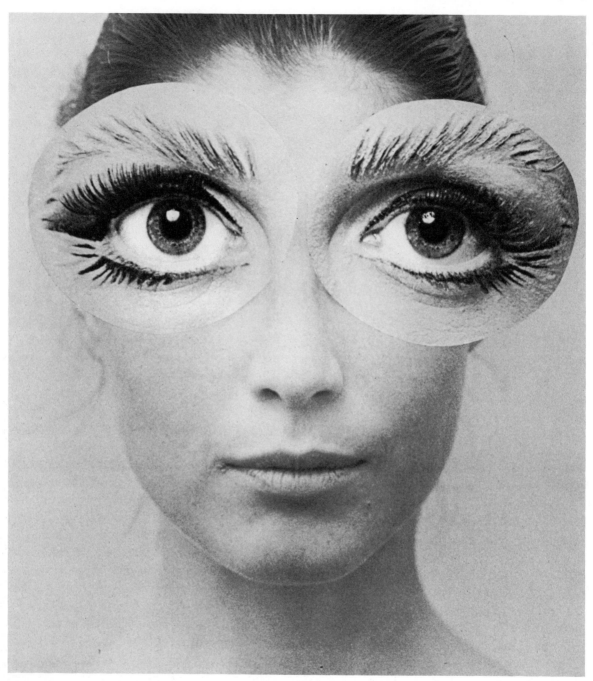

Eyes cut from one photograph were pasted onto
another, then the resulting picture was rephotographed
and reprinted. The objective was to arouse a strong
emotional response in the viewer. Nearly always,
people react to being stared at, even by a person in
a photograph. The eyes were enlarged to intensify the
feeling.

It doesn't have to be pretty, convey a message of importance, or demonstrate splendid craftsmanship. The beginner should understand that proof as such may be enough and not feel ashamed that he hasn't gilded the lily. Had he done it he might have weakened his proof, for simple, straightforward pictures are much more believable than artistic, pictorial ones.

Help one learn to see: Most photographs fall into this category, for the very process of making them tends to sharpen vision. The person just starting in photography doesn't see much at all. He doesn't really have a clue what his camera records—until he sees it all in his prints. Looking at them carefully helps him see better the next time he looks through the camera viewfinder. If photography really turns him on, he'll start seeing better *all* the time, as if he were in constant search for subjects for pictures. With experience, he develops a thoroughly disciplined vision.

For the purpose of developing vision, it doesn't matter much whether a picture is good or bad. If it is good, we search for the things that made it

This is one of the five or six thousand pictures taken by the author at the Birmingham (England) Repertory Theatre about twelve years ago. They could be used to prove beyond a doubt that he actually did cover the Rep in considerable depth. Photographs can be (and are) used to prove any number of things.

that way. If bad, for the negative, ineffective elements. Both experiences expand and sensitize vision. In this light, early failures aren't so bad. Instead of attempting suicide over pictures that bomb, the student should regard them as opportunities. It is true they cause griping of the gut, but that is always the price of artistic growth.

Amuse or entertain: What is more natural than photographing things that are amusing? A lot of people do it. The important thing is to not expect too much, for the truly hilarious photograph is extremely rare. Indeed, many top professionals have tried it and failed. Instead of setting our sights too high we should settle for modestly amusing pictures. Then we're not disappointed. The picture with modest wit is a lot of fun and worthy of everyone's respect.

The way to find amusing shots is to develop new points of view for looking at life, finding humor in the things that happen around you. Contrived humor usually fails. Stay close to home and the life familiar to you.

Entertainment photographs may not be amusing but interesting in some other way. They can record intriguing events, things, and places. Or they may use the photographic medium in an exciting way. Don't ask too much of such pictures, but let them be modestly entertaining. And don't be too upset if people refuse to let themselves be turned on by them. That is their problem. Many find photographs uncomfortably close to reality. Such people find their entertainment in things that offer an escape from it.

Record information of personal interest or value: One of photography's greatest strengths is as an information recording and storage medium. Once you've got data on film it is there forever. By data we mean a place, event, or thing; in fact, anything that will record on film is data of some sort. If you find something interesting or useful, that alone is good reason to record it. It is impor-

When the waiter saw the camera he made a face which expressed his feelings marvelously well. Though the picture has no merits beyond its humor, it needs none. Were we to judge it on its aesthetic qualities, the importance of its message, its photographic techniques, etc., we would overlook its real value.

Several years ago the author was interested in the way
pictures and statues of Jesus were displayed for sale in
New York City, and made a rather extensive record
of it. One could say that the objective was to
document things of personal interest or value, an
entirely defensible reason for taking pictures. More
people should try it.

tant not to confuse information storage with pictorialism, for they are usually entirely different. Neither type of picture is better or worse than the other. They're just different.

Record scientific data: It has often been said that science couldn't survive without photography, which is its main means for recording and storing data. Whatever interests science, photography records. It may be the traces of atomic particles in a cloud chamber, the underside of a starfish, or an aerial view of an alluvial flat.

The non-scientist can make scientific use of photography, too. Perhaps you would like to make a study of the bugs or weeds in your back

This photographic record might be of interest to archeologists and art historians. It is a detail of a Roman sarcophagus in New York's Metropolitan Museum. It should be judged as a record of someone else's art (the sculptor's), not as original art in itself. Records of this sort can easily be justified.

yard. Would you like to collect sea shells and photograph them? Perhaps you would like to study the behavior of white mice or frogs. In photography of this sort the important things are image sharpness, visual clarity, and selectivity (choice of the right thing, right moment, right distance, right camera angle, etc.).

If you go in this direction you should understand that other photographers won't understand your work very well, because most of them can't appreciate a picture unless it is pictorial. That's *their* problem. If *you* know what you are doing, all is well.

Record social-science information: A surprising number of people are amateur social scientists with their cameras. Primarily, this involves using photography to take a critical look at the human condition, especially in areas where people aren't faring very well. The camera asks, what is going on here, what is the cause, and how can it be improved?

In the cities, the most popular subjects are slums, settlement houses, welfare projects, and special schools. Rural conditions offer challenges too, for example, the welfare of migrant farm workers, the problems of small farmers today, the sad state of the American Indian, etc.

The person who gets into this kind of thing ought to carefully plan what he's going to do with his photographs. They accomplish nothing at all if the right people don't see them. He should do research to learn who they are, then plan his project in terms of how he wants them to react to what he has to tell them through photography.

In social-science photography it is important to accurately report what one sees, with a minimum of pictorial selectivity, trick camera angles, editorializing, and slick printing techniques. The objective is to record reality, not use the medium to make it look different. If you should do this kind of photography, ask yourself only if your pictures are real. Don't worry if they are not pretty, dramatic, or persuasive. As you build confidence in yourself and a command of the medium, you

Pictures like this interest social scientists, who use them to illustrate theses, articles, and books. It shows a familiar figure on Fourteenth Street in New York and a little bit of the street itself. Besides being a street musician and beggar, this man claims to be an ordained minister. He is a bright, optimistic person.

will find it difficult to restrain yourself from visually tampering with what you see. Nonetheless, you must record things as they are.

Stimulate thought: The beginner may think his pictures should incorporate answers, but sometimes it is more important to raise questions—

One of the main purposes of this picture is to stimulate thought. It practically insists that we speculate on its meaning. Why should there be lips on a tree? In what sense can a tree speak to us? What kind of a "person" is this tree? What is the photographer trying to say? How did he get the lips onto the tree?

even if he himself doesn't know the answers. Pictures that leave a viewer up in the air do him a favor, for they stimulate his thinking. A viewer will soon lose interest in a picture with a well-made, explicit point. In contrast, one that is strong and ambivalent may hold his interest for years, pushing him to solve its meaning each time he looks at it.

It is important for the photographer to stimulate his own thought, too. Perhaps the easiest way is to photograph mysterious subjects which the photographer does not completely understand. People who are honest with themselves realize they do this most of the time without even trying. It is bound to happen if one photographs other people. When one has puzzled himself with his pictures he then has the opportunity to use them in sorting through his thoughts and feelings about them. Thus, photography becomes a tool for self-discovery. It is more comfortable not to be puzzled, but this is an option we usually don't have.

If one of your pictures leads you toward self-discovery, you shouldn't demand that it do anything else for you. For you, it is a fine picture, even if it is technically weak and an aesthetic disaster. Pictorial failures may be of great worth to their makers; the wise student will take them seriously.

Freeze a moving event for examination later: Many of the events we experience change so fast we don't really get a chance to see them. This happens a lot on vacations, because people want to cover a lot of ground in very little time. The country speeds by, half unseen. A child's birthday party is another example: ten children running in twenty directions, mother crawling up the wall. By freezing time, photography will let us leisurely examine both the country and the party. Mother can joyfully look at her child when she doesn't have murder in her heart.

Often, we experience things that can be enjoyed more in retrospect than while they are happening. We may even blind ourselves to avoid discomfort. Social gatherings frequently fall in

this category. In the name of fun and good will, people get together to unintentionally make each other miserable. Viewed later, pictures of such gatherings can be fascinating. A delayed look can even contribute to understanding.

Extend vision beyond its normal limits: This category is filled mainly by scientific photography, with its electron microscopes, ultrahigh-speed cameras, X rays, etc. Science extends vision dramatically, making visible the submolecular and the galactic. It makes photographs with energy waves invisible to the eye, freezes the motion of things moving too fast to see, looks inside things never before accessible to vision, etc.

For the amateur photographer there are not too many ways to extend vision. Photomicroscopy is one, for the equipment is simple, readily available, and comparatively cheap. It magnifies things enough to open vistas unseen before, creating fascinating new worlds of vision. Or by using infrared film we can change the appearance of things or show how much infrared light is radiated by different kinds of objects. Even a simple red filter will extend vision somewhat. It will penetrate fog and haze to clearly record distant objects hitherto obscured.

You will probably not find yourself making pictures in this category, but you ought to be aware of it.

Prove that certain things exist: Had Marco Polo owned a camera it would have saved him a lot of trouble. To his dying day, people wouldn't believe what he had seen in the Orient, though they later learned he had spoken the truth. With photographic evidence it wouldn't have taken so long.

To a certain degree, each of us is a Marco Polo, for we see things that wouldn't be believed without documentary evidence. For example, I know a man who can stretch his spinal column five inches and another who occasionally unstraps his wooden leg and clubs people with it. Do you believe me? Of course not, you haven't seen the photographic evidence.

There are practical uses for this kind of evidence. You can use a photograph to prove to your landlord that the bathroom plumbing is faulty. A picture may be used in evidence to help collect insurance. You can mail a picture to your vacationing neighbor to prove that his fence has fallen on your corn patch. The things you can prove with photographs are almost innumerable.

The basic function of photography is communication. Simply by recording external reality we can communicate the reality behind what is seen —the condition things are in, what is happening to them, their environment, how people relate to them, etc. And on the human side, we can show people's health, age, state of mind, occupation, recreation, etc. The possibilities are unlimited.

My friend wanted me to photograph him doing his crazy act so he could look at the picture and see if he really looked crazy. Freezing action for later inspection is one of the common uses of photography, though this particular action is rather unusual. A sharper image would have served my friend's purpose better.

The photographer's primary aim may be communication. In my opinion, this picture says a lot about Tom and Betty and all other young lovers. In it there is nearness and distance, hope and hopelessness, sweetness and bitterness. It shows that a man's mind roves while a woman's mind patiently waits—sometimes forever.

Anything, large or small, when reproduced in a photograph, becomes a statement in visual form.

Emotion, states of mind, and abstract ideas can also be communicated, though this is sometimes difficult to do. It is far easier to show what things look like and let people draw any inferences they wish.

Even though you may approach photography as a personal pastime, its most fulfilling aspect is the ability to communicate with others. This may lead to disappointments, because people may fail to read the messages you so carefully put into your photographs. This is because photographs communicate much too much. You want a picture to say one thing and it says fifty; the viewer hasn't an inkling which one he is supposed to choose. Even if he does get the message the chances are high it will be on the unconscious level, so that he can't let you know what he learned.

This problem is only partly solvable. The best thing to do with your photography is to eliminate everything that doesn't contribute to your message, give pictorial emphasis to the things that do, and use captions to help you say what you mean. However, it takes a while to learn to do this well. In the meantime you should learn that visual communication is a tricky business and not let yourself get uptight about it.

As you've just seen, there are numerous types of pictures, some of them very unalike. The list could be expanded considerably. Knowing something about different types will help you decide on what kinds of pictures you are making. In striving to make pictures of quality this is important, for the criteria for quality vary according to picture type. There may be little overlap. For example, a good scientific picture may have little in common with a pictorial. An amusing photograph doesn't necessarily relate to photography as history.

You may find it educational to fit all the pictures you see into one or more of the type categories given. A few will fit a lot of them, most

pictures just one or two. As you continue to categorize you will gradually get a feeling for what constitutes quality in each area. Naturally, this will influence your photography. You must be patient, however, for it takes time to develop as a picturemaker.

You may wonder why the criteria for excellence were not spelled out when the types were discussed. In a sense, they were. It should be obvious that the humorous picture is measured by whether it makes one laugh or chuckle. The scientific picture must capture the particular data needed by a scientist. And so on.

To many, the transvestite theme is unpleasant, yet this young man at a costume party gave it a certain beauty and dignity. Is this picture primarily of interest to psychologists? Perhaps. However, it has a droll, slightly goofy quality that many folk might find attractive. Maybe we should classify it as humor.

• Beautiful and Ugly

Many picturemakers find themselves concerned with only two things: beauty and ugliness. They wish to create one and eliminate the other. Their desire is simple but the problem is not. It is difficult for the beginner to even differentiate between the two, for the borders between them aren't clearly defined. Furthermore, many things in the world are both beautiful and ugly. Some vacillate back and forth between the two. Photography can make certain ugly things beautiful, and vice versa. Our cultural ideas concerning beauty and ugliness keep changing. All this makes for confusion and despair in the heart of the student.

The trouble is compounded by the fact the learner hasn't developed a sensitivity to either beauty or ugliness. Unless they are greatly exaggerated you may not recognize either quality when you see it. Or you may detect it in one type of thing—people, for example—but in nothing else. This is a very commonplace situation.

Even recognizing beauty or ugliness doesn't mean one can capture them in photographs. You must know what they are made of in terms of their visual elements, such as line, contour, form, texture, and color. Only by knowing their anatomy can one with assurance set out to make a beautiful (or ugly) picture.

In the face of these problems, what can a beginner do? The most important thing is to jump into photography and swim like mad. Try it. Make picture after picture until your innate aesthetic sense begins to assert itself.

It will help you to look at photography magazines and annuals. Visit galleries where photographs are shown. You will see the work of experienced photographers who have solved the beauty-ugliness problem in a variety of ways. Experienced photographers believe there is much beauty displayed in these places. Though you may disagree with them at first, you will find that studying the work of others expands your photographic horizons.

Working hard to make fine prints will do much to enliven your awareness of the beautiful and the ugly. Before long you will discover numerous little tricks for changing a picture in either direction. You will see what darkness and lightness or contrast and flatness do. You'll discover the effects of different croppings. Soon you'll see that sharp images and fuzzy ones have different effects and that dodging and burning-in contribute significantly. As you work you'll learn to see prints better and, in turn, everything else. In time, you'll differentiate almost instantly between the pretty and the homely, the beautiful and the ugly.

Learning to see what light does to things (next section) will help your awareness of the subtle nuances of ugliness and beauty, for light is the ultimate source of both in photography. Without light we see neither of them.

In the beauty-ugliness sphere of photography there are several paths you can choose. My advice is to try them all. One way is to devote yourself entirely to making beautiful or pretty pictures. Many photographers do. This is easily justified, for mankind has a great need for beauty. It is also a challenge, because the majority of things aren't very pretty unless we make them that way.

A few photographers concentrate on showing the ugliness in ugly things. This is justified by our need to recognize and change them. It is hard on the photographer's stomach, however, as ugliness is very upsetting. I recommend that you try a few pictures in this vein, just to help you recognize visual ugliness when you see it and understand its visual components. This will help you keep it out of your pictures if you don't want it there.

The third path is the most interesting one, where beauty and ugliness coexist in the same picture. It creates an ambivalence that can be intellectually and emotionally stimulating. It is an interesting problem to get the two in the right balance. Usually, it is best to let beauty hold the winning hand.

The most popular approach to this kind of picture is to take something ugly or homely and use one's skill to beautify it as much as possible. Sometimes it is possible to remove the ugliness altogether, but it may be a better picture with some left in.

• The Photographer Is Affected by His Work

When people start judging their progress in photography they usually concentrate entirely on their pictures as ends in themselves, ignoring the process through which they were created. Though an obvious thing to do, it is severely limited, for it ignores the most important question: What does the creation of art do for the artist? If one is to reasonably assess his progress in photography he must find an answer. From a higher perspective we can see that pictures aren't very important, after all, but the people who make them are. Furthermore, the history of art has shown that artists have always been profoundly affected by being artists and that this is what attracted them to the arts in the first place. It should be worth our time to examine some of the things that may happen to you as you become a photographic artist.

I've mentioned photography as a way of learning to see, which has long been considered one of man's most important goals. Any artist can tell you that heightened perception is wonderful. Nearly everything that is beautiful in our culture derives from it. Thus, if you find that your vision is beginning to expand, that you are seeing more things in greater detail, you have good reason to be pleased with your progress in photography. You can't expect to have the fully developed vision right away, but signs of its coming should be welcomed with joy.

Looking at photographs can stimulate thought, but making them does so even more. The photographer thinks deeply before and during the time he photographs. He meditates when he is printing. When he shows his prints to others he ponders them in a different way. Certainly, you must consider an increase in deeply reflective thinking as a good thing, so if you find yourself thinking more you must also accept the fact that you are making good progress in photography. Remember that progress is an attribute of human beings, not of pictures, which are only tones and lines on sensitized paper. Please respect what is happening in yourself and remember that one of man's greatest problems is that he doesn't think enough about the outside world. As a consequence, his psyche becomes warped. Learning to turn thought outward heals and expands it. Remember that when you ponder something outside yourself you're doing more than merely sizing up a picture possibility.

When we search for meaning in our pictures we also ponder ourselves and thought itself. In the process, we batter down inner doors that block understanding. We open up the channels for feeling. We re-examine old opinions to make way for new ones. This kind of search is often painful, which may lead us to think we're getting nowhere with our work. The reasonable thing, however, is to see that the pain itself is a good sign of progress. It is always the price one must pay to become an artist.

One of the challenges is to understand photography as a scientific process—intricate, well thought out, workable. Seen at first as a massive confusion, it gradually becomes a thing of beauty and harmony. If you find that your comprehension is growing, it is a very good sign of progress. It will give you confidence you can understand other processes if you try, which is a wonderful thing. You may find that you are now able to look on the whole world of science with less fear and suspicion. This is certainly progress of a high order.

Most photographs are of people. If we photograph people quite a bit it may profoundly change our relationship to them in a good way. In fact, many young photographers use their medium primarily for this purpose. Usually, they are trying to overcome their fear of others. I've seen it

work dozens of times, so I gladly recommend it. When fear gradually disappears there is then room for love and understanding. Though this surely happens, I don't know why—perhaps because studying pictures of people encourages us to think about them and ourselves in solitude. This gives us a chance to work out things that we couldn't emotionally handle if we were with them.

If you find yourself thinking more about people, you can be sure you are making progress. If you think about them with affection, even better. Remember, it is much more important to care for one's fellow men than to make prize-winning photographs.

Many sad people see little beauty in the world, though it is all around us in great abundance. One of the prime virtues of photography is that it opens our eyes to beauty. We find glory in chunks or in tasty little bits almost everywhere we turn, for by looking for beauty we learn to see it. Perhaps you have found yourself seeing more beauty recently, though not necessarily capturing it in your pictures yet. You are doing well, as the most important thing is in seeing beauty at all. The ability to capture it in your pictures will develop in time; just be patient with yourself.

In this affluent society, many people have never experienced really hard, creative work. They can't understand its importance and how creative labor shapes the soul. However, most people who become enchanted by photography find themselves working extremely hard but enjoying every minute. Yet there are times when the gut seems about to burst. Failures bury us in pits of despair, and learning to control the medium seems a hopeless task. Nonetheless, a shred of hope carries us on to more hard labor. For creative people, even the pain is a kind of pleasure, for there is a point to the whole process.

If your involvement is like this you may rest assured that you're doing well. You have the great opportunity to learn the meaning of work and struggle. You've joined the battle against blindness, inner fear, and laziness. There is no other way to grow as a creative person.

In this section I've tried to show that preoccupation with an art medium changes people. Most artists seem to know this, but few outsiders. In assessing your progress in the photographic medium you should certainly measure its influence on you. Photography can easily turn your psyche into a great arena for debating and resolving important personal problems. This is good. It doesn't all happen in a day, so be patient with yourself. The possibilities are always open if you'll just take your time.

• Print Quality

Print quality is the most frequently used measure of progress in photography. It indicates how well one has mastered craftsmanship and the degree of development in photographic vision. It is tangible and can be talked about easily. And it is the only thing upon which photographers universally agree. If a print is thought good in Oshkosh, Wisconsin, the photographers of the world will agree.

Photographers have a tremendous respect for print quality. Indeed, they usually go overboard and think that any picture that has been beautifully printed must be good, even if they see nothing else to commend it. Many people have seen that the quickest way to earn the respect of photographers is to learn to make splendid prints. Some pursue print quality so persistently that they ignore everything else, so that their pictures are otherwise meaningless. They get trapped in technique for technique's sake and can't get out.

Learning an art is always a process of walking into traps and fighting one's way out again. It is even necessary. To get anywhere in photography, the beginner has to eat, think, and breathe print quality, to the exclusion of almost everything else. When you have mastered the art you should worry about fighting your way out of it. At this point, I doubt if you are trapped. When it happens don't worry, for it's a necessary part of the game.

There is only one good way to talk about print quality and that is by discussing original prints with the person who made them. The work of other people doesn't help much. Reproductions in books don't either, for they don't look much like original prints. Words by themselves are of limited value. Nonetheless, they can communicate some general principles.

Cleanliness: The quality print is clean in several ways: (1) no fingerprints on image or print border, (2) no scratches, spots, or squiggles from a dirty negative, (3) no chemical stains from image or border, and (4) no scum or other residue on the print surface.

Abrasions: The quality print is free of: (1) cracks in the emulsion, (2) creases, (3) indentations, (4) punctures, and (5) rubbed or scuffed places on the emulsion.

Fog: The quality print is free of fog caused by: (1) out-of-date paper, (2) too long a developing time, (3) too warm a developer, (4) accidental exposure to white light, (5) being held too close to a safelight, (6) a safelight with a larger bulb than recommended, (7) a developer contaminated with stop bath or hypo, (8) an exhausted (worn out) hypo, (9) paper that has been stored in hot and/or humid conditions, or (10) light leaks in the printing room.

Print color: The quality print is recognized by its color, which is influenced by developing time and temperature. In black-and-white prints the color is subtle, usually just a warmish or coldish look. Among quality printers, the favorite developing temperature is 68° F., plus or minus about 3 degrees. The favorite developing-time range is from 1¾ to 2¼ minutes. With many printing papers, the color tends to be warmish with short developing times, gradually getting colder as the time is increased. Most craftsman photographers like to get as cold a print as possible. However, they are leery of going too far over the maximum time for fear of getting fog.

Some papers are made with built-in warmness, though its degree is controlled somewhat by developing time. Some images look best timed at around 1 minute, others around 2. The important thing is to have the print color go well with the image, a characteristic of quality prints.

Exposure: The exposure of a quality print always satisfies exactly the requirements of the image by being neither too light nor too dark for it. One test for this is that the developed image usually looks good in bright, medium, or dim light. If it looks good only in bright light, it is overexposed. If good only in dim light, it is underexposed. Correct exposure is gauged only by the image, not by light readings and calculations. If an exposure makes the image work it is always correct.

Tonal range: The tonal range of a quality print satisfies exactly the tonal-range requirements of the image. Some people follow the rule that every print should have a tonal range from white to the blackest black the paper will produce. For some images this is all right, and learning to follow the rule teaches one the tonal possibilities of printing papers. However, it would ruin many images, for they may not need blacks or whites. Some should go from gray to black, some from gray to white, and others should range entirely in the grays. The amount of tonal range doesn't matter. The important thing is that it should make the image look just right, which is always true in the quality print.

Contrast: In a quality print the contrast always satisfies exactly the contrast requirements of the image. In most fine photographs the contrast is such that the image resembles the original subject as much as possible. Looking at such pictures is sometimes like looking through a window at the subject itself. However, such realism is not always desired, and effective contrast can range from very flat to very contrasty. The important thing is that it goes well with the image and idea of the picture.

Burning-in and dodging: In a quality print the burning-in and dodging always satisfy exactly the requirements of the image. A large percentage of negatives require one or both of these techniques.

The problem is to do it in the right places for the right amount of time. If they are overdone they make the image paint-sprayed or phony, and distract viewers from paying attention to the picture itself. In the quality print there is seldom any evidence that either burning-in or dodging has been done, though they may have been employed extensively.

Cropping: In a quality print the image has been cropped (proportioned and sized) to exactly fit the image requirements. There is neither too little nor too much picture space around the subject. The relation of picture height to width is exactly as it should be.

Sharpness: Unless pictorial requirements dictate unsharpness, the quality print is always sharp from edge to edge. This is often called grain sharpness, for many photographers use optical devices for focusing the grain present in all negatives. This is to make sure their prints are sharp. It is hard to tell when some images are in focus. However, when the grain is sharp you know they are. It can't be otherwise. Lots of photographers have a strong prejudice about grain sharpness and won't accept a print that doesn't have it.

If an enlarger lens isn't stopped down enough it will focus the image only in the center of the easel. The rest of it goes progressively out of focus toward the edges. Many cheap lenses will never give sharpness across the easel, even if they are stopped down.

These are the main criteria for print quality. You've probably seen that you'll need some experience in photography in order to understand them well. The concept "satisfy the requirements of the image" is a deceptive (and necessarily vague) oversimplification. If you sustain your interest in photography, you'll spend the rest of your life learning what it means. I'm sorry I couldn't give it all to you in a nutshell, but life just does not work that way. We seldom understand the answers it gives us until we no longer need to question.

This whole section on pictures should have opened up some avenues of investigation for you, possibly even answered a question or two. Do not be dismayed that photography has turned out to be a large subject. Each day you are somehow coping with a much larger one: life itself. Give yourself some time and you'll learn to handle photography very well indeed.

LIGHT

● What Light Does to Things

Early in the book you learned that light causes the chemical coating on film to react and form a latent image. Developing agents then make the latent image visible. Quantitatively, this is the entire basis of photography. If a sufficient quantity of light reaches the film it causes a reaction. For this purpose, light *quality* doesn't matter and any old light will do. However, there is more to photography than this. The secret to making fine pictures is to learn to handle light *quality*. Exposure meters can be relied on to cope with the quantity problem.

When we speak of light quality we are concerned with types of light sources and what they do to the world. That is, how do they make it look? Each type of light source has a different effect. And the appearance of each type of object is modified in a different way. For example, there is considerable difference between photographing something in sunlight or in the diffuse light streaming through a window. Depending on what it is, the diffuse light can enhance appearance and the sunlight degrade it, or vice versa. Thus, one must make the right choice for the picture to come out right.

The people most concerned with light quality are those who wish to make pictures that are aesthetically effective. However, even those who use photography as a recording medium should be aware of the many ways in which the appearance of things is affected by different light sources. This knowledge will help them make records which have greater visual clarity.

We have to understand what light does in order to consistently make visually coherent pictures. It is dead easy to make a photograph that is a visual morass, even to the point where we can't tell what its subject was. Making it clear, visually coherent, and meaningful is a difficult matter. We can count on luck some of the time, but more often photography is a skill largely dependent on our ability to see what light does to things.

Fortunately, the light problem does handle itself much of the time, so that beginners can make fairly commendable pictures without even being aware of light. They only get into trouble when they get more deeply involved in photography. Attempting more difficult things, they find their inability to cope with light quality defeating them at every turn. This is usually a low point in their experience in photography, sometimes even the lowest.

● Why We Have Trouble Seeing Light

When experienced photographers talk of seeing what light does to things they shorten the expression to "seeing light," which means the same thing. They universally declare that learning to see light is the most important thing in becoming an expert in photography (which is sometimes

even referred to as the "art of light"). Having struggled with the problem themselves, they usually rate it as the most difficult one in photography.

Strongly dependent as we are on vision, it is odd that we have so little natural skill in seeing light. Without light there would be no visual world at all and we would have little knowledge of our environment. Photography wouldn't exist, of course, for there would be no way for making images or for looking at them if there were. There would probably be no country and no culture, for the absence of light would indeed be a disaster. Considering its importance, why do we see it so poorly?

One problem is that there are too many things in the world, and light affects them in too many ways, for us to keep track of them. We have enough trouble coping with the things themselves and don't wish to concern ourselves with what light is doing to them. It is quite enough that it makes them visible.

Light creates absolutely everything we see, for we see only images formed of light which has been reflected by things in our surroundings, or our eyes form images of the lights themselves. Every texture, detail, contour, color, tone, shape, volume, or brightness that is communicated to our brains comes from light. And almost everything we see has all these attributes. Certainly, this makes for great complexity. Learning to see better only adds to it.

Perhaps the main difficulty with our vision is that we never think that we're responding only to light-created electrical impulses traveling through the optic nerve. Instead, we respond directly to the things that reflect the light to us. Through the psychological phenomenon of projection we find ourselves out there with the objects, not in our own heads reacting to their reflected light energy. We are filled with their "thingness" and strongly disinclined to make ourselves aware that their appearance is in totality created by light. As long as we can see as well as we like we would rather ignore light most of the time. Furthermore, it is our nature to apprehend our surroundings in large *gestalts,* not in terms of discrete visual qualities like tone, line, and texture.

These are some of the things that must be overcome or compensated for in learning to see light. Despite the confusion, it is possible to confront the great complexity of the visible world and learn to see what light does to all of it. Following ordinary paths, this is very difficult to do. However, there are special paths that have been worked out for photographers and other artists. They involve ways of simplifying things in order to see them better.

● White-on-White

Simplification helps beginners in all of the visual arts. They start their education by drawing or photographing simple things, gradually working their way toward complexity.

Photographers usually deal with objects of one kind or another. Fortunately, there is a very easy way to simplify many of them: It is to paint them white. This simplifies by elimination, for it gets rid of color, color differences, tone (except white), and tone differences. Though these things are also caused by light, they are too much for the beginner when added to everything else he's trying to see. Temporarily eliminated, they can be dealt with later. In the meantime the less distracted student can learn to see other important things that light does.

This approach to learning to see is a very old one once used to train painters. Students were given white plaster objects, usually sculptures of heads or parts of the body, and were expected to spend several years drawing them carefully. At first they would find it very difficult to see the light and shade patterns on the objects, but after a time would eventually become quite adept at drawing them. By that time they would be experts at seeing some of the most important things that light does.

Long ago, photographers borrowed this idea from the painters, replacing charcoal or pencil with the camera. They added the idea of a movable light source, making it possible to change at will the light and shade patterns on white objects. Some teachers of photography simplified the visual problem even more by using objects of extreme structural simplicity, for example cubes, cylinders, spheres, and pyramids. In some photography schools these simple forms are used in teaching basic lighting.

The problem with such simple objects is that they make rather dull pictures. Because the project isn't very pictorial, the student slops through it, entirely forgetting he's supposed to learn to see something. Thus he gets a cruddy picture and wastes an opportunity to see better what light does to things. For people with a modicum of self-discipline these simple objects are very informative; photographers have been learning to see with them for many years. For the undisciplined they are a complete waste of time.

All is not lost, however, for some white objects are pictorially interesting. The plaster heads used by painters are, for they are usually good copies of Roman portraits in marble. Nowadays, there are many interesting things that are already painted white or made of white plastic. When painted, some fruits and vegetables look swell; even a boiled lobster becomes an interesting white subject. For many years, photographers have used white eggs for lighting practice, since they are cheap, available, and sculpturally perfect. One person stripped a discarded TV set and found many things that looked good painted white.

Finding interesting objects to paint is a part of the challenge. If you pick stupid, dull, or lumpy things, your innate aesthetic sense will rebel and you won't be able to force yourself to experiment adequately with lighting. Be sure to pick things for their form, not for their color, tone, or texture. They should be interesting in themselves, not for some other reason. To illustrate, a lobster is interesting in itself, even though it's also good to eat, but a football is interesting only for what one does with it.

If you are going to do the experiments in this section you ought to select a variety of items to photograph, for you would soon get tired of playing with just one. Also, different kinds of objects are modified by light in different ways. If you wish to learn about light you have to give it a chance to do a few things.

Your objects should have a certain amount of bulk to them, like a bowl or jar. Things like straws, sticks, and flower stems are so thin you can't make light do much to them; and what little it does do you can't see very well. Things that lie flat on the surface are also a disappointment, so stay away from them. However, objects with bulk (body, volume) stand up from the surface where you can get at them with your lightings. They will help you see light.

Paint your collection carefully, preferably with matte-white spray enamel. Glossy enamel is not as good. If you use a brush, work wet enough to prevent brush strokes from showing. If you don't paint carefully, the results of your messiness will distract your vision so much you won't see what light is doing, which is the whole point of the work. Furthermore, they will spoil any picture you make. It is the photographer's nature that he wants to make good pictures while he's experimenting and if he doesn't he soon loses interest. Only a sustained interest in light will lead one to learn much about it. Don't let sloppiness interfere with your interest.

• White Background

Your background should be white too—all of it. When you look at your setups through the camera viewfinder you should see nothing whatsoever but things that are white in nature. The lightings may give them some other tone, but they have to be white to begin with. Then if tones other than white show up, as they certainly will, you will

know for sure they are caused by something you've done with light. You can trace down the causes, thereby learning how to handle lighting.

A piece of white paper or lightweight cardboard is convenient for a background, the larger the better. Small pieces cramp you, so you can't work with very many lighting variables. For small objects, a useful size is about 36 × 52 inches, though it's nice to have a larger one if you can find it. The paper should be spotlessly clean and free of creases, wrinkles, and scuff marks. Though you may not notice them while you are working, you'll discover them with dismay in your pictures.

Laid flat on a table, paper is good only for high-angle camera shots. However, you can curve it up a wall and get almost any angle you wish. Do this by pushing a small table (or ironing board, box, bureau, etc.) against a wall. Put one end of the paper flat on the table and let the other curve up the wall. Then tape down the four corners to hold it in place. It's usually best if the curve is fairly gentle. If it is too sharp it will show up in your pictures, which is not usually desirable.

When you put objects on the paper to light them, they should be fairly close to the front edge of the paper. If they are back near the wall you lose certain possibilities from the lightings. With really large background papers the distance from subject to wall can be quite long. It gives the photographer lighting control over the tonal relationship of subject and background, which is highly desirable. Though both are white, he can use lightings that will make the object white and the background black, and vice versa, or create tonal relationships that will fall somewhere between these extremes. If a beginner sees such things happen he can begin to understand that light (and nothing else) creates tonality.

Another convenient background is a white wall. Since it is large, the subject can be positioned far in front of it, giving the photographer tremendous control over the subject-background tonal relationship. If it is dirty, it can be far enough away from the subject to be completely out of focus, thus preventing smudge marks and fingerprints in the image.

When we use only paper for backgrounds we get in the habit of placing our objects on a surface. Though it works most of the time, it can also be limiting. With walls, we can have subjects thrust up in the air, thus enabling ourselves to see them from fresh viewpoints. Using walls also teaches us how to make-do with something readily available. The better photographers are expert at this.

● A Necessary Detour

Enough has been said about white-on-white to present the experiments. However, there are many factors which haven't been discussed at all. Though the experiments involve simplification of objects with white paint, they themselves are quite complex. Without additional information you wouldn't really understand what you are supposed to learn from them.

Another reason for temporarily pulling away from white-on-white is that the things you will read will apply to photography in general, not just to making pictures of white objects. If they were presented only in the context of white-on-white you might find it difficult to see this.

● Camera Equipment

For working indoors, certain equipment is desirable, such as tripods, exposure meters, lights and so forth. Since indoor lightings are not very bright, exposure times are liable to be long. Few people have steady hands in the $\frac{1}{2}$ to $\frac{1}{60}$ seconds exposure range and this creates a problem of camera movement. The problem is easily solved with a tripod, provided one also uses a cable release.

Separate exposure meters are desirable, because built-in meters aren't sensitive enough to register many of the lightings you may wish to use. The best bet is a cadmium-sulfide meter like the

Gossen Luna-Pro, for it will even read moonlight. However, selenium meters like the Sekonic will do the job most of the time.

Working indoors, we frequently wish to photograph small objects, but they are minute in the camera viewfinder, and if we move the camera closer they go out of focus. However, if one uses a close-up lens they are magnified enough to fill the whole frame. They can also be magnified with an enlarger, but there is always a severe loss of quality if we push enlarging too far.

Photographers usually like to crop tight with their cameras, so that additional cropping while printing is unnecessary. This gives them the best quality possible with a given film-developer combination. Follow their lead and make your image fill up the frame. Close-up lenses are inexpensive and useful for many kinds of pictures. I recommend that you get one (or more) early in your career in photography.

● Lights

If you are to learn about light you must work with lightings for which you are entirely responsible. They give you the opportunity to study your subjects and figure out why light affects them the way it does. If the light is not under your control, this may be very hard to do.

The type of light you should dispense with immediately is ordinary room light or that which comes through the window. Though they are very useful in photography, you must bid them a temporary good-by. Together, they are often referred to as "available light." They are available in the sense they are already doing their thing for the photographer, and he doesn't have to manipulate them or use additional light sources.

Oddly, beginners invariably get better pictures with available light than with controlled, but it is because they haven't learned to see what light does. In positioning light sources under their control, they make serious visual mistakes, simply because they can't see them happening. When they use available light they are hardly aware of light at all, and it automatically takes care of many of their visual problems. Working with available light, people can photograph for years without ever becoming aware of light as such.

Since controlled light may spoil some of your pictures, you may be tempted to avoid it. Don't. To learn, you need to make some mistakes. Without trial and error you may stall-out permanently on a plateau. By sticking for a while to light entirely under your control you will soon begin to understand the proper use of light. You will make good lightings and see them well. Furthermore, you will soon find you are also seeing available light better and understanding how you can modify it when desirable. No longer will you have to depend on gratuitous offerings from your visual environment.

We employ the white-on-white experiments to reduce visual complexity and make seeing easier. Further simplification is necessary for students. We are ordinarily confronted with too many light sources, except when we're in the sunlight. Too many sources makes it very difficult to see what each one is doing, which is precisely what we are trying to learn.

Beginners need months of drill in using only one light source. If there is only one it is much easier to sort out what it is doing. Such a limitation is not, as one might suppose, a pictorial liability to prevent your making fine pictures. On the contrary, it will make them much more probable. Thousands of fine pictures are made each year with just one light source. Indeed, many top-flight photographers rarely use more.

The most adaptable light source for photography is a photoflood bulb in a regular reflector. Clamp-on reflectors are all right, but reflectors on regular light stands are much better. There are also reflector bulbs, which have reflectors built into the back of them. Clamps can be put on them. If you have no light stand you can create one from a Christmas tree stand and a long stick. Clamp-on reflectors or bulbs can be positioned easily on the stick.

Most reflectors are round, which is good. Avoid the rectangular ones, because they limit you considerably. The round ones project the most useful light pattern: round, bright in the middle, fading out imperceptibly at the edges, until it disappears. You can see the pattern by pointing a light at a nearby wall. Rectangular reflectors cast patterns that break off sharply at the edges, which can ruin many a picture. They often have barn doors (light-control flaps or shades), which are used to change the shape of the light pattern. Though the idea is good, the barn doors cast irritating shadows. With a round reflector you can make really workable barn doors with pieces of cardboard held in place with masking tape or clothespins. The lighting patterns are good.

Because mobility is important in lighting control, it is desirable to have a lightweight light stand that can easily be moved around. Its standard should telescope from a rather low to a high position. The reflector should swivel easily on both its horizontal and vertical axes. Without such mobility one is severely limited in putting light through its paces. With experience, you can learn to do without some of it, but in the beginning you should have as much of it as possible.

● **Direct, Bounce, and Edge Light**

A light pointed right at a subject is called direct light. Pointed at a wall or other type of reflecting surface, it is bounce light. If it is aimed in front or behind the subject it is edge light, for only the edge of its light pattern strikes the subject. These are three of the most important lighting variables.

The easiest to use in making successful pictures is bounce light, followed at some distance by edge light. Direct light is very tricky and poison to all beginners, but they use it to slaughter pictures by the hundreds. Beginners cling to direct light because they find it impossible to believe that it is good to point the light everywhere but directly at a subject. Nobody but an expert can use direct light well.

Another reason people go for direct light is that it is much brighter than bounce or edge light, making it possible to use shorter exposure times. If we use tripods these shorter times aren't necessary, but beginners don't understand this. Thus, they feel compelled to use direct light and are very leery of bounce and edge light, which they should actually prefer.

When we do bounce or edge lightings with one floodlight, the shutter speeds 1, $\frac{1}{2}$, $\frac{1}{4}$, $\frac{1}{8}$, and $\frac{1}{15}$ are often necessary, yet they are entirely adequate if one uses a tripod. Longer exposures made with the B setting are frequently used, too. It really doesn't matter how long the exposure is. Objects sitting on tables or paper backgrounds aren't going anywhere, so you don't need fast shutter speeds to freeze their movements. Furthermore, even portraits can be made with speeds as low as $\frac{1}{2}$ or $\frac{1}{4}$ second. All you have to do is tell people to sit still or say nothing and wait for the moments of stillness that always occur naturally.

The figure was illuminated by bounce light striking it from both sides from below. The lights behind it were the mundane light sources one can see by looking out any city window at night. Putting them out of focus gave them a romantic and mysterious feeling. In sharp focus they would have ruined the picture.

● **Light-Source Size**

What a light source does to things is largely dependent on its size. The quality of shadows, for example, varies greatly with different sizes. Because shadows are of great importance pictorially, we'll look into what happens to them. There are two types: cast shadows and form shadows. The first are cast on surfaces by objects blocking off their light. Form shadows are on objects them-

selves on the surfaces that are turned part or all the way from the light.

Shadows create their pictorial effects through several means: their size, relative darkness, placement, shape, number, degree of connectedness with other shadows, edge quality, and so on. As you experiment with lighting you will gradually see what all these things do. The size of the light source mainly affects edge quality. It can create sharp-edge form and cast shadows, or soft-edge ones. In a given picture, the selection of type makes a considerable difference pictorially, for these types of shadow have very unalike qualities.

Sharp-edge form and cast shadows are created by small light sources, soft-edge ones from large sources. The sun, small in relation to our surroundings, creates sharp shadows. An overcast sky, which is huge, gives us extremely soft ones. A floodlight is relatively small, making fairly sharp shadows. However, if you point it at a wall, the wall itself (or part of it) becomes the (secondary) light source. Being larger than the diameter of the floodlight reflector, it creates softer shadows.

The percentage of the wall acting as light source depends entirely on the size of the circle of illumination created by the floodlight. If the light is up close it is small, but if it is far enough back it turns the entire wall into a source. Most walls are large enough to create shadows that are very soft indeed.

In this white-on-white picture everything has been sprayed with matte-white enamel. The grays and the strong tonal range have been created by the lighting (bounce light from the right). You can see that paint has turned cheap glassware and worn-out light bulbs into minor works of art. The shell didn't need this help.

● Shadows

Without shadows, sharp or soft, most pictures would be very dull. Without them, especially form shadows, things tend to look unreal. Absence of shadows can even make things disappear altogether. In the white-on-white experiments, for example, a certain shadowless lighting will make white objects almost invisible in the camera viewfinder. Unbelievable, but true.

Shadows, especially in pictures, help us see space. Remove them all and the space disappears. However, shadows can also confuse space in

Though this is a white-on-white setup, lighting has made gray the predominant tone. Can you look at the shadows and tell what kind of a lighting it was? Notice that the form shadows on the eggs have very soft edges; so do the cast shadows in the foreground. How many light sources were used? What are your reasons for thinking this?

A plastic doll and white candle in front of a black background. The challenge was to make the subject look as if it were illuminated from within. The light source for the picture, another candle, was hidden behind the subject, just the tip of its flame showing.

for yourself. Their very nature will make this kind of seeing much easier than usual. It is also why they were invented for students.

Shadows have an influence on visual complexity. Shadowless, a picture is as simple as its subject will allow it to be. Add a bunch of shadows and it gets much more complex. However, soft-edge shadows seldom complicate things much, whereas sharp-edge ones often do. They may even double or treble the number of shapes in a picture. This can make for great confusion, especially in black-and-white pictures. In color pictures the color itself helps sort out the confusion.

As a rule, photographers prefer soft shadows for almost all their pictures, for they reduce problems very considerably. In contrast, sharp-edge shadows are always a problem in themselves. For portraits in particular, soft-edge shadows are desirable. In consequence, photographers tend to limit themselves to fairly large light sources. Skylight has long been a favorite for portraiture, as have bounce and edge light.

Sharp-edge shadows can be especially disastrous on faces, which is why one should avoid small light sources, including the direct sun. These small sources also dramatize every minute textural detail on a face. Unless the skin is absolutely perfect this usually looks bad. Large sources diffuse these details, a cosmetically desirable effect. Sharp-edge shadows on faces frequently look like dark scars or paint slashes. When the whole figure is photographed they often create the illusion that its parts aren't stuck on right, for they tend to distort and twist form. All-in-all, one can do very well without small light sources and their sharp-edge shadows.

pictures, turning it upside down, warping it, or eliminating it altogether. The culprits in this case are nearly always sharp-edge shadows. Though the space distortion in a picture is usually only partial, it happens so often that we should always be suspicious of sharp shadows. In contrast, soft-edge shadows rarely distort space, though they frequently lessen it.

Form shadows in pictures can create the illusion of form, or volume, but they can also destroy it. Pictorially, both things are useful; sometimes you want volume, sometimes not. Soft-edge form shadows are by far the best volume creators, yet they can also be used to diminish it. Sharp-edge form shadows are consistent volume destroyers.

When we return to the white-on-white experiments I will tell you how to see all these things

This was essentially a white-on-white project, even
though the fair-skinned girl had brown hair and the
floor was oak-colored. The walls and the window
shade were bright white. The light source (small) is
behind the girl, of course, and it is the only one in
the room. The idea was to use light to create a certain
mood.

Two lightings of the same white-on-white setup.
Notice how the feeling of volume in the eggs differs
in the two pictures. In the top one they're solid and
round, in the bottom one flat and dimensionless.
Both pictures were made with bounce light, but it came
from different angles. As you see, the angle makes a
difference.

• Front, Side, and Back Lighting

The direction from which light strikes a subject makes a lot of difference in the pictorial effect. We generally describe the directions as front, side, and back lighting. Beginners generally use the least desirable, front lighting, because it is the most obvious thing to do with a floodlight. Front lighting doesn't give light a chance to do anything interesting, like creating form and space. Instead, it flattens everything out. Coming from behind the photographer (or from between him and the subject), front lighting illuminates things too fully, thus depriving them of their visual mystery. Thus deprived, many things are dull and uninteresting. Almost always it eliminates the "mood" from pictures.

As its name suggests, back lighting strikes the subject from behind, often creating a full- or semisilhouette effect. Sometimes you see just a bright line around the edge of the subject. This lighting is usually dramatic, because the picture contrast is high and there may be areas of dramatically dark obscurity on the subject. However, it is overdramatic for many types of pictures and the obscure areas too extensive. Beginners should experiment with it extensively, nonetheless, for it helps reveal to them the unexpected possibilities of photography. It also helps them break the bad habit of wanting to light everything from the front. Perhaps the most important thing to see is that visual drama can be created at will in photography.

Side lighting is by far the most useful type, especially if it is from a large source like the sky, a picture window, or a wall used as a reflector. It is very good for creating the illusions of form and space and controlling the degree to which they are realized. That is, you can have a lot of both, or just a little. Side lighting gives us strong control over the degree to which things are revealed or obscured; and this is very important in taking command of the medium. It enables us to control pictorial mood, which most photographers consider an absolute necessity.

An all-white arrangement of walls and ceiling,
illuminated by a candle on top of a white cupboard.
It should prove that brilliant tonal contrasts can be
created by light alone. It also shows that we can
create a predominantly dark picture with a light
subject. Through lighting we can get any tones we
want.

With all three lightings we can use direct, bounce, or edge light. Remember, I told you to avoid direct light until you really know your stuff. Used from the side or back, it can be interesting at times, but from the front it is a disaster. In all three positions, bounce light is pictorially the safest. Edge light has to be fiddled with quite a bit with each subject, yet it has interesting possibilities from all positions.

• Light-to-Subject Distance

The beginner usually plops down a light stand near his subject and lets it just sit there. The expert moves it back and forth a lot. If it is pointed at a wall or reflector, he still moves it around in as many ways as he can think of, to see what he can make it do to his subject. Since the wall or reflector becomes the source in bounce light, he experiments with various positions for the reflector or moves his subject nearer, or farther away from, the wall.

Sometimes, subject and light source should be nearly rubbing noses. At others, they should be far apart, even ten feet or more. The only way to see which distance works best is to try them all. I haven't tried to tell you exactly what effects you'll get each time you manipulate a light, for that depends a lot on your subject and its background. There can be no absolute rules. The important thing is to try positions, distances, types of light sources, etc., so that you can see for yourself. Even knowing that you can do these things will give you a good start.

You should be convinced that there are innumerable experiments to perform with a light. Whether you try them is up to you. Certainly,

A white-on-white setup of hard-boiled eggs with their yokes removed. There was one white cardboard on the table top and another on the wall three feet away. The single photoflood was between the two and below table level. This accounts for the strange lighting on the eggs and the blackness of the foreground.

Both black and white obscurity are mentioned in the text. You get the first by losing things in blackness, the second by losing them in whiteness. It can be done either through lighting or printing. These two prints from the same negative show the two kinds of obscurity and the different feelings they create in images.

you should not just plop a light stand down and let it sit there forever, the way some beginners do. You should feel compelled to do *something* with it, even if you have great difficulty in really seeing the effects it creates. Stick to this struggle valiantly, if you can, for it is the very heart of the problem of becoming a photographer. Eventually, you will find that you can see, a wonderful thing.

● Relative Obscurity

Though the terms are used loosely, light and lighting don't mean quite the same thing. Light is the raw energy we work with. A lighting is what we do with it. Light always reveals, if there is anything to reflect it. However, a lighting may obscure more than it reveals. For example, a candle by a tree in a night forest is a lighting, yet we can only see three feet of bark and the rest of the forest is invisible. A spotlight on a dark stage is also an obscuring lighting, for it reveals just one actor and obscures everything else. Replace it with a match and the relative obscurity is even greater.

Without relative obscurity, photography would have far fewer expressive possibilities. Thus, becoming a photographer means learning to manipulate it, to make things more or less obscure at will. We should know how to reveal things as much as possible, obscure them to the same degree, or place them anywhere else we like in between. This is one of the most important skills involved in picture control.

There are several ways of obscuring something in a photograph. One is to underexpose the thing in the print, so there is nothing to see but white or very light gray. Another is to throw it far out of focus when photographing it, so that it turns into an undefinable blob in the picture. In printing, the thing and its surroundings can be burned-in to a full black, making it very obscure indeed. Cropping some of it off with the printing easel will make it partly obscure.

Though photographers use these methods a lot, their most important tool is lighting. An expert in lighting can make things as obvious or as obscure as he wishes. You will seldom need to totally obscure or totally reveal an object, but will always want it somewhere in between. The nuances of placement have a large influence on the success of pictures.

In general, large light sources reveal things, a bright overcast sky being one of the best examples. Striking a subject from just one side, large sources reveal less, for there are obscuring shadows. From the front, large sources reveal nearly everything.

Because they cast dark, sharp-edge shadows, small light sources obscure things a lot more

Though it seems not, this also was a white-on-white setup. The white-plaster head was near a white wall in one room, and the bright area behind it is a wall in another one. The large gray area shows details of a connecting hallway. The challenge was to use selective obscurity to make the sculpture come to life.

A picture made at night in a white-walled room, demonstrating that black obscurity is indeed easy to create if one knows how. It can be both dramatic and pictorial. The simple secret of making something black is to not let any light, direct or reflected, fall upon it. Blocking it off is the main problem.

The homemade spotlight mentioned in the text was used to make this picture. It shows that spotlights create selective obscurity with ease and that they can simplify subjects greatly. There is visual drama, of course, and a detached and eerie feeling. It should be obvious that a lighting creates both black and white.

than large sources. Not so much from the front, but from the back or side. Small sources in the form of spotlights obscure even more, for light is channeled into a beam that illuminates only the objects it is aimed at. Everything else is consigned to black obscurity.

Using a spotlight is a good experience, because it proves beyond a doubt that a lighting can create and control obscurity. However, it tends to make pictures overdramatic and is thus of limited use. You can make one by wrapping a foot-long cylinder of black paper around a 15-watt light bulb (a larger bulb would create a fire hazard). With this spotlight you can see all the basic effects and even take pictures, if you wish.

In learning to control relative obscurity it is best to work with side lightings, using medium to large light sources. Bounce light is good for this, because you can control its size by varying its distance from the wall. Combine this with varying the distance of the subject from the same wall; this will vary the lighting contrast.

• Contrast Control with Light Reflectors and Absorbers

An important factor in obscurity control is lighting contrast, which hasn't been mentioned before. High contrast with side or back lightings obscures things. Low contrast in all lightings reveals them. Mainly through contrast control we place things where we wish to on the revealed-obscured continuum.

One of the main reasons for working with just one light is to simplify the problem of seeing lighting contrast and learning simple ways of controlling it. Though an additional light can be used to control the degree of contrast, it isn't necessary. Furthermore, it would befuddle the beginner's head so that he wouldn't learn to see what either of his lights was doing.

Imagine light striking only one side of an object, leaving the other side in total shadow. The tonal difference between the two sides is called lighting contrast. The side with no light at all will look entirely black, even if the subject itself is light in tonality. Obviously, I've been describing a very high lighting contrast. It can be reduced simply by making some light strike the dark side. There are numerous ways of doing it. One way is to point another light at the dark side of the object. By moving it close or pulling it back, we can get any desired degree of lighting contrast, or eliminate it altogether. Though effective in contrast control, the second light is not desirable for a number of reasons.

Another way to reduce the contrast is to *reflect* some light onto the dark side. For this we use a light reflector, which isn't necessarily a special device for photographers only. A reflector is anything that reflects light; it's as simple as that. Most things do in some degree, even a piece of coal. Naturally, the best reflectors are things of light tone, preferably white, though light colors are also all right.

Walls are usually good reflectors; if they weren't, homes would be very dismal. Sheets and light-colored towels reflect well, as do white rugs and blankets. Aluminum foil that has been wadded up, then straightened out again, is popular with photographers. White window shades are often used. So are pieces of ordinary white paper or cardboard. The cardboards are especially useful when you are working with table top setups, because you can prop them up on the table near your subjects, just out of camera sight. Sometimes pieces only two or three inches square are useful as reflectors.

The degree of contrast on the subject depends on the closeness of the reflector and the amount of light striking it. Unlike a second light source, the reflector cannot entirely eliminate contrast. Since this is not desirable anyway, it is nothing to worry about.

You may find it hard to understand how reflectors are secondary sources of light, that light is actually coming from them. It isn't enough to know they wouldn't look white if this weren't so. Only direct experience will illustrate the point.

One way to see it is to point a light at an object and bring it very close. The other side will then look very dark. Next, bring a white cardboard up close to the dark side, positioning it to aim at the object but catch the full brightness of the light, too. You will see a dramatic lightening of the dark side. If you still need convincing, remove the card and put it back again several times, watching the object all the while. Until you've tried an experiment like this you may not believe that a reflector actually reflects.

It is even more difficult to see that a room is a multifaceted reflector: four walls, a ceiling, and a floor. Using all these reflecting surfaces we can create many lightings; it is just a matter of moving the floodlight around—here, there, up, down, sideways, etc. Contrast can be manipulated by the subject's positional relationship to the walls. For example, if you bounce a light from a wall and have the subject close to the light that is reflected, the contrast will be high. However, if you move the object slowly toward the opposite wall it will gradually lose contrast, because light reflecting from this wall will "fill in" the shadows. It does this even though there is no light source near it, for white or light-colored walls pick up light very readily. Experienced photographers use this knowledge about walls all the time.

Occasionally, we wish to reduce contrast entirely and eliminate as many shadows as possible. Using the room as a multifaceted reflector, there is an easy way. Standing in front of his subject, the photographer merely points his light back over his own shoulders, aimed partly at the ceiling and partly at the wall behind. This does a very effective job of flattening the lighting on the subject and filling in all the shadows. Because of the way light is reflected from the walls, ceiling, and floor, it strikes the subject evenly on all sides.

Sometimes the walls reflect more light than we like, for example, when we want our subject to have deep shadows. By reflection, the walls fill in the dark areas and we must find ways to stop them. This is the time to use a light absorber.

Placed near the subject, it makes one side perceptibly darker, because it blocks off light reflected from the walls and refuses to reflect any light itself.

Anything that is dark in tone is a light absorber, though this is hard to believe. It is dark *because* it absorbs light instead of reflecting it. We tend to think a black object is black because it is black and don't comprehend that it does something to light. It actually soaks up light like a sponge. As you've seen, there are times when this quality is useful in photography.

Black paper and cardboard are convenient light absorbers. Black cloth is good but not quite as adaptable. For the ultimate in blackness (light absorption), black velvet is the thing. In a pinch, one can use any dark thing that is available, even an overcoat. In some studios there are flats (small, movable walls) that are painted black on one side and white on the other. They help photographers reflect or absorb light at will, working very swiftly if they wish.

Bear in mind that this information on light reflection and absorption is mainly concerned with contrast control and that one of the important reasons for it is to control relative obscurity. Another significant effect is volume and space control. With no contrast, the feeling of space or volume in pictures is diminished or even obliterated. With too much contrast, the same thing may happen. However, just the right amount of it, in the right places, can create very strong illusions of volume and form.

• Evenness of Illumination

A lighting is said to be even if the light striking the subject is of the same intensity at all points. Sometimes this is desirable, sometimes not. In discussing the light pattern of a floodlight, I said that it is bright in the middle, gradually fading out toward the edges. Though the gradation is smooth, it still gives us uneven lighting. The photographer uses this smooth unevenness for pictorial effects.

The purpose of these two white-on-white pictures is to show that light can both create and destroy space (depth, distance, dimension). Except for the lightings (and the elephant) the pictures are identical. The above one was made with bounce light, with a light absorber on the other side. For the picture on right, light was bounced from above and behind the camera position.

The challenge was to photograph five eggs, making one dominant and the others subordinate. Through lighting and clever arrangement, it could have been done in a white-on-white setup. However, a different approach was used. Four eggs were painted gray to match a gray background. Naturally, the white egg was bound to dominate.

He even increases it considerably when he uses edge lighting.

The light pattern can be made very even if the floodlight is backed away from the subject; the greater the distance, the more even the illumination. Conversely, the closer the light the greater the unevenness. Front lightings, with bounce or direct light, with small light sources or large, can be made extremely even. Sunlight, open shade, and a bright overcast are the very best sources of evenness.

Because I've mentioned the subject, some readers will soon get themselves hung up on evenness, struggling to get it all the time in their lightings. There is no better way to limit oneself as a picturemaker. Evenness of illumination is good *sometimes,* but definitely *not* always. As a general rule, unevenness is much more useful.

The greatest need for even light is for making photographic copies of charts, posters, paintings, photographic prints, etc. Without it, prints come out with unsightly tones in the wrong places. They really look scruffy. However, when one is aware of the illumination problem and its simple solution, it is very easy to make good copies. Those in doubt should go outside and use the sun, open shade, or an overcast sky for making their copies. In sunlight, the copy material should be approximately perpendicular to an imaginary line drawn to the sun. If sunlight strikes it from the side it will emphasize all its surface defects; illuminated by a small light source, they cast unsightly shadows.

Sometimes we want even lighting in part of a setup, but not all of it. It is usually the background that we would like that way. Getting the background illumination *fairly* even is usually sufficient, because we can easily go the rest of the way by burning-in or dodging while printing. For some types of lighting this is necessary anyway, for example, side lightings with large light sources; there is almost always an unavoidable lighting fall off from one side of the set to the other. Often, such pictures look better if the background tone is *not* evened out, for the very unevenness may create a feeling of light and light direction that is very pictorial. In printing, the degree of this unevenness is easily controlled; one can have as much or as little as he likes.

Judging the evenness of illumination on a set is trickier than one might suppose, so that it is wise to depend on an exposure meter (as a brightness measuring device). To illustrate the problem, on a setup four feet across, the light on one side of the background may be two, four, or even eight times brighter than the light on the other side. At the same time, the photographer may not notice this difference, even though he is looking very hard to see it, it is there. Though it sounds ridiculous, this unevenness is quite common. It helps explain why experienced photographers check the corners of their sets with exposure meters. They can then make dozens of prints from one negative, without having to waste time on burning-in and dodging. With the light balance perfect in the setup, further tonal manipulation at the printing stage is unnecessary.

Though it is dangerous to generalize, there is an all-purpose trick you can use. There are few times when it won't work for pictures made with indoor setups, especially with simple backgrounds like a wall or paper. Either in your lighting or your printing, match the top two corners of your picture. Also match the bottom two. It is seldom necessary for the tones of the top corners to match the bottom ones. For unknown reasons, people like this tonal matching in their indoor pictures. But it is a studio trick that can become monotonous if used in every picture you make, indoors and out.

● **Separation**

Separation is one of photography's favorite terms. It refers to the tone difference (contrast) between two things that overlap in the camera viewfinder—for example, an object and its background. A substantial tone difference is called

good separation. Little or no difference is called poor separation.

Far more often than not, it is good to have separation between all the overlapping things in a picture. When it is absent, things blend together in the print, spatial relations are confused and space lessened, and the apparent volume of objects diminished or destroyed. Things may even lose their identity. All of this ruins visual clarity in pictures.

The causes of separation are lighting and the natural difference in tone of objects. For example, two things of identical tone will separate easily if one is more brightly illuminated than the other. In even illumination, a gray object separates easily from black or white things.

In natural-light photography, separation is seldom a problem, for natural-light patterns are usually of fairly even intensity. However, when a problem does exist, little can be done about it except to look for another picture. In controlled-light photography, separation is frequently a problem, yet it can be solved easily through light manipulation.

In an even-light pattern, things usually separate themselves, because of their natural difference in tone. Variable-intensity light patterns (from a floodlight, for example) often blend things of a different tone together. To illustrate, if a light object is placed in front of a darker one, they will separate easily if they receive the same amount of illumination. However, in a variable-intensity light pattern the darker object may be more brightly illuminated, making it match the lighter object in tone. Naturally, this is called poor separation, or a blend.

In the white-on-white experiments, that begin on page 104, the separation problem is artificially exaggerated, because everything on the set is white and there is no natural tone difference to separate things. The only tool for creating separation is the light-intensity differential. At first, you may see this problem as hopeless. With enough experience, you'll see you can create good separation at will and that by exaggerating the separation problem you are able to find all its solutions.

Offhand, one would think that having things of different color and tone in a picture would automatically solve the separation problem, but it just doesn't work out that way. I've said that the intensity of light striking an object will affect its tone; the angle of illumination will do it too, for it affects the degree of light absorption.

In sunlight or open shade the illumination angle is no problem; things are all illuminated from the same angle. In a controlled lighting, the light source will not only be closer to some things than others but will strike them at different angles. For both reasons, the separation between lighter and darker things often disappears, and if one isn't looking for it he may not see it. It shows up strongly in prints, when it is too late to correct the problem.

Photographing things of different colors will guarantee separation only if we are using color film. With black-and-white photography it is no insurance at all. In this case, tone difference is all that counts. Black-and-white work makes it necessary to see colored things in terms of their tone, intentionally disregarding their hue and brilliance. It is hard to do this, especially with very strong colors, for we are so distracted by their vibrancy we can't decide whether they are dark, medium, or light in tone. However, our film can; if colors don't separate tonally it will automatically blend them together.

It is usually good to have the majority of the overlapping areas in a picture well separated, but have quite a few tonal blends, too. Most of the illustrations show this. It's just that the latter shouldn't predominate. A little blending here and there adds space to a picture and volume to the objects in it. Separation and blending work as a team. Separation for its own sake is not good. If you have it all the way around the edge of everything it usually creates a strong feeling of artificiality, as if things were pasted onto the picture.

For the student, the important things are to be aware of separation as an element in pictures, to learn to see it, and to try to comprehend its pictorial effect. It is not something to worship, as many photographers do, but a useful tool to be used in two directions. That is, one should learn how to both increase and decrease it, for each effect can be useful in picturemaking.

• Tone Is Relative

We strongly tend to believe that the source of an object's tone is the object itself. It is a primitive way of thinking developed early in life. We say a thing is dark because it *is* dark or light because it *is* light, and that's all there is to it. This explains nothing, of course. There is actually only one source of tone: light. By falling on things, light creates their tone; and as light intensity changes, tone does too. Thus the objects in our world are changing tone all the time, because light intensity is constantly varying, affected by time of day or year, weather conditions, indoor or outdoor environments, etc. We are strongly aware of the light variations but only casually aware of how they change tone. The photographer should make himself acutely aware of tone change, though it isn't easy to do.

For the beginner, the problem is to see that a black cat isn't always a black cat, a challenge trickier than it seems. According to how he is illuminated, it is sometimes black, more frequently dark gray, and occasionally medium gray. Though we always see it as black, the camera sees the variations. Depending on his tonal environment, it can even see the cat as a light gray.

Stated another way, the problem is to learn to see that the tone of an object is relative to light intensity and the object's reflection-absorption characteristics. The latter is easy to see; we know very well that a black cat is black (high light absorption, little reflection), a white rabbit white (high reflection, little absorption), and a gray

goose gray (average reflection and absorption). The difficulty is that the cat, the rabbit, and the goose are changing tone all the time and we hardly see it.

One of the reasons is that we usually see things in familiar contexts. That is, we experience the same things and environments each day. Part of each context is a light-to-dark tonal hierarchy into which everything fits. We see each thing in terms of this tonal context and decide whether it is light, dark, or medium in tone. However, the label we give it is relative only to the context, not to the actual amount of light being reflected at a given time. We are little interested in the fact that the entire group of things shifts up and down in tone with variations in light intensity. As long as things within the group keep their places in the tonal hierarchy we are entirely satisfied.

If we can make ourselves more aware of tonal contexts and learn to think of tone as relative, it greatly helps our understanding of light. Through variable-intensity lightings, tonal contexts can be changed considerably. The tonal relationships of objects within the context naturally change, too. Thus, in a particular lighting a gray duck becomes white and a white rabbit gray. The camera viewfinder confirms it and so does the final print.

Though what I've said may seem self-evident, it isn't when you try to see it happening. For many years I've watched students struggling with the problem. One has to work hard and cleverly to irrefutably prove to himself that the tone of an object is mainly dependent on the intensity of the light falling upon it.

Mechanically, it is simple to set up the proof. For example, it is dead easy to put, say, a sugar lump in front of a sheet of black paper and make a picture in which the sugar is dark gray and the background dead white. From near the camera they will look this way, also through the viewfinder. The final print will strongly confirm it. All this evidence should certainly prove that a white thing has turned gray and a black thing

white. Nonetheless, people can't see it while they are staring right at it.

Considering all the information given on light and lighting, you should be able to guess how to do the sugar-lump experiment. Put the sugar on a black piece of paper and separate sugar and black background by several feet. Turn out all the lights but one photoflood, which should be close to the background paper and pointed right at it. Be sure that none of its light hits the sugar. Surround the sugar lump on two sides and top with black paper. You can make it dark gray, and with a little fiddling, you can even make the sugar as black as coal. Your problem is in believing what you see.

Except for forcing yourself to see something, it is not especially useful to know how to make black sugar lumps. The important thing is to know how to make *subtle* tone changes and to clearly see them happening. Even knowing that tones *can* be changed at will is a great help. Obviously, the primary tool is light. Increase its intensity in part of a set, the tone is lightened. Decrease the intensity and the tone is darkened.

One of the primary reasons for the white-on-white experiments is to see without a doubt that tone is mainly relative to light intensity. By doing the lightings you will create a multiplicity of tones —from black through a variety of grays to white —in settings that are entirely white in nature. These tones will be inescapably there and their relationship to light intensity will be equally inescapable. Let us hope you don't escape the inescapable by refusing to see it when you are making it happen.

To make sure that everything started out as a flat white in this setup, I sprayed the bread slices with white enamel. The center of the light pattern was on the background, only its edges striking the bread and the figurines. My idea was to show that a dramatic, dark picture can be created with a white-on-white setup.

• **Cast Shadows for Light Control**

In the foregoing sections you learned that light of variable intensity is very useful for controlling tonal relationships. The light source recommended, a single photoflood, casts an illumination pattern varying from bright in the center to very dim at the edges. With this variation alone, a tremendous number of things can be done. Bounce and edge light offer many additional possibilities. Nonetheless, it is desirable to have even more control over lightings.

Cast shadows are frequently useful for control; by falling on part of a subject they darken it relative to the other parts, a fact quite obvious. It is less obvious that the darkening can be so subtle it doesn't even look as if shadows were involved. Though shadows that look like shadows are sometimes useful, subtle shadows can do a lot more things.

Subtlety depends on the location of the shadow caster (the object that obstructs the light) relative

A white egg with white pushpins on a white table top in a white-walled room. The light comes from the window, which is out of focus behind the egg. This picture makes it obvious that a lighting can create blacks as well as whites. It should also be clear that black is merely the absence of light.

to the light source and the subject. If it is very close to the light source and well away from the subject, it will create subtle shadows with very soft edges. They won't even look like shadows especially, but they will effectively alter tonal relationships in the set. They can be made large or small, depending on the size of the shadow caster.

Shadows become less subtle as the light source is moved back from the set and the shadow caster toward it. We reach a point where they are very dark with sharp edges. Though they are obviously shadows then, they can be very useful at times. Whether one should use obvious cast shadows depends mainly on what the lighting is already doing to the subject. If there are strong shadow patterns, additional sharp shadows wouldn't be unduly noticeable. A carefully positioned shadow caster of the right shape will create shadows that will fit in well with those already there.

Anything that blocks light can be used to cast shadows. In small setups, one can often use a book stood on end, controlling the width of the shadow by angling the book. For larger shadows, sheets of cardboard are useful. One can use a simple dodger, like the type used in printing, but much larger. Some photographers put them on light stands and call them head screens. Sometimes a photographer makes a shadow with one hand, using the other to trip the cable release. I've even seen people used as shadow casters.

For subtly darkening large areas, it is often good to work with shadow casters close to the light source, or even fastened to it with tape or clothespins. For this purpose, sheets of light cardboard are very convenient, either whole or cut into smaller shapes.

● The Peephole-and-Squint Trick

Only an experienced visual artist can look at something and easily see all the things that light is doing to it, and even he can't do it all the time. Occasionally, he has to rely on tricks to help him.

Beginners need them most of the time, once they've learned how to use them. The most important ones have been around for years and are thoroughly proven.

One of the reasons we can't see very well is that there is much too much happening in our visual environment. When we try to see an object or visual quality we are distracted by dozens of other things bidding strongly for our attention. It happens indoors and out, and even if we are looking at an isolated object sitting on a paper background, the distractions are invariably there in quantity. Furthermore, parts of an object may prevent us from seeing other parts, or within a given part conflicting visual qualities may confuse our perception. Worst of all, we are not even aware that all these distractions exist, though without our knowing it they plague us all the time. They make us relatively blind to the world we live in.

The solution, of course, is to temporarily eliminate distractions from our field of vision, since they are making it difficult for us to see. Though there are numerous ways to do it, the easiest is to use the fingers to make a peephole to look through. (The opening should be about the size of a dime.) When we look through it, most of the visual environment is excluded. The trick is to have one eye closed and the one at the peephole squinted nearly closed.

Squinting through the peephole, a photographer examines his subject several times area by area, each time concentrating on a different visual quality. One time color, the second time contrast, the third time separation, etc. Dividing the subject into areas and separate visual qualities helps you see each of them better. Though he also tries to see it as a whole, it is a much more difficult problem.

The reason for squinting is to eliminate some more of the visual distractions. In squinting we look through our eyelashes, which then obscure eye-catching details. This frees our attention to devote itself to other things. It helps us see shadow patterns, contrast, the tonal relation-

ship of colored objects, composition, the edge quality (sharp or soft) of shadows, tonal blending, and separation. It also helps us see which parts of a subject are visually dominant (very eye-attracting) and which are subordinate (making little bid for our attention). Squinting can be used with or without the peephole, for both serve the same purpose. One can also learn to do it with both eyes at once, though perception is more complex that way.

At first, using the peephole and squint trick doesn't help very much, because we let our attention wander a lot and don't quite know what we are looking for. It is also hard to squint steadily for periods of twenty or thirty seconds with the eyes closed exactly the right degree. Learning to concentrate is the more difficult task, but using the peephole trick helps us to do it. This is good, for learning to see is largely a matter of bringing wandering attention under tight control.

A person teaching himself to see should be squinting much of the time. It takes strenuous effort and the eye muscles get very tired. However, no harm is done and one gets used to it. There is no escaping the fact that very hard work is necessary for developing better vision. Perhaps the hardest part is to decide what one is looking for.

• The Picture-Frame Trick

Some photographers use black paper or cardboard frames for viewing their subjects. Like peepholes, frames isolate things from surrounding distractions. They can be used with the eye either open or squinted. If a frame is held motionless in front of a subject, it gives the feeling of looking at a framed picture, especially if the head is also motionless and one eye closed. With the image neatly isolated, it is easier to look at it analytically.

The effect is like looking through the camera viewfinder, but the frame is much faster to use. If the camera is on a tripod, using the viewfinder to examine the subject from different positions is a very cumbersome process. The image in the paper frame is also much larger and easier to see. Lighting phenomena that might escape attention in the viewfinder stand out clearly in the frame.

A convenient size is an 11 × 14-inch cardboard with a 4 × 5-inch rectangular hole cut in it. It should be neatly cut, or the frame itself will distract attention, the very thing we are trying to eliminate. Holding the frame close to the eye gives us a wide view, at arm's length we get a narrow one. For an area-by-area check of a subject, we move up close to it with the frame held at arm's length. We use the frame in basically the same way as the peephole and try to see the same things: shadow patterns, contrast, separation, etc.

When using the various tricks for examining a subject it is important to stand along the line of sight of the camera lens, either in front of the camera or behind it. We want to see the same things that the camera does. If we examine the subject from the side we get a poor idea of how the picture will come out and can make big mistakes in our lighting. For example, overlapping parts of the subject may be well separated when viewed from the side but totally blended together in the viewfinder. For many pictures this would spell disaster, and other things equally bad could happen. So always stay near the lens axis when sizing up a subject. It is hard to remember at first, but one gets used to doing it in time.

• Polaroid Check Pictures

For those who can afford a second camera, a Polaroid Land camera is very good to have. Professional studio photographers often use it to check their exposure calculations, compositions, and over-all lighting patterns. Though one could make area by area checks on a subject by making numerous Polaroid close-ups, it would be a very expensive procedure. It is best to make just one shot of the entire setup to get an impression of it as a whole.

Sometimes, a photographer has several lightings in mind but can't decide which one he likes best. If he takes a Polaroid of each he can compare

them side by side, instead of relying on his memory of what they all looked like. Most people's visual memory is rather poor, and this includes photographers.

Polaroid shots are too small to be of much use in seeing details, but their very smallness makes them very good for seeing the over-all light and shadow pattern, composition, cropping, and the illumination balance from one side of the set to the other. Sometimes such things are harder to see in larger pictures.

• The Moving-Light Trick

We all know that moving things attract our attention and that it is hard to concentrate on things that are sitting still. These facts can be applied to the problem of seeing what light does. When we've made a lighting on a set we may shirk analyzing it carefully. It is very hard work for the eyes and they rebel. However, if we swing the light source back and forth, the resulting movement in the light and shade patterns makes it easier for the eyes to concentrate on what light is doing to the subject. The movement also shows us a variety of lightings to choose from.

If we do two lightings at 10-minute intervals, it is hard to compare them for quality. The visual effects of the first one have slipped from memory. However, if we move the light source rapidly from one to the other, comparison is much easier. It is also less fatiguing. We must always remember that learning to see is very hard work, sometimes to the point of causing nausea, and do what we can to make it easier for ourselves.

Though the moving-light trick is used for comparing different lightings and make seeing less laborious, it is also excellent for the same things as the peephole, the frame, and the Polaroid picture. Movement as such attracts our attention to all the effects created by light.

The tricks can all be combined in various ways. If one of them isn't working well for you, try it with another. Say you are using a frame in an attempt to see the separation in a part of a

setup and are having no luck at all; the separation is there but you can't see it. Start moving the light source. It constantly increases and decreases the separation, making it easier to see—especially through a frame. Or say a moving light source isn't making things clear to you; squinting may be just the addition needed. In fact, the two tricks are often combined.

You must understand that trying a trick only once or twice won't do a thing for you and that each time you use it you should repeat it many times. Even a lighting expert does. Using the moving-light trick on a difficult and unfamiliar subject, you might switch the light back and forth twenty or thirty times. This gives you ample opportunity to analyze your subject and see everything that light does to it. With a familiar subject you may have to move the light only four or five times, however.

Repeating a trick many, many times is especially important for the beginner, because you still don't know for sure what you are looking for. With sufficient repetition, the trick itself helps you learn. This is naturally very fatiguing at first, but it is the price for learning to see.

• The On-and-Off Trick

This trick is useful when you are using more than the one light source recommended for beginners. The problem with a second (or third or fourth) light source is that an inexperienced photographer can't see what it does to the light and shadow pattern already created on the subject by the first light. In consequence, the additional light source destroys all the good qualities carefully created with the first one.

However, there is a simple way for learning to see what the second light is doing. It is to snap it on and off many times while making an area-by-area examination of the subject. One looks for *changes* in shadow pattern, contrast, separation, dominance and subordination, etc. With all the tricks we look for the same things; it's just that there are different ways of doing it.

It is generally a good idea to combine this trick with squinting through a frame or peephole, though experienced photographers usually just squint. They do it automatically whenever they are creating lightings.

The tricks I've described are the main ones used in photography. With practice, you can learn what you are supposed to see with them, then learn to see it well. The over-all objective, of course, is to learn to see light.

• Some Observable Qualities of the Visual World

One of the beginner's toughest problems is to learn what to look for when creating lightings, using available light of various kinds, choosing and arranging subjects for pictures, using tricks for seeing better, making prints, etc. In all these cases you are looking for the very same things, but don't know what they are. Ignorance makes learning to see a laborious and frustrating problem. However, when you have learned what to look for, the task is much easier. This book can go only so far in helping you, because seeing and understanding depend so much on personal experience and inner growth.

Many of the visible qualities that light creates in things have already been discussed. Most of them can also be observed in photographs. They are being repeated now in concise form, as well as some not mentioned before, which will be discussed at greater length.

The qualities differ considerably, for some can be measured objectively, while others can only be assessed subjectively. We could call the former "objective visible qualities," for they can be measured or mapped with instruments; and many people can observe them and arrive at identical conclusions concerning what they've seen. Some examples are separation, contrast, dominance, and visibility.

We could call the others "semisubjective visible qualities," because the observer is always a part of the thing observed. That is, these qualities are simultaneously things in the visual world and reactions to them in the observer. This complicates the problem of learning how to see, for it means having to turn one's attention inward and outward at the same time. Though it would simplify matters to dispense with semisubjective visible qualities, it would also make it impossible to learn to see. We cannot eliminate the subjective factor, for seeing the world involves seeing oneself, and vice versa.

Some of the semisubjective qualities are beauty, pictorialism, and clarity. Though they are things that we can see, our perception of them is strongly influenced by experience, taste, and sensitivity. Thus, people's reactions to them vary. We can say that such qualities have both subjective and objective components. For example, an object is beautiful only because people think that it is (subjective), but it has certain visible qualities that make it that way (objective). However, not everyone will agree it is beautiful (subjective).

Listed below are forty visible qualities in pairs, each of which is a continuum. If you always think of them this way it will help you to see. For example, you should remember there are all degrees of separation and blending, sharpness and softness, contrast and flatness, etc. In handling light, the objective is to create the degree of, say, contrast that satisfies the requirements of a given picture. It could be a lot or very little, for there is nothing good about contrast as such. It is merely a visible quality that can be manipulated for a variety of reasons.

The photographer's problem is to place visible qualities in suitable places on their continua, not to try to move them to the extremes. For example, pictures seldom need extreme contrast or flatness, for something in between is usually more appropriate.

The pairs are not opposites in terms of their "goodness" and "badness," though it may appear that desirable qualities are paired with undesirable ones. Certainly, we prefer clarity to confusion, strength to weakness, and beauty to ugli-

ness. However, confusion, weakness, and ugliness can make important contributions to pictures. Indeed, some pictures wouldn't make any sense without them.

Usually, both sides of a continuum are in a picture, each acting as a foil for the other. For example, a static surface helps a dynamic object, unimportant subordinate things help an important thing achieve necessary dominance, and so on. The problem is not to rid pictures of opposites, but to use them well. Playing opposites against each other is an important part of the photographer's art. It involves learning to move at will in either direction on all of the continua.

Light is not entirely responsible for the visible qualities, because things make their own contributions, too. Skillful lighting will not make a thing of beauty of a dead crocodile, but it will help us tolerate it. It can't make a beautiful woman look like an old witch, though it can dim her glory somewhat. The important thing is that lightings have an affect on all the qualities listed.

All the continua interrelate and overlap, so that working on one of them, say, contrast and flatness, may affect ten others. If a person is adjusting the contrast of a subject he should watch how the other things change, too. Though this complicates the problem of learning to see, we learn to live with it in time.

- **Visible Qualities, Objective and Semisubjective**

1. separation—blending
2. contrast—flatness
3. dominance—subordination
4. sharpness—softness
5. simplicity—complexity
6. volume—flatness
7. space—two-dimensionality
8. visibility—obscurity
9. clarity—confusion
10. diffuse—specular
11. heaviness—lightness
12. strength—weakness
13. obvious—subtle
14. dynamic—static
15. evocative—non-evocative
16. pictorial—non-pictorial
17. reality—unreality
18. beauty—ugliness
19. interesting—uninteresting
20. rational—irrational

Working by itself, the ceiling light would turn this man into a silhouette, for it is well behind him. However, the candle is just barely strong enough to lighten his face and pick up highlights on his hands and clothing. Nonetheless, there is still a semisilhouette effect, which separates him from the background.

This young actor was lit by a very large light source:
a huge skylight. Such a lighting is very, very flat. It
gives the many form shadows on his face such soft
edges that they don't even look like shadows at all.
It also eliminates lighting contrast to a large degree.
However, we have "natural" contrast here.

1. *Separation and blending:* The degree of tone difference (contrast) between things that overlap in the viewfinder. Separation and blending can be changed by using another angle of illumination, changing the distance between the things that are overlapping, choosing between an even or a variable-intensity light pattern, and using reflectors, light absorbers, or shadow casters.

2. *Contrast and flatness:* The degree of tone difference between parts of a subject. High contrast generally comes from small light sources (including spotlights), side lightings, and lack of fill light from reflectors or walls. Flatness comes from large light sources, front lightings, and maximum reflection from walls or reflectors on the shadow side of the subject.

3. *Dominance and subordination:* The degree to which things attract and hold our attention. Dominance depends a lot on uniqueness; the more unique things are to us the greater their attraction. Subordination leans heavily on familiarity and similarity. A thing that we're used to, that is surrounded by others like itself, doesn't attract the eye. Lighting can make a thing *tonally* unique or similar to other things in its environment, thus affecting the degree of its dominance or subordination. The two qualities work as a team. The usual idea is to make important things dominant, less important ones subordinate. Subordinate things act as a foil for those that are dominant.

4. *Sharpness and softness:* This category is concerned with the apparent sharpness of subjects, not of images. Apparent sharpness is strongly influenced by contrast and the edges of cast and form shadows. Small light sources create dark, sharp-edge shadows and high contrast, thus causing an over-all feeling of sharpness. Large light sources create lighter shadows, softer edges, and lower contrast, causing a feeling of softness. The ultimate in sharpness would come from an infinitely small light source, the ultimate in softness from a very diffuse one large enough to entirely surround the subject.

From the very soft tonal gradations on their faces, you can tell that the lovers were being struck by light bounced from somewhere in the room. The bright spot comes from a table lamp behind them. The wallpaper was extremely garish, but the dim light toned it down very nicely. We call this effect "subordination."

5. *Simplicity and complexity:* The simplicity or complexity of a subject is mainly determined by the number, size, and variations in contour of the shapes it contains. Objects are shapes (or groups of them). Shadows are also shapes, though soft-edge ones are sometimes so subtle we can barely see them as such. Sharp-edge shadows (from small light sources) are easily perceived as shapes and usually add to the complexity of a subject by increasing the number of shapes in it. Soft-edge shadows (from large light sources) contribute to simplicity, especially if they are very light.

Bounce light coming from above and behind the camera removes nearly all shadows; if all parts of the subject are of the same natural tone, the simplicity is nearly total. A lighting that

makes most of the shadows join together is also a simplifier, for it diminishes their number. Though it causes sharp shadows, a spotlight can simplify greatly by leaving almost everything obscured in deep shadow.

6. *Volume and flatness:* Depending on what light is doing to it, a solid opaque object may look either like a volume or a flat shape. Though we *know* it is a volume, it doesn't always *look* like one. In photographs especially, objects can look as flat as pancakes, which may or may not be desirable. To convey a strong feeling of volume, an object should be quite a bit lighter on one side and well-separated from its background. There should be a smooth tonal gradation from light to dark, not a sharp break between highlight and shadow.

Side lighting with medium to large light sources usually creates the feeling of volume. Most front lightings and all low-contrast lightings create flat-

A white body, white walls, and two white candles—but we have a dramatic picture that is predominantly black. Because they are small light sources, candles create strong shadows and high contrast. Though they are a lot of fun to work with, one needs an ultrasensitive meter like the Luna-Pro for reading exposures.

ness. By creating sharp-edge shadows, small light sources often cause subtle optical illusions that confuse or distort the appearance of volume.

7. *Space and two-dimensionality:* Settings or scenes may appear to include more or less space (or depth or distance) than they actually do. The appearance can range from infinite space to total two-dimensionality.

The things in a picture affect its feeling of space. Objects with a strong appearance of volume contribute to it, flat objects to two-dimensionality. Side lightings with fairly strong contrast add depth to a setting or scene, though too

The lighting situation in this large, bare room was utterly desolate—except for the soft glow of light on the floor. As a photographer, I recognized the floor as my salvation and decided to silhouette my model against it. When one sees light doing something interesting, he should always take advantage of it.

much contrast can destroy it. Little or no lighting contrast leads to flatness, or two-dimensionality. Therefore, a broad light source surrounding the subject or right in front of it will make it very flat.

8. *Visibility and obscurity:* When we are shooting pictures, everything is usually very discernible to us, though the tonal range in our subject may be as high as a thousand to one. We can easily see into the brightest highlights and the very darkest shadows. Photographs won't record all we see, however, for they have a much shorter tonal range. This means that dark things may disappear into blackness in the print, light things into whiteness. Though this is sometimes inconvenient, it gives you the opportunity to let people see only what you want them to.

Through control of lighting, you can make things visible or obscure to any degree you wish. You can lose them in whiteness or blackness, or place them anywhere you like in between. Where you place them depends on their function and relative importance in the picture. Two of your main controls for visibility and obscurity are lighting contrast and the angle of illumination.

9. *Clarity and confusion:* Numerous factors determine whether a picture is clear or visually confused. Lighting is one of the important ones. If a subject is visually confusing to start with, a lighting that creates numerous sharp-edge shadows and intricate shadow patterns will make it more so. However, lighting that creates soft-edge shadows that blend together gently will add nothing to the confusion already existing.

Sometimes confusion is desirable, though usually not. However, we should know how to increase or lessen it at will. Sinking parts of a subject into black or white oblivion is often the best way to reduce confusion, the idea being that the removal of visually disturbing and extraneous elements will naturally contribute to pictorial clarity. Or it may be that only stronger separation is needed. Just about everything that one can do with light affects the clarity-confusion continuum to some degree.

There was a moderately large light source (two adjacent windows). The light struck the pale yellow wall at such an angle as to turn it quite dark. The man was at a considerable distance from the side wall to his left, so little light reflected from it to fill in the dark shadows on the side of his face.

A very soft bounce lighting made with the light source about six feet from the side wall. Bounce lightings not only treat faces well but create a good feeling in the room. They make everything look soft, round, and handsome. Naturally, this contributes to the model's feeling of well-being, which is good.

10. *Diffuse and specular:* This category is concerned with the highlight qualities of matte and shiny surfaces. Light reflected from a matte surface is diffuse, from a shiny surface specular. A matte surface scatters light rays in all directions, while a shiny one reflects all parallel rays in the same direction. Because it is being scattered, light makes the matte surface look smooth and creamy. When it is reflected from a shiny surface we see the reflected image of the light source itself. Undiffused, it is usually strong enough to heavily overexpose the portion of the film it strikes. Furthermore, the image of the source often confuses or distorts the shape of the object which is reflecting it.

Both problems are solved by using very broad light sources for photographing shiny objects.

Struck by the fact that light created an interesting pattern on the floor, I asked this dancer to use it as a little stage. From the soft reflections on her neck, one can tell she was lit by a very large light source from the right side of the picture. It was a long, high wall. The opposite wall was very dark.

Polished metal things are often entirely surrounded with paper or plastic "tents," which, when illuminated from outside, become secondary light sources. The image of such a source is still reflected by a shiny surface, but it is quite large—not a small, too-bright spot.

11. *Heaviness and lightness:* These are rather intangible qualities, as are the others remaining on the list. They are qualities more felt than seen. That is, one picture may *feel* heavy, another light. However, there is a close correlation between feeling and seeing, because dark things are always felt as heavy and light things as light.

Lightings that produce a preponderance of dark shadow might be called heavy. If light areas predominate they are light. Any change in lighting might affect the lightness or heaviness of a subject, so it is a good idea to be on the lookout for changes. Pictures may have heavy, medium, or light themes. Naturally, themes and visual qualities should match in weight. The beauty of a young child is an example of a light theme, the tragedy of war a heavy one.

12. *Strength and weakness:* The appearance of strength or weakness in subjects depends considerably on how they are illuminated, though other factors are also involved. High contrast goes with strength, low contrast with weakness. The feeling of volume contributes to strength, flatness goes with weakness. Abrupt tone changes are strong, subtle ones weak. Some photographers reserve visual strength for masculine themes, visual weakness for feminine ones. However, it is also interesting when they are switched around.

13. *Obvious and subtle:* Light can do all the things I've mentioned in either an obvious or subtle way. For example, the apparent volume of an object may be so obviously realized that it seems one could reach into the picture and pick it up. Subtly realized solidity would sometimes seem real, sometimes not, and would demand much more of the imagination.

Remember that all the tricks of lighting can be used in both obvious and subtle ways. You

should make your choice in terms of what you want your pictures to express.

14. *Dynamic and static:* This category is closely related to the two previous ones, in that strong, obvious, and dynamic are nearly synonymous. So are weak, subtle, and static. However, I keep them in separate categories, because they lead to fairly different ways of looking at things. For example, dynamic and static are good terms for helping us think of "movement" in pictures, which is an indirect way of describing their impact on our eyes.

A picture with strong or busy movement is called dynamic, and it jars our perceptual systems. A picture with little or no movement is so static it leaves us unaffected. The qualities we should seek depends on our pictorial objectives. A picture of thunder and damnation should be very dynamic; one expressing peace and quiet should be relatively static. From what has been already said you should be able to create both dynamic and static lightings.

15. *Evocative and non-evocative:* These terms describe both visible qualities and our reactions to them. Saying that something is evocative means that it stirs us emotionally. We want our pictures to do this, too. We are stirred by things because of their qualities and our prior experiences with them. In creating lightings, we do our very best to identify, analyze, and recreate the visible qualities that have aroused us in the past, using our memories and feelings as a guide.

Though our eyes are vital for the task, only our guts can tell us how well we are doing. Some lightings are evocative because they remind us of such things as dawn, sunset, campfires, candlelight, spring mornings, or young love by moonlight. Though they will enhance many subjects they work best on the ones most appropriate. For example, candlelight will do nice things for a cabbage but immensely more for a pretty girl. With the information you have, you should be able to create lightings of the evocative kind.

16. *Pictorial and non-pictorial:* A photograph is pictorial if it looks like we think a picture should look. Depending a lot on the subject itself, a given lighting makes it look pictorial, nonpictorial, or something in between. It is a very subjective quality, of course, though it is strongly influenced by our experience in looking at photographs and paintings. If we see a thing that resembles what we've seen in pictures, we feel justified in making a picture of it. If that quality is absent we are very reluctant to click the shutter. Very narrow at first, our concept of pictorialism gradually broadens with experience.

Standing right under a directional ceiling fixture, this man is very strongly lighted. The heavy contrast and harshly defined shadows on his face are in keeping with the agony he appears to be experiencing. It is only appearance, however, for he is actually as happy as a clam and singing a gay song at a party.

The interesting and delicate facial tones come from light that was bounced from the floor in front of the girl. You can tell this because the undersurfaces on her face are light, the top surfaces dark. Little light reached the white background, so it came out gray. This lighting is often useful for portraits.

The light source was a ceiling fixture that functioned rather like a spotlight. You can see it caused sharp-edge shadows and high contrast. The nearby light-colored background wall photographed almost black, because so little of the light hit it. The lighting makes this living room look as if it were a nightclub.

These young pirates are cavorting on the parental bed
—dirty shoes and all. In the small, white-painted
bedroom, sky light from windows on two sides bounces
all around, making everything look soft and bright.
Sky light in small, bright rooms is very good for family
photography and very easy to use.

The lighting concept was to make the girl's skin look luminous and beautiful. On the theory that blacks make whites look lighter and brighter, I chose a black background. Her black gown and dark hair contributed additional black tones. The main light was bounced from the right. There is a strong reflection from the left.

As we are working with light it is important to see that our perception is filtered through our experience with pictures. We call a lighting good only because we've seen it before. We see what we've learned to see, respect what we've learned to respect, and perceive only the things we are looking for. As students, we should attempt to identify and analyze the qualities that, in our opinion, make a thing look pictorial or not, then carefully track down our reasons for thinking so. This inner exploration is a part of the process of learning to see.

17. *Reality and unreality:* Our experience mainly determines whether a lighting makes things seem real or unreal to us. For most of us, for example, a shadowless lighting makes things look unreal by robbing them of lighting contrast, volume, and space. However, they wouldn't look unreal to an Eskimo who has often trudged over snow fields under bright overcast skies. He is used to a world with no dimension.

Photographers get entranced by the problem of realism. They try to make pictures that are more real than life, turn reality into fantasy, or record the world exactly as it is. Light is an important tool for this purpose, though not the only one. As you are working with it, remember that each lighting change may make things either more or less real than before. The problem is to put your fingers on the specific qualities that account for the difference.

18. *Beauty and ugliness:* The visible qualities of an object make it beautiful, ugly, or something in between. Its nature limits what light can do to it, yet within the limits light can create dramatic changes. It can make pretty things prettier and homely things more homely. Sometimes it can make pretty things homely, homely things pretty. However, light can rarely reduce real beauty to ugliness or elevate ugliness to beauty, though it does happen now and then.

All the lightings I've described here shift the

I used two light sources here: edge light from the
man's left and a small bulb pointed at the background
well below the height of his shoulders. The background
light was used to give barely minimal separation. The
reason for this darkness and obscurity was to
communicate the idea that this man is essentially a
mystery.

position of things along the beauty-ugliness continuum, the direction of the move depending on the nature of individual subjects. For example, a side lighting will add beauty to one subject and ugliness to another. The problem, of course, is to see clearly in which direction they move.

Changes in a lighting often shift a subject's position on the continuum. Having determined the direction it has moved, we must identify the visible elements responsible for the shift. We must also dig into ourselves to discover and analyze our unconscious concepts of beauty and ugliness.

19. *Interesting and uninteresting:* Our degree of interest in something is determined by numerous factors, not all of them visible or obvious, such as our experience with it or knowledge concerning it. However, a subject can also be interesting or not in a strictly visual sense. Its shape, for example, can be intriguing or dull. So can its color, design, shadow patterns, highlight patterns, etc. In fact, each separate visible quality can occupy either end of the continuum. Added together, they make a picture a success or a failure.

Though we're unaccustomed to judging the relative interest of contours, tonal ranges, textures, shadow patterns, and separations, we can teach ourselves to do it well. Gradually, we learn the merits of each kind of lighting, what it can contribute to pictorial interest. We also learn how much jazzing up each kind of subject requires. Fascinating things require very little, of course, uninteresting things a lot.

20. *Rational and irrational:* When we make pictures we always wonder whether they make any sense. We suspect, often with good reason, that many of them don't. Naturally, we want them all to be a product of rationality.

There are many factors that contribute to making a picture appear sensible. Lighting is one of the important ones. Well done, it can make a picture everything we think it should be. Poorly done, it can turn it into nonsense.

This category is closely related to several others. To illustrate, if a picture is evocative, pictorial, beautiful, and interesting, we are sure it makes good sense. However, if it is non-evocative, non-pictorial, ugly, and uninteresting, it usually strikes us as nonsense. Many changes in lighting can affect the meaningfulness and good sense of a picture. The student's job is to learn to detect this as it happens.

● **The Tricks Will Help You**

Earlier, when the basic tricks for aiding vision were described, I mentioned only a few of the things you should be looking for when composing or evaluating a picture subject, or in a lighting setup. Now, however, you know of many visible qualities that you should make yourself aware of. Developing this awareness is a big and important job. Using the tricks can help you understand what was said about the qualities and can also help you see them better. You won't develop this sensitivity all at once, so you must be patient with yourself.

Use the tricks all the time, not just when you are making pictures. Wherever you are, light is always available for study without your having to lift a finger. Take advantage of its generous availability and analyze it constantly. Light creates the visual world you live in. As a photographer you have a vested interest in all the aspects of light.

● **A Bonus Trick**
 for Hard-Working Students

An important part of the art of seeing is knowing all the visible effects and their causes. You now know quite a bit about both, though mainly in a verbal way. If you were to see a sharp-edge shadow you would probably look for a small light source; low contrast would lead you to a large light source, such as a reflecting surface that fills in shadows, or a front lighting. You now have the knowledge, because this section of the

book has actually been an essay on causes and effects.

However, we haven't discussed the problem of telling where light is coming from. If an effect has been created, we need to know where it originated. But sometimes tracing the origin can pose quite a problem. This is not always true, of course, for some sources of light are obvious. For instance, if we look at a subject with fairly strong lighting contrast we can readily see that the bright highlights come from a floodlight, a bright pattern of bounce light, a window, or some other light source we couldn't miss if we tried.

It is much harder to tell the origin of light striking a shadow area of a subject. If we can see anything at all in the area, we know that *something* is reflecting light into it; the question is what? It is usually safe to assume that a wall or the ceiling is doing it, but not always. There is a simple way for locating the source. It is to hold a hand (or finger) close enough to the area to cast a shadow. An imaginary line drawn from the shadow through the finger will point right at the source of light.

If the shadow is very delicate, with soft edges, it means the source is large. A darker, sharp-edge shadow indicates a smaller source. A double shadow comes from two sources. Absence of a shadow tells us the light source is off to one side of the hand.

Using the hand-and-shadow trick, you will often detect light coming from surprising places, such as other areas in the subject itself or from a white shirt you are wearing. Of course, the reason for locating all the sources for the light falling on a subject is to make them subject to control if desirable. They can be blocked off, shifted to a different location, brightened, dimmed, etc. However, if we don't know where light is coming from there is not much we can do about it.

LIGHTING EXPERIMENTS

We've nearly reached the end of our detour, and you can now proceed to experiment with light. Before doing so, please reread the sections entitled "Why We Have Trouble Seeing Light," "White-on-White," "White Background," and "A Necessary Detour."

When people do experiments they naturally have certain expectations. Those who expect the right things tend to do them correctly, learn what they were supposed to learn, and enjoy the work. For those who expect the wrong things, experiments become a misery and a waste of time. This being the case, I will say what one can reasonably expect from doing the experiments described:

1. Only a small percentage of the possible lightings on an average subject would make good pictures.

2. Part of the problem of learning to see is to unravel the secret of what makes bad lightings bad. We have the equally difficult task of deciding what makes good lightings good. The results of the experiments have not been given in advance. You must detect both kinds for yourself.

3. A lighting that is bad for one subject may be good for another. The student's problem is to discover why. And which lighting is good for what.

4. There are no mechanical differentiating devices built into experiments to automatically inform us which lightings are effective on a subject and which aren't.

5. Visible qualities like separation and blending, contrast and flatness, and space and two-dimensionality are neither good nor bad in themselves. The only question is, what do they accomplish in a given picture?

6. You should take a picture of everything that happens—good, bad, and indifferent—in each of the steps of your lighting experiments. For moral support, you must remember that most lightings on an average subject aren't very exciting.

7. It is likely that you'll sense when a lighting isn't doing anything worth while and you will be reluctant to photograph it. Force yourself to. Unless you are an expert, you will miss most of what light is doing when you're looking right at a subject, but pick up much of it later when you look at your prints. It isn't enough to merely sense that a lighting is ineffective; you must also pinpoint the exact causes.

8. The prints don't have to be large, but they should be made with great care if you want to learn anything from them. Poorly made prints are so psychologically depressing that they badly distort perception. Furthermore, beginners get confused between lighting and printing defects, not knowing which is which. It takes considerable will power to force oneself to make good prints of badly lighted subjects. Nonetheless, they are

necessary for helping us see why the lightings aren't working well.

9. Hurrying through experiments destroys their value. Though you could probably rush through them all in an hour or two, it would be a total waste of time and the end to your hope of benefiting from them. Take your time and carefully study each step along the way.

10. Doing an experiment just once is seldom enough. Most of the ones given here should be done many times, using different kinds of subjects and groupings thereof.

11. The purpose of the white-on-white experiments is not to teach people how to photograph white objects, no more than cancer research with mice is for learning how to cure mouse cancer. The only reason for using white objects is that they give us a remarkable opportunity to see clearly some of the important things that light does.

12. The success of the experiments depends very heavily on the care with which you select and prepare the subjects for your lightings and photographs.

• Equipment and Materials

1. one photoflood light on an adjustable stand
2. table
3. large sheets of white, gray, and black background paper
4. a variety of white-painted objects
5. a variety of unpainted objects
6. camera and film
7. tripod and cable release
8. exposure meter
9. masking tape and clothespins
10. one or more close-up lenses
11. black and white cardboards for light absorption and reflection
12. smaller pieces of cardboard for shadow casting
13. a white-painted, seven-inch juice can
14. three white eggs
15. a workroom with white or light-colored walls

• Preparing the Basic Setup

1. Shove the table against a wall, about four feet from the corner of the room. Move all other furniture out of the vicinity.

2. Put the white background paper on the table, curving one end of it up the wall. Tape it in place.

3. Position the camera and tripod so that the only thing visible in the viewfinder is the whiteness of the background.

• Exploring Contrast and Flatness

1. Place a white object on the white background.

2. Position the floodlight on the side of the table nearest a side wall. Point it directly at the object from such an angle that from the camera position the shadow line bisects the object. Observe how much contrast is created.

3. With one light absorber, the black cardboard, near the dark side of the object, see how much you can increase the contrast. Using several absorbers, see if you can make the side pitch black.

4. With one or more *reflectors* on the dark side, see how much you can *diminish* the contrast. Eliminate it altogether if you can.

5. Edge the photoflood now, so that the bright part of the light pattern is pointed between the object and the camera, with just the edge of the light striking the object. If necessary, reposition the light so that the shadow line bisects the object once again. With the reflector(s), try again to eliminate the contrast, making sure they are reflecting a bright part of the light pattern.

6. Move the floodlight to the other side of the table and, using direct light, center the shadow line again. Is there more or less contrast than in step 2? How do you account for the difference, if there is any?

7. With light absorbers, increase the contrast as much as possible. Is it as easy as before? Will absorbers of the same size do the job?

8. With edge light alone, and light reflected from the nearby corner wall, see how much you can diminish the contrast. Move the light around quite a bit to find the most effective position for it.

9. Return the light to the side of the table nearest the corner wall, then swing the reflector around to point at that wall. It should be about three feet from it. Observe the contrast on the object. Swing the light slowly back and forth in a 180-degree arc, carefully observing the contrast changes. Now move the light to within a foot of the wall. What happens to the contrast on the object? Slowly swing it again, observing the changes.

10. With the light at the side of the table, choose the bounce-light position that creates the most contrast, then use a reflector to diminish it as much as possible, then an absorber to increase it to the maximum. Compared with what happened when you were using direct and edge light, how successful are your efforts?

11. Once again, move the light stand to the other side of the table and point the light at the far side wall. How much contrast do you get? How do you account for what you see? With a light absorber, see how much you can increase the contrast.

12. Now raise the light source up high on its stand and point it at a spot on the ceiling directly over the table. Where is the break-off line between light and shadow now? Is there much contrast? How do you account for the light you see in the shadow areas? Tip the light down sharply to point directly at the object. What do you observe now?

13. Now create a lighting that wipes out contrast altogether. Play around with it until the effect is indeed total. If you don't remember how, refer to the text again.

14. Quickly run through all the lightings again and decide which ones make the object look best, which ones worst. Be sure to make photographs of the two extremes.

15. Replace the white object with an un-painted one. Carefully repeat the entire project, taking judicious note of the contrast changes you see. If you like, repeat it again with a person as your subject. Whether they are photographing people or objects, photographers run through the same lighting maneuvers. They insist on lighting equipment mobility, so that they can run through all possible lighting variations as quickly as possible. Having done this experiment, I think you can now understand why.

● Exploring Separation and Blending

1. Place three white objects on a white background in such a way that they overlap in the viewfinder. Measuring along the lens axis, they should be about three inches apart.

2. Position the floodlight by the side of the table nearest a side wall. Point it at the objects from such an angle that their highlight sides blend with each other and the background, too. Maneuver the light until the blending is absolute when viewed from the camera position. You should see no highlight separation at all in the viewfinder.

3. Continuing to point it at the objects, move the light back and forth, sideways, and up and down until the highlight sides separate. You may have to do a good deal of maneuvering.

4. Use edge light with the light stand by the nearest wall, to see how much separation you can get. Don't hesitate to edge the light very radically. You can also bring it very close to the objects, for it won't hurt them to get a little warm.

5. Use bounce light from the same side of the table to blend the highlight edges together as completely as you can. Move the floodlight up and down, along the wall in both directions, and at various distances from it.

6. Still using bounce light, create as much separation as you can. Use all of your imagination in finding ways to bounce the light. In addition to using the wall, try bouncing it from a cardboard reflector right on the table with the objects.

Try bouncing it from the floor or from a reflector propped up below the level of the table.

7. Using direct, edge, and bounce light consecutively, try reducing and increasing separation by casting shadows on one or more of the objects. Try different sizes and shapes of shadow casters, and use them in a variety of positions. Find combinations that won't produce obvious shadows. Don't take much time making shadow casters, because crude ones work very well.

8. Move the objects eight inches apart and repeat all the steps. What difference, if any, does the greater distance make?

9. Replace the objects with three that aren't white. Carefully repeat all the steps. As a photographer, your real concern is with ordinary things, not white-painted ones; so take special pains with this part of the experiment.

10. Have a friend sit himself in front of the background, profile to the camera, facing the nearest side wall. With edge light, then bounce light, blend the edge of his face with the background. Next, use a shadow caster to create separation. Then, without using shadows, use both edge and bounce light to create as much separation as possible.

11. Quickly run through all the lightings again, with white objects, ordinary objects, and your friend. Decide which ones did most justice to your subjects and what, if anything, separation or blending had to do with it.

● Checking Out the Background

People tend to ignore what light is doing to their backgrounds, and this gets them into numerous difficulties. This project will draw your attention to it and tell you what things you should be aware of. Always, the background is an important part of a picture. You should certainly know what it is doing at all times.

1. With bounce light from above or behind the camera, establish an absolutely flat light pattern on both the horizontal and vertical parts of the background paper. If you are successful you should get identical meter readings from all four corners.

2. Experiment with bounce light from the nearest side wall to get as large as possible a difference in meter readings between the two top corners. Experiment some more with side bounce light to get the corners as much alike as possible.

3. Bounce the light from the farthest side wall and see what that does to the evenness of the background.

4. Center the floodlight in front of the background, four feet away, moving aside the camera if it is in the way. Now get as even a lighting as you can. Take meter readings of the four corners and the center. Can you get all the readings to match? Back the light away a few more feet and try it again. Can you detect tone differences as well as your meter can?

5. With the light still about four feet from the background, edge it so that the middle of the light pattern cuts the edge of the paper. With the meter, measure the brightness difference between the two sides. Move the light closer and do it again. How far back do you have to move it to make the brightness difference negligible?

6. With light bounced from the floor, see how great a tone difference you can make between the horizontal and vertical parts of the background. With the center of the photoflood below table level, try the same thing with direct light.

7. The curve in the paper sometimes shows up in pictures as a shadow, a highlight, or a combination of both. Though this is usually undesirable, it is sometimes useful. With a fairly tight curve, run through all the lightings you've learned about to see what they do to it. Repeat the series with a moderate curve and a very gentle one. Which lightings tended to erase the curves, which made them stand out?

8. Working with direct light, use a shadow caster to make a soft-edge gray tone across the entire top half of the background; then do the same thing to the bottom half. Repeat the ex-

periment with bounce light from the near wall and with edge light. Do it in such a way that the shadow caster doesn't show in the viewfinder. Casting shadows accurately in bounce light can be quite difficult, but they can really pay off pictorially.

• Controlling the Subject-Background Tonal Relationship

One of the most important areas for control in photography is the subject-background tonal relationship. Properly handled, it contributes much to photographs. Mishandled, it often ruins them.

1. Position a white object on the table so that it is the maximum distance from the vertical part of the background paper.

2. With direct, edge, and bounce light consecutively, make the object much lighter than the vertical part of the background.

3. With the same types of light, make it much darker than the background.

4. Aiming the light source from below the level of the table top, use direct, edge, and bounce light consecutively to make the object much lighter than the background again. In this and previous steps you may wish to use reflectors, light absorbers, or shadow casters.

5. Using direct, edge, and bounce light, try to make the major part of the object match the background in tone.

6. Move the object to within five inches of the vertical part of the background. Repeat steps 2, 3, 4, and 5. How do you account for the difficulty (or impossibility) of creating the desired tonal relationships?

7. Quickly run through all the lightings again and decide which of them would make the best, and the worst, pictures.

8. Replace the white background with medium-gray paper. Repeat all the lightings, attempting to get the subject-background tonal relationships that were requested. It's not as hard as it sounds.

9. Now use a black background and create the same effects. You'll have to use all your ingenuity for this problem.

10. Still using the black background, replace your object with an unpainted one and go through the entire experiment.

11. With the same object, go through it again with a gray background.

12. And go through it once more with a white background.

13. Replace both objects with a willing friend, so that you can do head and shoulders portraits. This time use the whole wall as a background. To help control his tonal relationship to the wall, move him sideways along it. This will control the amount of fill light reaching him from side walls. Also, vary his distance from the background wall, from one foot to ten feet (if you have enough room).

14. Using direct, edge, and bounce light, make his face much darker than the background, then much lighter. Where necessary, have him shift positions in the room.

15. With all three types of light, make his face a tonal match for the background.

16. Bounce the light off the floor in front of him to see how that affects his tonal relationship to the background.

17. For the same reason, bounce it from the ceiling directly over his head. Do it once when he is standing two feet from the background wall and again when he's as far away from it as he can get in your workroom.

18. Quickly, run through all the lightings and positions again and decide which were most, and least, flattering to your model.

• Lighting to Specifications: Creating and Destroying Volume

You have been told a lot about getting various visible effects, so at this point you should be able to create them to order without being told how to do it. The purpose of this project is to

test how well you've learned. It will also teach you more about lighting and seeing light.

• Creating Volume

1. For this project, use a white-painted, seven-inch juice can, one floodlight, and a white background paper that has been curved up the wall. Decide for yourself the size of the paper, the position of the can, the type of lighting, and whether to use reflectors, light absorbers, shadow casters, etc.

2. The image will be vertical, the cylinder filling a little more than half of the frame. Its top will appear as a well-defined ellipse. Nothing will appear in the viewfinder except the cylinder and white paper.

3. Tonal relationships: One side and the top of the can will be white, the other side nearly black—the blacker the better. The top of the can will be a brighter white than the light side. The vertical part of the background will be a rich gray.

4. Shadows: The form shadow and the cast shadow will have soft edges but be very dark. Seen from the camera position, the edge of the form shadow will bisect the can vertically.

5. Gradation: The tone change from light to dark on the front of the can will be very smooth. There will be no sign of a sharp tone break.

6. The foreground will be substantially darker than the light side of the cylinder, but considerably lighter than its dark side.

7. Insofar as it's humanly possible, you will make the two top corners of the background match in tone, testing the match with meter readings. The nature of the other requirements may make it impossible to get an exact match.

When you've met the specifications, replace the white can with an unpainted one to see what it looks like. Try it with any other cylindrical things available, including your fingers and your arm. The question you should ask is, do they have a feeling of volume?

• Destroying Volume

1. Use the white can and background again.

2. Tonal relationships: The top and both sides of the can will match. The whole can will exactly match both the horizontal and vertical parts of the background. It is easy to make all these things match fairly well, but to make them go all the way is quite a job.

3. Shadows: none.

4. Gradation: none. Check the four corners and the center of the background with a meter. You should get identical readings.

When you've satisfied the requirements, observe other cylindrical things in the same setting to see what they look like. Your question: Does the lighting make them look flat or like they have volume?

• Manipulating Simplicity and Complexity

1. Make a white-on-white still-life arrangement with five or six objects. Position them fairly close together in a pleasing composition.

2. Create a lighting that will complicate the picture as much as possible. Don't be satisfied with anything less than visual chaos. If you don't remember how to do such a lighting, refer to the text again.

3. Establish another lighting that will simplify the picture as much as possible. Go all the way on this.

4. In steps 2 and 3 you will probably get images you won't like very much, so do a third lighting, halfway between the extremes, that will make your subject as handsome as possible.

5. Repeat the entire experiment with an arrangement of things that aren't white.

• Exploring Strength and Weakness

1. Choose a subject, not necessarily white, that you see as being boldly fashioned, or very masculine. Create as strong a lighting for it as you can.

2. Now light it as weakly as possible. How does this change the feeling you get from looking at it?

3. Replace it with a very delicate subject and use a very strong lighting again, going as far as possible to make the delicate thing look strongly virile.

4. Now set up a lighting that makes it look delicate to the very extreme.

5. Finally, do lightings for both subjects that make them look just right.

• Exploring Space and Two-Dimensionality

1. Put three white eggs on a white background, positioning them about ten inches apart and at a 45-degree angle to the lens axis.

2. Using just the floodlight (direct, edge, or bounce), see how far apart you can make them seem when they are looked at through the viewfinder.

3. With the help of one or more shadow casters, see how much you can increase the apparent depth.

4. Using only the floodlight, try to destroy all the apparent depth.

5. With the help of any means available, create an apparent depth about halfway between the extremes.

(If necessary, refer to the text to refresh your memory on how to accomplish these steps.)

• Exploring Dominance and Subordination

1. Put five or six white things of approximately equal size on a white background. Make a pleasing arrangement, but one in which none of the things seems dominant when examined through the viewfinder. This by itself will take a little doing.

2. Set up a lighting that will make one of the things dominant. Use any lighting trick in the book.

3. Rearrange the objects so that, without the help of special lighting, one of them seems domi-

nant. Arrange a lighting that lessens its dominance.

4. Now create a lighting that greatly increases it. Do this either by making it stand out more or by making all the other objects more subordinate.

5. Rearrange the objects and illuminate them so that all but one are lost in dark oblivion. You'll have to be pretty tricky to solve this problem.

6. Now lose all but one of them in white oblivion. You'll probably break your back figuring out how to do this one.

7. Substitute unpainted objects and repeat the experiments.

8. Using these same objects and a gray background paper, do the experiments again.

9. And repeat them yet again, using a black background.

10. Abandon the setup for a while and go to another part of the room with the photoflood. See what you can do to make pieces of furniture and other things either dominant or subordinate.

• Exploring Confusion

1. Choose a hodgepodge of unpainted things and arrange them in a disorderly way. Make the composition in the viewfinder as chaotic as you can. And don't settle for just ordinary chaos.

2. Through experimentation, find the lighting that adds most to the confusion. If you wish, use shadow casters, reflectors, light absorbers, or anything else you can think of.

3. Through experimentation find the lighting that reduces the chaos to the lowest possible level. Use your imagination on this. Your lighting may or may not turn the original disorder into something pictorial. It probably won't.

4. If it doesn't, see if you can find a point between maximum and minimum confusion that has pictorial possibilities, but don't be surprised if you can't. After all, you started with a hodgepodge and it may be impossible to overcome it through the use of lighting alone. Since a project like this offers little hope of a good picture, you may have

to talk yourself into doing it. The important thing to remember is that you are learning principles that can be applied to good pictures later.

• Exploring Beauty and Ugliness

1. Find a subject you consider beautiful, or at least very pretty. It doesn't matter what it is, painted or unpainted, large or small, animate or inanimate, etc. Using any or all of the lighting tricks you've read about, make this pretty thing as homely as you can. However, don't be surprised if it is a difficult task.

2. Now find the lighting that does the most to embellish your subject's beauty. Use all the tricks in the book, if necessary.

3. Find the ugliest thing available and light it so that it would make a handsome picture. Such a thing is possible, but you really have to sweat to win this game.

4. Through experimentation, find the lighting that does the most to increase your subject's ugliness. Use all or any of the tricks you've read about. It isn't as easy as it sounds, for you have to discover what ugliness actually consists of if you are going to effectively increase it. Finding the basic visible elements that make up either beauty or ugliness is a long-time job.

• Illumination from Within

1. Arrange three white eggs on a white background. Find a lighting that will make them appear as if they were illuminated from within, like light bulbs. In this project you must follow the old rule that light makes dark, and vice versa. This means that a dark area makes a light area seem lighter, and a light area makes a dark one seem darker. You'll certainly have to use this concept to make eggs look like burning light bulbs.

2. Try to do the same thing with a smooth, unpainted object (like a rock) on a gray background.

3. Using the same object, try it again on a black background. Try it with the eggs, too. Don't let the apparent simplicity of this project fool you, for it is one of the most difficult lighting problems in photography. However, some photographers can consistently make their subjects seem to radiate from within, which gives their photographs a wonderful beauty.

• Postscript to the Lighting Experiments

The assignments in this book are not like those usually given students in photography. Most teachers tell their pupils to make good pictures of certain subjects or to handsomely illustrate various themes. Such projects are very reasonable. However, they are not basic enough in some respects, because they seldom deal directly with the student's fundamental problem of learning to see.

In contrast, the experiments you've just read about are primarily concerned with helping you see better, and the problem of making good pictures is temporarily put aside. I assume that after you've learned to recognize and manipulate the visible elements of your environment and your photographs, you will naturally wish to apply this knowledge to improving your photography. You'll certainly wish to do *something* with your new set of tools.

A careful reading of the experiments will give you a sound knowledge of the practical methods used to determine the pictorial potentials of the basic tools used in handling light—light sources, reflectors, walls, shadow casters, etc. The same methods are used for assessing all lighting equipment, no matter how sophisticated it is. They are even used by professionals with equipment worth hundreds of thousands of dollars.

The techniques discussed in the experiments work anywhere, not just in indoor workrooms. I've explained my reasons for asking you to work temporarily indoors. Once you've successfully done the projects, it is time to take your new understanding out into a larger world. Whatever you

do, don't let yourself become dependent on controlled light and your workroom. Unfortunately, many people do.

In a sense, doing the assignments will turn your workroom into a microcosm of the whole visual world. The lightings you will create will duplicate in miniature most of the lighting phenomena in your environment. The important thing is to see that this is actually true and to intentionally relate everything you do indoors to something happening elsewhere. It won't happen automatically, so you will have to make a determined effort to see the relationships.

Earlier, I said you could probably rush through all the experiments in an hour or two, but that it would be a complete waste of time. It makes better educational sense to use all your spare time for a month or more. Even a highly skilled photographer would have to devote time, because some parts of the experiments are quite difficult. When you try them you may think they're impossible, though this is not true.

Despite occasional tough spots, the projects were carefully designed for the rank beginner. Even rushing through them disinterestedly, one can assuredly pick up information of value.

• Conclusion

The text is for people with no prior experience in photography, though it is filled with material it took me thirty years to gather. I hope I've managed to keep my promise to myself by writing about it in a way you find both simple and useful.

The book's first line says that photography is actually a very simple craft. I trust you can wade through all the complications I've introduced and see that this is really true. I've merely tried to take the simplicity apart so you can see how it works.

This is basically a treatise on causes and effects in photography. I hope it helps you become a master at controlling causes and a true artist at seeing and understanding the effects, however subtle they may be. May photography be an unending source of pleasure and excitement for you.